Getting Started with Digital Imaging

Getting Started with Digital Imaging

Tips, Tools, and Techniques for Photographers

Joe Farace

AMSTERDAM • BOSTON • HEIDELBERG • LONDON • NEW YORK • OXFORD
PARIS • SAN DIEGO • SAN FRANCISCO • SINGAPORE • SYDNEY • TOKYO

Focal Press is an imprint of Elsevier

Acquisitions Editor: Emma Baxter
Senior Project Manager: Brandy Lilly
Assistant Editor: Stephanie Barrett
Marketing Manager: Lucy Lomas-Walker
Cover Design: Alisa Andreola

Focal Press is an imprint of Elsevier
30 Corporate Drive, Suite 400, Burlington, MA 01803, USA
Linacre House, Jordan Hill, Oxford OX2 8DP, UK

Library of Congress Cataloging-in-Publication Data
Farace, Joe.
 Getting started with digital imaging : tips, tools, and techniques for photographers /
Joe Farace.
 p. cm.
 Second ed. of: Digital imaging
 Includes bibliographical references and index.
 ISBN-13: 978-0-240-80838-3 (pbk. : alk. paper)
 ISBN-10: 0-240-80838-X (pbk. : alk. paper) 1. Photography--Digital techniques.
2. Image processing--Digital techniques. I. Farace, Joe. Digital imaging II. Title.
 TR267.F36 2006
 775--dc22
 2006028109

British Library Cataloguing-in-Publication Data
A catalogue record for this book is available from the British Library.

ISBN 13: 978-0-240-80838-3
ISBN 10: 0-240-80838-X

For information on all Focal Press publications
visit our website at www.books.elsevier.com

06 07 08 09 10 10 9 8 7 6 5 4 3 2 1

Printed in Canada

Contents

Contents

Foreword
by George Schaub

Digital photography has changed the way people record, store, print, and share pictures. The basic rules of photography have not changed. Matters such as making the best exposure to express the subject, using different lenses for a unique point of view and working with various shutter speeds to express motion are all a part of the digital photography experience, as they are for film photography. It's still about "writing with light," but it's more like working with a word processing program than a typewriter.

The essential digital difference is that pictures are now composed of large amounts of *information*: codes that represent color, brightness, and edge contrast. Digital pictures can be made up of millions of these codes, which require computation to integrate them into what we see as a photograph. But it is within these codes that the real excitement and creative opportunity in digital photography resides, as they can be easily changed to correct things like poor exposure and color, or radically changed to create fantasies and dream pictures that could only exist in a digital world, and in your own imagination. Luckily, none of us need know the intricacies of computers or code writing to accomplish these tasks. Both camera and image processing software allow us to make changes that affect both how the original image is recorded and how we can enhance that image later.

We see those changes happen in real time, the instant after the shutter release is pressed on the camera liquid crystal display (LCD) and on the computer monitor after an effect is applied in image processing software.

Digital photography is both art and craft. The art is what makes photography a very powerful form of self-expression, one that allows us to record both precious memories and our own unique view of the world. The craft is in understanding the potential: what you can do with a digital photograph, and how to do it. It is an amazing combination of science and poetry, a powerful medium that allows for a great deal of creativity and play. And, with today's camera and software technology, there is greater access to this visual experience than ever before. While being visually aware and open to creative possibilities is as important now as it was with film photography, your ability to realize your personal vision, and to make consistently good pictures whether they be family portraits, vacation pictures or even fine art, is made so much easier via the digital route.

You might not agree that digital is easy if you are just starting out. By easy I mean that digital gives you the ability to be more experimental, more productive, and more creative with less toil. Image effects that could take a day in the old darkroom environment are now available with one click of the mouse. Having the ability to set the image characteristics of every frame you shoot is surely easier than having to change film mid-roll. And being able to share your pictures with one click e-mailing beats making prints, putting them in an envelope to mail them off, and hoping they get to family across the country in one piece.

I can think of no better guide on your digital photography journey than Joe Farace. Joe has been working with and reporting on digital photography since its inception. As the Editor of *Shutterbug* magazine, to which he contributes articles and regular columns, and in various workshops in which we taught together, I have had the good luck to be able to work with him and appreciate his knowledge, his photographic skill, and his ability to communicate both. He has always displayed the unique ability to make great pictures and explain how he made them, as well as to communicate the skills required in a way that makes it accessible and fun for his readers.

If you're new to digital photography Joe will open the creative door for you. If you've delved into the craft and want to learn more, his writing and photography will bring a deeper understanding of what might at first seem complex and difficult tasks.

I trust that you will find this book invaluable in enhancing your digital photography experience.

George Schaub
Editorial Director, *Shutterbug* magazine

Acknowledgments

*I just moved here from Big Lake, Ontario and now I'm
in this . . . dreamplace.*

Books like this one are not created in a vacuum and many wonderful people contributed to its production. The most important being Elsevier's Emma Watson whose idea for a book about digital photography coincided with my own desire to update "Digital Imaging: Tips, Tools, and Techniques." This new book's title may be a little overreaching, but the content is as complete as I could make it while injecting an element of fun that I think is necessary for working with digital photography.

I would like to thank George Schaub, my Editor at *Shutterbug* magazine, for writing the forward to this book. I also like to thank all of the software companies whose products appear within these pages. Without their help and assistance, this book would not be as comprehensive as it is.

Finally I would like to express my deepest gratitude to my loving wife Mary who has endured my photographic obsessions for more than 20 years. She is the inspiration that gets me up in the morning and her encouragement and support show up in every image.

All of these wonderful people have contributed to help me produce the good that you will find in this book and made it as complete as it could be. Any mistakes are mine alone.

Joseph Farace
Brighton, Colorado 2006

Introduction

Let's get this film down to the lab at Mrs. Mason's drugstore.

The Photo Marketing Association's *US Photo Industry 2006: Review and Forecast* reports that digital camera sales are on the rise, and will continue to rise through early 2007. Last year, 41.1% of US households owned a digital camera, and that figure is expected to grow to 52.4% this year. Once again, digital cameras are expected to outsell film cameras, and 82% of all cameras sold in 2006 will be *digital*. As anybody who read my work over the years might guess, I attend a lot of car shows and can't remember the last time I saw *anybody*—participants or observers—shooting film.

So, as pundits have reported so many times before, is film dead? I don't know. I still occasionally shoot film using Leica single lens reflex and Hasselblad rangefinder cameras, but almost all of my negatives (I seldom shoot slides) are scanned using an Epson (www.epson.com) or Microtek (www.microtekusa.com) scanner and printed on Canon (www.usa.canon.com) or Epson ink-jet printers. Sometime during that trip from capture to output, those silver-based images are transformed into pixels, manipulated, and printed on decidedly non-digital paper. Is the final print digital? Who cares? It's a *photograph*. How I arrived at what you see on the paper is unimportant, only the image and its impact on the viewer matters (see "Digital Dreams").

Digital Dreams

I like panoramic photographs; that's one reason I still shoot film using a Horizon 202 (www.kievusa.com) or Hasselblad (www.hasselblad.com) Xpan. Sometimes I make photographs using a digital SLR and crop them into a panoramic shape. Which one of these two images was made with film and which one with digital? Which one became a 4×12 *foot* mural that was displayed in a car dealership's service department? From the reproduction here you can't tell, can you? More important, it doesn't matter. For the record: The drag racing image was made with a Canon EOS 1D Mark II (a digital SLR); the car show was captured on film with a Kiev USA Horizon 202.

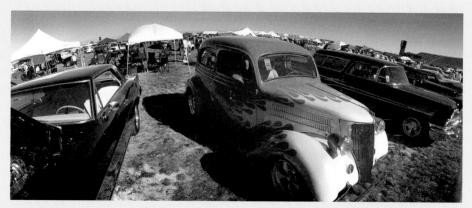

This photograph of cars at The Good Guy's show in Fountain, Colorado was made using a Horizon 202 panoramic camera and Kodak 400 NC color negative film. Exposure was 1/250 second at f/16, determined by a Gossen Luna Star F2 hand-held meter. Image was scanned using a Microtek (www.microtekusa.com) ArtixScan 120tf film scanner that's well suited for scanning medium and panoramic format film. © 2005 Joe Farace.

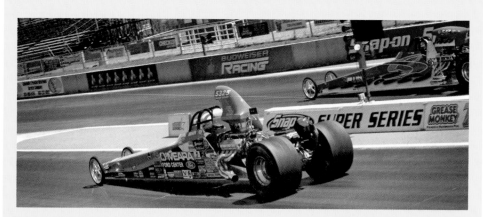

This photo of Bill Lagoni driving his O'Meara Ford-sponsored dragster was shot with a Canon EOS 1D Mark II using a 75-300 IS zoom lens set at 75 mm. Yes, I was that close to the action. Exposure at ISO 200 was 1/320 second at f/11 in Aperture priority mode. The camera was panned during exposure. © 2005 Joe Farace.

The Net

As you might have already noticed, I will be using a web-centric approach to the products and services that are mentioned in these pages. Whenever I mention a company's name for the first time, I will also list in parenthesis the addresses (URL) of web sites where more information about that particular product or company can be found.

FANTASTIC FOUR

Digital imaging consists of four phases that are not too different in *intent* from the traditional silver-based imaging process:

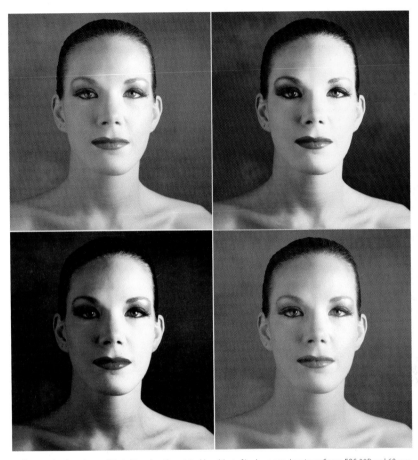

To illustrate the four phases of digital imaging, the original headshot of Leah was made using a Canon EOS 20D and 60 mm EF-S macro lens. A Lowel (www.lowelego.com) Ego Light was used along with an F.J. Westcott (www.fjwestcott.com) reflector to light the portrait. Exposure at ISO 400 was 1/200 second at f/3.5 to *minimize* depth-of-field. The color variations of the original image were created using nik Color Efex (www.niksoftware.com) and the black and white used Pixel Genius PhotoKit (www.pixelgenius.com). All four versions of Leah's portrait were combined into a single document using Adobe Photoshop CS2's Layers function. I'll show you how to make an image like this later in the book. © 2005 Joe Farace.

Capture: This occurs at the moment—*decisive* or otherwise—when the shutter clicks, but digital photography extends that metaphor by providing other ways of capturing images of people, places, or things. It can also occur/happen when you digitize a slide or negative that was originally shot on film.

Enhance: Some of the enhancements you can make in your desktop darkroom are similar to what you might accomplish in a traditional darkroom, but with digital you can produce something seen only in your mind's eye. In the digital darkroom, you have the all of the advantages of cropping, adjusting brightness and contrast, or tweaking color while working with the room lights on.

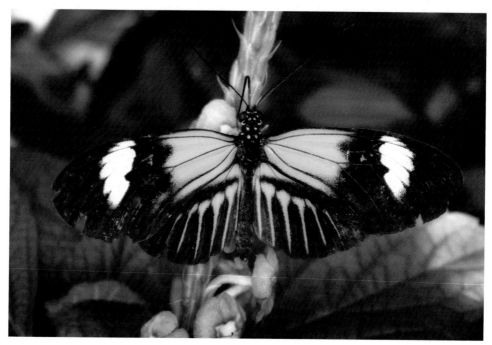

Some people, such as my pal Rick Sammon, make wonderfully realistic photographs of butterflies; but I prefer *interpretive* image making. This original photograph was made at the Butterfly Pavilion (www.butterflies.org) in Westminster, Colorado using a Canon EOS 20D and a 60 mm EF-S macro lens. Exposure in manual mode was 1/60 second at f/13 with lighting provided by Canon's Macro Ring Lite MR-14EX. Special effects were created with nik Color Efex Duplex: Color filter. © 2005 Joe Farace.

Output: This is the step where computer hardware and software collide with traditional print making to produce output that, when done properly, cannot be distinguished from a sliver halide photograph. To make sure this phase of the process matches what you *created* in the digital darkroom, it helps to have a large, color-corrected monitor.

Presentation: You can make prints using an ink-jet printer or at a kiosk in Wal-Mart then and place them in a conventional album, but there are many other ways to use digital images that are, *truly* digital. Using photo sharing web sites such as SmugMug (www.smugmug.com) you can share photographs with family and friends around the globe. See what's possible by taking at look at my own SmugMug page (http://farace.smugmug.com).

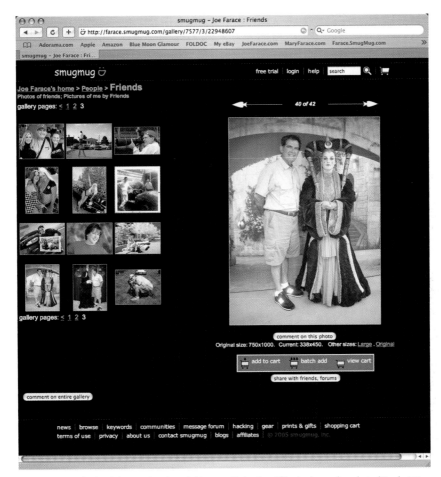

Photo sharing sites let digital photographers share their images with family and friends who can also order traditional prints via the site. This page appears in my Friends gallery on SmugMug that displays pictures of me made by my friends, such as this one of Queen Amidala and I, along with pictures of my friends made by me. © 2005 Mary Farace.

CAPTURE THE SUN

As far as getting involved in digital imaging, the good news is that you can be as digital as you want to be! The advantages of both purely digital capture and digitizing film are many, and include the following.

Recycling: Once you've captured an image onto a memory card, you can re-use that CompactFlash, Secure Digital, or Memory Stick, many hundreds of times. Not only is this media re-usable, it's editable. Every digital camera includes an LCD preview screen that lets you see the captured image immediately. If someone's eyes are closed, you can erase the photo where they have their eyes closed and re-shoot it right there on the spot.

This photograph of Leslie was snapped at the very instant a bug flew in her mouth! It's a funny picture to be sure, but seeing the result on the preview screen gave me the opportunity to reshoot, plus gave us both a big laugh. ©2004 Joe Farace.

Flexibility: Scanners are now so inexpensive that anyone who owns a computer can also afford to purchase a flatbed scanner, such as the $99 Epson Perfection 2480, and use it to digitize prints whose negatives have long ago been lost and turn them into twenty-first century digital images.

The Epson Perfection 3490 Photo has an affordable $99 price tag. It has an optical resolution of 3200 dpi (dots per inch) combined with fast USB 2.0 connectivity, making it the best photo quality scanner at this price point. Photo courtesy of Epson.

Convenience: When your memory card is full of images you can copy them onto writable CD discs that cost just pennies each, and stack them in a compact space. Who knows, by using the right digital asset management software, you might finally be able to keep track of all of your images and find that picture of your dad on his old sailboat.

ARTIFICIAL LIES *aka Le Manipulateur*

When initially setting up your digital darkroom you're going to need image-editing software along with the output devices to print digital images. Digital imaging software is available in three broad categories.

Beginners can use snapshot software that offers basic manipulation techniques such as cropping, changing brightness and contrast, and useful features like redeye reduction. Some *free* programs that fall into this category include Apple Computer's (www.apple.com) iPhoto, and Google's Picasa (www.picassa.com) for Microsoft Windows.

Picasa is a *free* Windows-based image management, Web sharing, and enhancement program that offers one-click photo repairs and lets you e-mail, print, make gift CDs, instantly share via their "Hello" feature, and post pictures on your own blog. © 2005 Joe Farace.

Intermediate users work with programs that add more capabilities for image editing, often including features that let them produce special effects. Applications in this class often accept plug-ins that allow you to extend the capabilities of the program from within. Windows-based software in this category includes Corel's (www.corel.com) PaintShop Pro and Ulead's (www.ulead.com) PhotoImpact. MediaChance's (www.mediachance.com) $49 PhotoBrush is a Windows-only best buy.

PhotoBrush is a $49 Windows-based program that combines image editing and artistic media painting. The latest version adds RAW file support for over 100 different cameras and PhotoBrush not only accepts Photoshop-compatible plug-ins (more on them in Chapter 9) but also can read and write Photoshop's PSD files as well. © 2005 Joe Farace.

Serious image makers use professional-level tools that have the most powerful capabilities but also demand a serious digital imaging computer. This category is dominated by Adobe (www.adobe.com) Photoshop CS; and while there have been challengers over the years, there are few competitors left. Corel's Painter offers professional-level tools and lets you produce images for the Web, fine art, or separations for prepress applications.

HOME FIELD ADVANTAGE

Software is one area of the digital imaging process that has decided advantages over traditional photography. When you commit to a camera system and make a corresponding, and sometimes hefty, investment in lenses and accessories, switching brands can be too expensive for most photographers. Digital imagers, on the other hand, can assemble a digital software toolkit that contains products from many different companies, all of which are complementary, and some of which share software components.

When working with digital images, manipulation techniques fall into several categories:

Enhancement: After capturing an image, the next step is to make it look as good as it can. Some of the tools built into image enhancement programs, such as Levels and Curves, may be tricky for beginners to wrap their brains around, but inexpensive add-ons such as PhotoTune's (www.phototune.com) 20/20 Color MD let you tweak an image by making a series of choices between two alternatives.

Using PhotoTune's 20/20 Color MD Photoshop-compatible plug-in is a lot like going to the eye doctor. You just click on whichever image you like best between two that are offered and in a few seconds, the image's color, density, and dynamic range are tweaked! © 2005 Joe Farace.

Retouch: Since photography began, portrait photographers have retouched negatives with pencils and dyes, applying artwork and airbrushing to improve on nature's little imperfections. Photoshop-compatible plug-ins, such as Kodak's (www.asf.com) Digital GEM Airbrush Professional, lets you smooth skin, reduces harsh shadows and highlights, minimizes imperfections, and preserves details such as hair, eyelashes, and eyebrows.

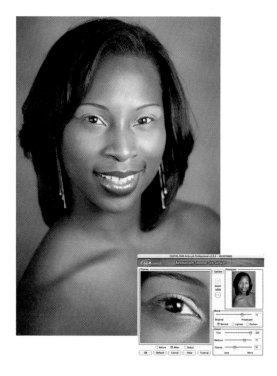

One of my favorite retouching tools for portraits is Kodak's Digital GEM Airbrush Professional, a Photoshop-compatible plug-in. © 2005 Joe Farace.

Restoration: Repairing old faded and damaged photographs used to be the province of the specialist, but now anyone with a little patience to learn a few

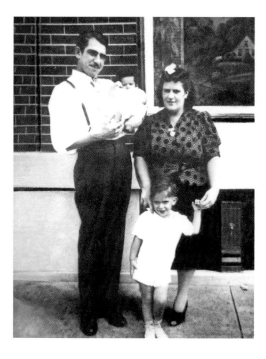

One of the best things you can do with a scanner and some digital imaging software is to restore old photographs such as this 1940s shot of me with my mom, dad, and sister. I'm the cute li'l tyke in the short pants.

new digital tools and tricks can use image-editing programs to fix old scratched photographs and make them look like new again. The good news is that the original and often fragile print is left untouched and undamaged by the process.

Creativity: Digital imaging software empowers user to produce images they could only dream of. Years ago I labored many hours in a wet darkroom to produce a composite image showing what an historic statue would look like when moved to a different location. Digital imaging applications that have Layers function, such as Adobe Photoshop CS, let me do a better job in much less time, and I don't have to work in the dark with smelly chemicals.

Only part of this photograph, that I call "Colorado Hot Rod," was made in Colorado. I originally shot the car shot in Fountain, CO in 2004, but Bob Geldmacher photographed the background image in 1971 using color slide film. (Hiding under the hot rod there's a shot of my then-new 1971 Porsche 914 and me.) They were combined using Photoshop CS's Layers function and finished with nik Color Efex filters. © 2005 Joe Farace/Bob Geldmacher.

PRINT THE IMAGE

Making your own prints using a desktop darkroom eliminates a trip to a photo lab and is a lot faster than going to a 1-hour lab. I think that's one reason many pros like digital imaging, and many amateur photographers as well. You can even have your own desktop minilab. All-in-one devices, such as Canon's Pixma MP760 let you print high-quality proof sheets and snapshots directly from memory cards without using a computer.

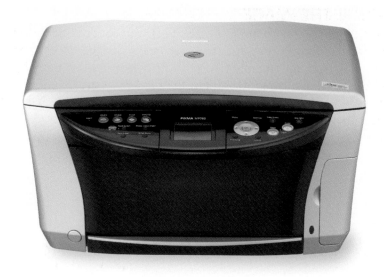

Canon's PIXMA MP760 all-in-one is a versatile tool combining printer, scanner, copier, and card reader that works with your computer, or all by itself. The printer function has 1856-nozzle print heads that eject droplets as small as two picoliters and produce photo quality output up to 4800 × 1200 dpi. Photo courtesy of Canon USA.

Printing your photographs doesn't have to be complicated. To make your next ink-jet printing session produce the kind of output you want, here are a few tips:

Read the manual: It's usually short and contains helpful information on the printer's *driver*, which is the most important bit of software needed for achieving optimum results. The manual has all kinds of other information about what type of media works best at what settings, and highlights other features, such as how to make borderless or double-sided prints.

If you decide to use paper different from what the printer manufacturer offers, take the time to read this media's instructions to learn which driver settings are compatible with the paper and will produce the best results. Since this is an imperfect world, go to the paper company's website to look for the latest recommendations or even printer profiles to achieve more precise results.

Out here in the real world there are lots of variables and not every paper and ink combination works together the way you might like. Before making a big investment in papers, purchase a sampler pack or small quantity of the paper and make a few prints with your own test files. Write notes about the printer driver's settings and paper used on the back of the prints and file them for future reference. Don't be flummoxed by this quick start guide to printing, there's a lot more in Chapter 11.

PRESENTING THE IMAGE

The last part of the digital imaging process gives the concept of output a world-wide dimension and opens the door to what you can do with your photographs after you've captured, manipulated, and output them. Because of the Internet, you can now share digital images with friends and family anywhere on the planet. What's more, you can create presentations that combine still images with video clips, music, and graphics to tell a story.

Photo sharing: Instead of mailing a photo album across the country to friends or relatives, you can post them on a web site such as WebShots (www.webshots.com).

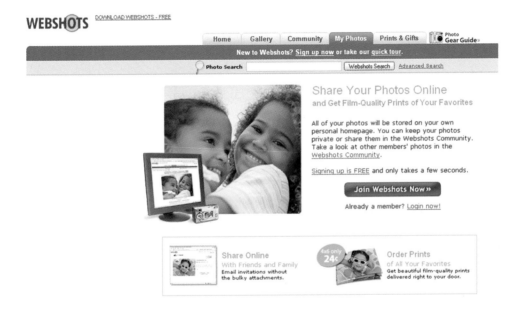

Not only to photo sharing web sites such as WebShots.com make it convenient for people anywhere in the world to *view* these photographs, they also let family and friends order reprints from the images directly from the on-line service taking you out of the re-order loop. Photo courtesy of WebsShots.com.

Build your own web site. If you have aspirations to sell your photographs to the public, having a website gives you the same storefront on the digital highway as much larger gallery operations. Even if you don't want to sell your images, having a personal web site gives you a way to communicate with others in ways that could have only been dreamed about 10 years ago.

Assemble a digital album: ... and record it onto a CD-ROM disc. With inexpensive album software, such as, E-Book Systems' (www.ebooksys.com) FlipAlbum CD Maker, you can turn your family photographs into a presentation complete with musical accompaniment and special effects transitions between images.

Programs such as Microsoft's (www.microsoft.com) PowerPoint empower professional and amateur photographers alike to create presentations as well as e-books.

The best advice I can give about going digital is to have fun with your image making. Don't be so serious or the playful, experimental aspects of digital imaging will get lost.

TORN CURTAIN

The computers I used for this book are the same ones I use every day: An Apple Power Macintosh G4 with two 40 GB internal hard drives, DVD-R drive, built-in Iomega Zip drive, and an external SimpleTech 300 GB FireWire drive. My Windows machine is a 2.6 GHz Compaq Presario with 160 GB of hard disk space, CD-RW, and DVD drives. In the digital imaging universe, these are what I would call middle-of-the-road machines. I know photographers working with less complex computers, and others working with more extensive systems. Digital imagers working with systems with more power, larger memory, and higher capacity storage will be able to produce the effects in this book faster than I was able to, while those with smaller, slower systems may have to be more patient.

All of the images and effects produced in the how-to sections of the book were created using both computers. This was done for a very practical reason: Not

every software program is available for both Mac OS and Windows environments. Programs that are platform-specific, like the Windows-based Ulead System's PhotoImpact, were run on my Presario computer. Cross platform software packages, such as Adobe Photoshop CS2, were run mostly on my Power Macintosh system and occasionally on Windows.

Most of the photographs were created using digital, 35mm, 6 × 6, or 4 × 5 film formats. Film images were digitized with a Microtek ArtixScan 120tf or Epson Perfection 4870 Photo scanner. Unless otherwise credited, all of the photographs you see in these pages are copyright Joe Farace.

A word about quote and subheads: I'm a movie buff. All of the quotes that start each chapter are from movies and the occasional TV show. Some of the subheads also reference some of my favorite films. If you *get* the references, great. If you don't, don't worry about it, just ignore it and read the text.

TWO-MINUTE WARNING

Before jumping into Chapter 1 I want to share a few important "rules" about how I create my personal digital images:

Keep it simple: it's a cliché but true nonetheless. Start with image capture and making sure the image you make isn't cluttered, makes a strong point and tells a story, the simpler that story is, the easier the photograph will be to "read." It's also true for image enhancement and manipulation. I prefer to use one or two steps rather than many different steps for the simple reason that we are dealing with binary numbers represented as pictures. Software crunches those numbers and over time there are minuscule rounding errors that occur; keeping these number of steps to a minimum minimizes these errors and maximizes image quality.

The "20-minute" rule: I have discovered that if I can't make the final image look the way I have previsualized in 20 minutes, I am never going to do it. I have spent hours working on an image wasting paper and ink trying to make an image file to look like what I dreamed it *should* be. Fuggedaboutit. Sometimes it's just doesn't happen. Try to capture it on the file the next time and learn from your mistakes.

Let the tools do the work; use Power Tools: You can build a house with a hammer and manual saw but the work goes faster with power tools. I like to use digital power tools too, so I'll be introducing you to Photoshop-compatible plug-ins and Actions that make quick work of digital effects and do a great job at the same time.

FUN WITH DICK AND JANE

All photographs—digital or silver-based—combine elements of reality with imagination. How these elements are combined is up to the photographer, but there is no denying that digital imaging has presented the creative image maker with some powerful tools. In this book, I'll introduce you to some of those tools and show you how you can use them for your own digital explorations.

Not every aspect of every possible imaging technique will be found in these pages. There are many ways to produce any kind of creative photographic effect. That's why photography is still just as much art as it is craft. Some writers and gurus may insist there is only one way to produce an image, but I don't agree. This book has been designed to show you *one* way of creating digital images, not the only way. You should use my meanderings as a jumping-off point for your own explorations, not as a destination.

Kevin Elliott, of Mac MD (www.macmdcare.com) recently gave me some advice I'd like to pass on to anyone wishing to get started in digital imaging. "When a photographer has achieved a certain level of skill, they expect to compress the time it takes them to get into digital imaging," he told me, "when they really have to start all over again."

In this book, traditional silver-based photography meets digital imaging. It's not just a new edition of "Digital Imaging: Tips, Tools, and Techniques" but also a new approach for amateur photographers and aspiring pros who want to work with digital images. I try to take you "behind the screens" to show you how to use the *tools*—not just the software—that can be used to produce prints or digital image files for via e-mail or posting on the World Wide Web.

Joe Farace
Brighton, Colorado 2006

Welcome to the Digital Darkroom

Pardon me, boy, is this the Transylvania Station?

Photography, as we know it, is going through its most profound changes since William Fox Talbot shocked the Daguerreotypists with his concept of "the negative." Since its beginnings, photographers have continually worked with some kind of camera and darkroom. Over time, these tools have changed in form but not in

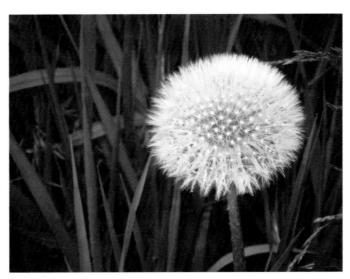

This *Taraxacum officinale* (a.k.a. dandelion) was photographed with a Sony Cyber-shot DCS-W100 point-and-shoot camera in Macro mode. The built-in flash was used and the camera's exposure compensation was set to minus one stop to darken the background, placing the focus on the foreground. © 2006 Joe Farace.

function. Just as the format of the camera you use defines the kind of imagery you can produce, the kind of computer you decide on using can have a bearing on the kinds of digital images you are able to create.

There's an old photo lab saying that states: "speed, quality, and price—choose any two." That may hold true for traditional photographic services but the way Moore's law has been applied to digital imaging means you can have all three— when you choose the right computer! For the digital imaging computer buyer, speed, quality, and price have been replaced with price/performance, total cost of ownership, and return on investment. The computers that digital imagers prefer to use will, for the most part, parallel the kinds of cameras they are using now. In general, this boils down to three categories of computer-using photographers.

For amateur shooters who use digital point and shoot cameras, the most important factor in selecting a computer is price and performance. These computer users will be satisfied with computers that meet the minimum system requirements for the kind of entry-level image-editing software they may choose to run.

Photographers who prefer state-of-the-art digital SLRs will want state-of-the-art desktop computers for their digital imaging work and will want to consider the total cost of ownership. This includes both the time spent on learning the system and the cost of maintenance and upgrades.

Professionals and those photographers working in high-end digital SLRs or medium format digital cameras need workstations that can handle the large files produced by digital images created with such cameras, and will be looking for workstations that provide a return on their larger investments by speeding up the time it takes to process large images in large quantities.

You can convert color digital images into black and white inside the digital darkroom, or capture them directly as monochrome files as I did with this photograph of Tia Stoneman using a Canon EOS 5D. Exposure was 1/160 second at f/6.3 in Program mode. ISO was set at 400. © 2005 Joe Farace.

The Origins of "Digital Darkroom"

One of the first digital imaging programs available was called "Digital Darkroom" and was produced in 1989 by Silicon Beach Software. With this program, Silicon Beach programmers, Ed Bomke and Don Cone, introduced the world to the concept of graphics software *plug-ins*. When Aldus Corporation purchased Silicon Beach's products, Digital Darkroom became a part of that company. When Adobe Systems acquired Aldus, Digital Darkroom was abandoned in favor of Photoshop. As time passed, MicroFrontier (www.microfrontier.com), producers of the photographic software Enhance and Color-It!, purchased the right to the name "Digital Darkroom" and now offer some pretty cool software for the Mac OS and Windows under that name. During its time between homes the words "digital darkroom"—now with lower-case "d's"—came into widespread use, as a way to describe desktop imaging, and it is under those conditions that the term is used in this book.

BACK TO THE FUTURE

If you buy a digital camera just to save money on film and processing you may be in for a surprise. While it's true that someone who shoots lots of slide or negative film can quickly amortize even the purchase of a new $3000 Canon EOS 5D, there's more to this equation than just the cost of the camera and a few memory cards.

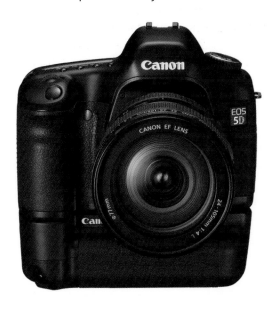

The new EOS 5D fits into the same "good, better, and best" strategy that Canon used with their film-based SLRs. It's plopped down right in the middle of their product line between the EOS 30D and Canon's 1D *alphabet soup* models. Unlike the EOS 3 film camera that looks and feels more like an EOS 1, the 5D's magnesium-alloy body reminds me more of a chunky EOS 30D; but where else are you gonna find an SLR with a full-sized chip for $3000?

One of the biggest differences between the worlds of film and digital photography is the start-up cost. After purchasing a film camera you can take the exposed film to any minilab in the country and they'll gladly make prints from the exposed film for a modest charge, but when you purchase a digital camera you also buy into the concept of the *digital darkroom*. For some computer users this may just mean a few hardware or software upgrades along with a new peripheral or two, but if you're starting from scratch, *MacWorld* magazine once estimated that, depending

on your digital imaging goals, the cost of establishing a digital darkroom can go as high as $6500. But I don't believe it has to cost *that* much. Here's why . . .

A SHOT IN THE DARK

A few years ago I sold all my traditional darkroom equipment, lock, stock, and tongs. After sitting untouched in my new home's basement for several years, I decided it all had to go. I loaded enlarger, lenses, carriers, and trays into my car, and took them to a local photo show, selling them to practitioners of silver halide printing for below bargain prices. Why? Many years before my fire sale, I happily made the transition to the digital darkroom and now that all of these boxes upon boxes of traditional darkroom gear are gone, I haven't looked back.

Assembling your own digital darkroom isn't complicated or expensive and is much like putting together a camera system: you can tailor the equipment to meet your specific applications and budget. You can build a complete system for less than $1500 or spend more than the cost of a shiny new BMW 3-Series; it all depends on your budget and what you're trying to accomplish.

DON'T GO NEAR THE WATER

Much like you can make photographs with a $3000 Canon EOS 5D or a $20 Holga (www.freestylephoto.biz/holga.php), virtually any *new* computer system can be the basis of a digital darkroom; but digital imaging, like the devil, is in the details, so here's how to start assembling your new darkroom.

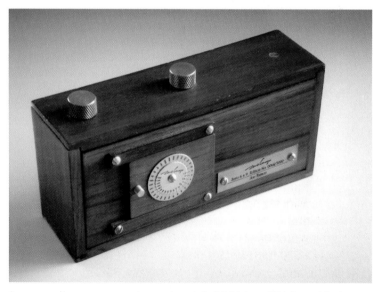

Any camera, and I mean *any* camera can be your entrance to the digital darkroom. This is the actual Zero Image (www.zeroimage.com) pinhole camera that I use to make photographs. The camera uses 120 films and has no shutter, no lens, no controls of any kind but it can make pictures! Don't believe me? Look at this. © 2005 Joe Farace.

I am a big believer that photo ops are "right around the corner" and this photograph was made just a mile or so from my home at an old sugar factory. Camera used was a Zero Image pinhole camera along with Agfa color negative film. Exposure is by guesswork. Since the effective aperture is about f/225, I use the "hippopotamus" method of counting seconds for this 8-second exposure. One hippopotamus, two hippopotamus . . . The cool-looking edge effects were produced after the fact in the digital darkroom; I'll show you how to do it later in this book. © 2003 Joe Farace.

Budget-minded digital imagers could start with the least expensive Mac Mini, iMac, or Microsoft Windows-based computer they can find. As I write this, you can purchase a new Mac Mini from the Apple Store (www.apple.com/store) for $600. This gets you a 1.5-GHz Intel Core Solo processor, 512-MB memory, a 60-GB hard drive, CD-RW/DVD-ROM drive, and built-in WiFi and Bluetooth. You'll need a $100 monitor, a $20 keyboard, and a $20 mouse, or you can use these items from your old Windows machine. If you spent another $200, and got another copy of Windows, you'd actually be able to run both Windows and Mac OS on this one computer.

A Windows-based package from e-Machines (www.emachines.com), such as the W3107, costs $398.99 and features a 1.8-GHz AMD Sempron chip, 512-MB

DDR random access memory (RAM), 10B hard drive, DVD ± RW, and an included 17-inch flat cathode ray tube (CRT) monitor. Since computer prices and specification change faster than even digital cameras, this will probably change based on when you're reading this, but you get the picture.

As I write this, a new Apple MacBook with an Intel Core Duo processor costs less than $1100 and is an ideal entry-level computer for digital darkroom workers that want to work in the Mac OS. Torn between the Mac OS and Windows? We'll get to that in just a bit. Product shot courtesy of Apple Computer; insert shot © 2005 Joe Farace. (*Note*: You'll need a shot of a MacBook instead of an eMac, and the W3107 from e-Machines.)

When it comes to a computer's processor, faster used to be better, but now computer makers have hit a speed wall. Instead, they're adding processor cores to speed throughput. Intel's Core Duo is just such a system, now appearing in both Macs and PCs. But you don't need to worry much about it. Adobe's Photoshop Elements 4 (www.adobe.com) requires only an Intel Pentium III or 4 or Intel Centrino (or compatible) 800-MHz processor. You'd be hard pressed to buy a new computer at those speeds. I'm currently running the *Full Monte* Photoshop CS2 on a 600-MHz G4 Power Macintosh with 768-MB RAM. Would I like more power? Yes, but I'd like to own a Chevrolet Corvette too.

For Windows: Pick a Chip, Any Chip at All

What's the difference between an Intel Celeron and a Pentium? (Die-hard techies can skip this part.) A Celeron is basically a Pentium chip with some stuff missing; specifically the *cache*. A cache is a hunk of fast memory that holds recently accessed data, so it's ready when you need it and the CPU doesn't need to go fetch it from RAM. This missing ingredient means a Celeron chip is slower than a Pentium, but it also means it costs less. Where does AMD's (www.amd.com) Duron's (who makes up these names anyway?) chip fit into this equation? All tests seem to indicate that the Duron will clean the Celeron's clock, and if you need more power (and who doesn't?) AMD's flagship Athlon is generally considered to be a high-performance chip that rivals Intel's Pentium. The hot new kid on the block is the Intel Core Duo, with not one, but two processors on a single chip, for a theoretical doubling of data throughput per clock cycle. You can expect more chips to go multiprocessor in the near future. If all of these issues are important to you, visit Tom's Hardware Guide (www.tomshardware. com) for tests and comparisons on all of the different kinds of chips and advice on how to optimize the performance of your own Windows-based computer.

PERMANENT AND TEMPORARY STORAGE

You can never have too much RAM, so get as much as you can afford. Even for the least expensive system, I urge beginning digital imagers to have a minimum of 512MB, but *more* is always better. If the computer you're considering won't allow you to increase the amount of memory, choose another one. Photoshop Elements 4, for example, requires only 256MB of RAM, but that doesn't include the operating system and all the other stuff computers need to operate.

I hate to contradict Mies van der Roh, but when it comes to hard drives, *more* is more. The 80–100-GB hard disks included in our theoretical start-up systems are more than adequate, but more space is always useful. With 80-GB hard drives selling for under $65 at places such as www.dirtcheapdrives.com, it makes sense to upgrade or add to the puny drive that's already installed in your computer. Two drives are better than one: I have two 120-GB drives inside my Power Macintosh G4. When there's a problem starting from the main drive, I have *another* operating system installed on the second drive enabling me to start the computer and fix problems on the other drive. This is a trick I learned from Kevin Elliott (www. macmdcare.com) who also partitioned my main hard drive so that one boots from Mac OS 9, the other from OS X, giving me even more flexibility.

If you store all your digital images on the computer's hard disk, you'll quickly run out of space. That's why your digital darkroom should include at least one form of recordable media. Most photographers currently use writable CD-R and DVD-R discs, and who can blame them? These discs hold lots of image files and cost a few pennies each. Re-writable CD drives are popular and many inexpensive computers include CD-RW drives as standard equipment. One of the optical storage technology's biggest claims to fame is longevity. Good-quality CDs have an

expected shelf life of 30 years, making them a good choice for anyone worried about long-term storage (be sure to buy quality name-brand discs) but format longevity is another question. As the prices of writable drives and media drop, DVD becomes a more attractive storage option. Instead of storing megabytes, DVD discs store *gigabytes* of image files, meaning you'll have fewer discs to store and locate.

I have a 300-GB external (FireWire) drive, mostly to keep image files stored. Keep in mind the corollary to the *"More"* rule; backing up is harder to do. And you better back up. *Every* image file on that 300-GB drive is also backed up onto a CD or DVD disc.

You are going to need a way to capture images, but instead of connecting your digicam to your computer with the included cable to download images, purchase a card reader that reads all kinds of media. Even if your current camera only uses *one* media type, you never know what your *next* camera will use. Devices such as Belkin's (www.belkin.com) Hi-Speed USB 2.0 8-in-1 Media Reader and Writer let you drag and drop images files to a computer, or even from one media card to another. Since it operates under the speedy USB 2.0 protocol, it's fast. If your computer is still using the original, slower USB, don't worry. The reader/writer is backward compatible. You should still strongly consider adding a USB 2 card if your older computer has an open slot. They are inexpensive and speed up your workflow more than you might imagine. (*Note*: There's more on card readers in Chapter 2.)

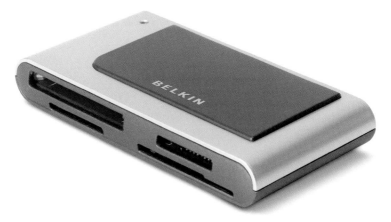

With slots dedicated to *eight* types of media, Belkin's Hi-Speed USB 2.0 8-in-1 Media Reader has the ability to read and/or write CompactFlash I or II, SmartMedia, IBM Microdrive, Secure Digital, Multimedia Card, Memory Stick, and even Sony's white MemoryGate Memory Stick. But *not* the xD-Picture Card used on Fuji, Olympus, and other cameras. Drawing power through the computer's USB port, the 8-in-1 Media Reader doesn't require additional power making it an ideal for hot swapping with other computers or devices.

PCI Meet Your Replacement

PCI (Peripheral Component Interconnect) slots are the standard way to connect sound, video, and network cards to a motherboard, whether Mac or PC. As processors, video cards, sound cards, and networks have gotten faster and more powerful, PCI's fixed width of 32 bits limited it to a maximum of five devices. PCI Express (PCIe) provides more bandwidth and is compatible with existing operating systems. It's a high-speed serial connection that operates more like a switch controlling several serial connections leading to where the data needs to go. Every device has its own dedicated connection, so devices don't have to share bandwidth, speeding up the entire process. What does this mean to you except some new buzzwords? A single PCIe lane can handle 200MB of traffic in each direction per second and move data at 6.4GB second in each direction to handle a Ethernet connection as well as audio, storage, and graphics adapters. And that's a good thing.

Belkin's PCIe Cards increase the amount of available computing bandwidth to offer four-times-faster data transfer than standard PCI (see "PCI Meet Your Replacement"). PCIe Cards add expansion ports to your computer using the new PCIe technology and let you future-proof your computer to support new bandwidth-intensive applications. Cards available include: FireWire 800 and USB 2.0 PCIe Card ($149.99) SATA II RAID 2-Port (1 Internal/1 External) PCIe Card ($69.99); FireWire 3-Port PCIe Card ($79.99) SATA II RAID 2-Port PCIe Card ($59.99); and USB 2.0 5-Port PCIe Card ($69.99).

THE MONITOR AND MERRIMAC

They're big—and getting bigger—they takes up lots of desktop real estate, generate heat, a bit of radiation, and can give you headaches if you stare at them

too long. CRT displays have been around a long time, and while some underlying hardware components have been improved during that time, notably in size, resolution, and even reduced radiation, the underlying technology is more than 60-year old.

One of my pet peeves is how expensive monitors have remained relative to overall system cost. If you've been shopping recently, you know that there are some bargain monitors out there and while some of that downward price pressure can be attributed to competition, the real reason is the growing popularity of liquid crystal display (LCD) flat-panel displays.

Bigger is better, and larger monitors have become more affordable. You should get the largest monitor your budget permits. Over time, I've migrated to LCD monitors for both my machines. Older LCD screens were not adequate for critical digital image manipulation, but after Apple introduced their Studio Display series, the ball game changed dramatically. I have a 22-inch Apple Studio Display on my Power Mac G4 and a 20-inch Apple Studio Display on my Compaq. Yes, I have an Apple monitor on my Windows computer!

The Apple Cinema Display features a 22-inch active-matrix LCD that delivers a wide-format design with 1600 by 1024 pixels and has a wide (160°) horizontal and vertical viewing angle for maximum visibility and color performance. It supports 16.7 million saturated colors, for use in all graphics-intensive applications. Photo courtesy of Apple Computer. Inset photo © 2005 Joe Farace.

After I upgraded my Power Mac G4 with a 22-inch Cinema Display, I decided to move my 20-inch Apple widescreen monitor to the Compaq, which proved easier than you might think. Older Cinema Displays used a propriety—big shock here—Apple Desktop Control (ADC) connection, so the first thing I needed was

an adapter that would convert ADC to standard DVI (digital visual interface) as well as provide power. The solution was Apple's $100 DVI to ADC Display Adapter, not to be confused with its $29 ADC to DVI connector cable. The second piece of the puzzle was installing a video card that's equally at home inside a Mac OS or Windows computer. This turned out to be an ATI Radeon 9600 Pro and the quality of the image on the 20-inch Cinema Display is spectacular.

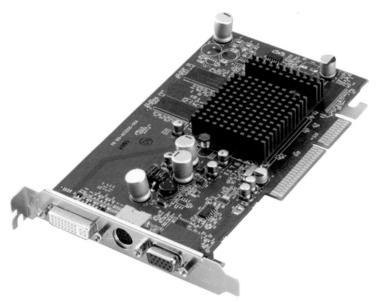

High rollers will be glad to know that the ATI Radeon 9600 Pro video card supports Apple's 30-inch HD display. The board requires a computer with an AGP (Accelerated Graphics Port) slot, so before installing make sure yours has one.

MONITOR CHECKLIST

Before plunking down your hard-earned cash for a new monitor, there are many characteristics and features you should consider.

Color: Monochrome monitors have gone the way of the dodo bird and passenger pigeon. If you haven't already noticed it, almost every monitor sold today features both color and high resolution. Gamers demand it, digital imagers require it, and software designers have turned even the most mundane office application into a desktop or Web publisher, which is why color viewing has become de rigueur.

Type: Where previously the major decision was between color and monochrome, the new choice is whether to purchase a CRT or an LCD flat-panel display. While some desktop monitors are CRTs, the space saving flat-panel monitors are beginning to take over; but the migration to the newer monitors has been slow, hampered by their high cost. Meanwhile, CRTs have become more affordable, and you can purchase a much larger glass monitor than a flat-panel display for the same money. Don't be confused by monitors labeled "flat screen" and those

labeled "flat panel." A flat screen monitor is a classic glass-tubed CRT whose face is almost completely flat instead of the slightly rounded face found on most traditional monitors. Many others have emerged recently that have a standard curved tube with a flat-faced lens on the front that brings the image to a flat focus in front of you; not quite the same thing, and focus and distortion can be a problem. A "flat panel," on the other hand, is always an LCD screen.

Planar Systems' PE line of flat-panel monitors are designed for corporate users as well as home office users and students, but are great for budget-minded photographers too.

Besides higher cost, LCD screens are not without a few problems of their own. Dead pixels can occur in screens used in laptop or desktop computers. A standard LCD screen can have an occasional dead pixel that will display as black or green—no matter what's displayed on the screen. On the other hand, LCD screens use less power. A typical 17-inch CRT uses 100W, while an equivalent-sized LCD screen needs less than 40. Whether you can measure these savings on your electric meter each month may be difficult, but you will conserve more energy with a flat-panel display.

Space: It's not just the final frontier, it's something too many monitor buyers overlook when shopping for a new display. Most LCD screens occupy a smaller footprint and take up one-third less desktop volume than a traditional monitor. CRT makers aren't throwing in the towel. Some companies have introduced

short-length monitors that take less space than traditional glass monitors with the same screen size. My view is that if monitor companies brought more compact CRT monitors at more aggressive prices to market earlier, nobody would be using flat panels except well-heeled early adopters.

Monitor size: When comparing CRT monitors, keep in mind that a monitor's size refers to an approximate diagonal measurement of the monitor's tube, not what you can actually see on the screen. In the past, manufacturers routinely overstated monitor screen sizes in much the same way that TV set builders have being doing for decades. A lawsuit challenging this long-standing industry practice and was settled by several companies and the terms of the settlement state that all monitors built after a certain date must be described by their actual viewable area. The settlement states that: "Defendants cannot refer to the computer display as 15 inches unless the viewable area is also disclosed." One of the big differences between flat screens and glass CRTs is that LCD screens measure their actual size, and that's why a flat-panel monitor will always provide more usable work area than a CRT of the same stated size.

Samsung's SyncMaster 173 MW is an HDTV-ready computer monitor, stand-alone TV, and video display with digital and analog interfaces. Photo courtesy of Samsung.

Other than screen size and resolution, the next most important factors in evaluating your choice of monitors is dot pitch, refresh rate, and whether the monitor is multiscan or interlaced.

Resolution: This is a measure of the degree of sharpness of what you see on the screen and is measured by the number of pixels that are displayed across and down the screen. The ratio of horizontal to vertical resolution is typically 4:3, the same as TV sets, but that's changing. Apple's Cinema Displays use a wide-format design similar to that used by HDTV and have a resolution of 1600 × 1024 (at least mine does; newer models will differ). This format allows the Cinema Display to display two pages of graphics or wide screen movies without seeing a letterbox effect.

Shadow masks: All CRT monitors have a shadow mask, which is a thin screen that's attached to the back of the screen preventing the outer edges of the electron beam from hitting the wrong phosphor dots. Any distortion caused by heat from the beams can disturb the beam's accuracy that results in a loss of color purity. Some manufacturers produce this screen from a metal called Invar, which has an extremely low coefficient of thermal expansion and thus produces a better on-screen viewing experience.

Dot pitch: The classic definition of dot pitch is that it's the diagonal distance between the red (center) dot of two adjoining pixel triads on a monitor as measured in millimeters. Most people acknowledge that it's the distance between two pixels of the same color. Dot pitch can vary, but the smaller this number, the sharper the on-screen picture will be. Instead of dots, Sony's Trinitron CRT tubes use vertical stripes, so their dot pitch ratings are similar, but not exactly the same as non-Trinitron tubes.

Refresh rate, a.k.a. *vertical scanning frequency*: This is a measure of the maximum number of frames that can be displayed on a monitor in a second as measured in Hertz (Hz). Hertz is a measure of electrical vibrations and 1-Hz equals one cycle per second. If the refresh rate is too slow, you get flicker. While many monitors measure refresh rates from 60 to 85Hz, with some even higher, most people won't notice any difference at rates higher than 75Hz.

Multiscan or interlaced? MultiSync is a trademark of NEC, but many people use that term incorrectly when describing any multiscan monitor. On a typical monitor, a scanning beam starts at one corner and traces a single, pixel-wide horizontal line, then goes on to trace the next line. How fast the monitor makes both horizontal and vertical scans varies depending on the kind of graphics card used by the computer. A multiscan monitor automatically matches the signal sent by the graphics card and does all the work of making sure the graphics board and your monitor match.

ROCKET'S RED GLARE

One of the biggest problems facing computer users is glare from the monitor. While more and more CRTs have some kind of anti-reflective coating, this feature is far from universal, and even "non-glare" monitors experience some level of glare. In fact, one of the many advantages of flat-panel displays is that they produce much less glare than the shiny glass used on many CRTs.

Computer Vision Syndrome is caused by monitor glare that can create symptoms such as eyestrain, headaches, and fatigue. The best solution is to place your monitor where glare is not a problem, but this is not always possible. Glare can be solved with products such as Polaroid's anti-glare filter, which also includes a conductive coating to eliminate static and dust problems, which can magnify the effect of glare. If you want more aggressive glare protection, consider a Circular Polarizer that eliminates 99% of the glare while enhancing contrast by 18 times. Polaroid's filters include a built-in grounding strap to eliminate static electricity. When shopping for glare shields also look for the American Optometric Association Seal of Acceptance.

Where you sit in relation to your monitor is important too. Your screen should be between 18 and 31 inches from your eyes. When looking at the center of a screen, your head should be angled slightly downward. If you need to refer to another document as a point of reference, place that document at the same height and angle as the screen by using a document holder. If your monitor is too low, use a support to move it to a more comfortable height.

Don't forget the very low-frequency and extra low-frequency radiation that emits from the sides and back of a monitor. These days most monitors adhere to Swedish Tjanstemannens Central Organisation (www.tco.se/index.htm) standards for radiation emissions, but you should check your monitor's specifications to ensure they meet or exceed TCO standard.

This photograph of a classic Jaguar XJ-S was made out "in the real world": using a Pentax K100D and 70–150-mm lens. Exposure in Program mode was 1/350 second.

OUT HERE IN THE REAL WORLD, AND I DON'T MEAN MTV

What kind of computer should you buy? One answer is based on Farace's immutable rules of the computing universe: No matter what kind of computer you buy, it will be replaced by a cheaper, faster version within 6 months. Don't let that depress you. Start by purchasing the most powerful computer *you can afford*. The bad news is that even the most advanced personal computer will be technically obsolete in 18 months. Maybe you'll be lucky and stretch it to 2 years, but most likely not. Nibbling away at this obsolescence is what I call the "mud flaps" factor. Over time, many computer users add software that makes their computer easier (or cooler) to use. Sooner or later, all of these bits and pieces take their toll, reducing the amount of available resources on the computer, creating conflicts and incompatibilities.

Building a digital darkroom, it turns out, is similar to building a traditional one. Based on your budgetary constraints, you assemble the tools that match the kinds of images you want to produce. I think its possible to assemble a digital darkroom containing all of the components that I have outlined, for *less* than the cost of a traditional wet darkroom, and you don't have to soak your fingers—or tongs—in chemicals or work in the dark.

Asking about the kind of computer I use is as relevant as knowing the kind of camera I use. It doesn't matter if I use a Hasselblad or Canon (I use both) and you already own 12 different Nikon lenses and several bodies. The same is true for operating systems. You can tailor the equipment to your specific applications and budget. You can build a system for less than $1000 or spend more than the cost of a shiny new Mini Cooper S; it all depends on your goals and budget.

Since 1984, I've been using both Mac OS and Windows operating systems, but today 90% of my imaging is done under Mac OS X, the rest under Windows XP until recently. I always advise people to purchase a computer that provides the best support. Not customer support; all computer companies provide universally bad—although some strive for intolerable—customer support, I mean the kind of help you can get from a friend; in my case, Mac MD's Kevin Elliott.

Windows on a Mac?

The big news for the future is that while digital imaging software may be available in both Microsoft Windows and Mac OS versions, both kinds of programs can be run on one kind of computer: An Intel-based Mac. Apple's Boot Camp software allows Windows XP software to run on any Intel-based Mac OS computer. As I write this, Boot Camp is available as a public beta (www.apple.com/macosx/bootcamp), but is expected to be part of the release of the next update to the Mac OS, code-named *Leopard*. You'll still need to install a copy of Windows because "Apple Computer does not sell or support Microsoft Windows," but Boot Camp will burn a CD of all the required drivers for Windows so you don't have to scrounge around the Internet looking for them. When it finally arrives, will Vista run under Boot Camp? I'll be surprised if it doesn't.

OPERATION SWORDFISH

You would think that the choice of operating system boils down to the Mac OS or Windows, but it's not that simple. The GIMP (GNU Image Manipulation Program) is a *free* open source photo retouching and image authoring program, and while some of its fans claim it's *just as good* as Adobe Photoshop, it's not. It is, however, hands-down the best free image-editing program available, and better than many programs that cost a hundred bucks or more. GIMP was originally a Linux-based product, but now is also available for Microsoft Windows and Mac OS X, which is built upon a UNIX framework.

Free image editing never looked this good. The GIMP was originally a Linux-based product, but now is also available for Microsoft Windows and Mac OS X, which is built upon a UNIX framework. © 2004 Joe Farace All Rights Reserved.

Before installing the GIMP, Windows users must first download and install the GTK run-time environment, and Mac OS X Panther users have to install X11. (It's on Apple's OS X CD.) The official website of the GIMP (www.gimp.org) contains all the information about downloading these files along with the scoop on installing and using the GIMP with these operating systems. This comprehensive site includes the source code, serves as a distribution point for the latest releases, and provides information about the GIMP community. If you are Mac OS user on a dial-up connection and the thought of downloading 40MB of data sounds unappealing, the MacGIMP Project (www.macgimp.org) sells a CD for less than 50 bucks. Windows users will need a broadband friend or a lot of patience.

On the Mac OS, you are still operating under the X11 environment, so some parts of the GIMP, such as the Open dialog, look similar but are different from the standard OS X dialog box. © 2004 Joe Farace All Rights Reserved.

Linux, Linus, but No Blankie

Once upon a time, there was a brilliant *findlandssvensk* (Swedish speaking Finnish) student named Linus (pronounced Lee-nus) Torvalds who was born in Helsinki, Finland. He wrote the Linux kernel: the essential part of the operating system for Linux. Linux was his implementation of Unix, without proprietary code. It has been made available to the world, essentially free, as part of the "open source movement."

Open source is a method of licensing and distributing software that encourages people to copy and modify it freely. Today a Google search yielded a total number of 93,600,000 hits for Linux.

Computers can run Linux or UNIX, but for most computer users, the choice of an operating system still really boils down to a choice between the Mac OS and Microsoft Windows. All Apple Macintosh computers are currently shipped with OS X. Available in both Home and Professional versions, depending on your specific application, Windows XP—like Mac OS X—has been designed for ease of use, but has been controversial from its launch, with many formerly staunch supporters in the media highly critical of this version. Based on my personal experience with this operating system on my own desktop and at workshops, it has accomplished its goal of being more accessible, and is an image-friendly OS.

No matter what kind of computer you choose, I think you should make it "friendly" with the other major platform. It's a great idea for your Windows computer to

be able to read Mac OS disks. Out of the box, most recent Macintosh computers already read Windows disks and discs, but you'll need software such as DataViz's (www. dataviz.com) MacOpener software to make it work in the other direction. You can think of it as the digital equivalent of being able to use Contax lenses on your Canon EOS camera. Going the other direction, DataViz's MacLink Plus Deluxe is indispensable software for translating Windows-based files for use with your Mac OS computer. While Adobe Photoshop-compatible plug-ins are platform specific, Photoshop Actions are not and having MacOpener on my Windows computer lets me copy Action files back and forth between my Power Macintosh G4 computer and my Windows XP computer-using Mac-formatted CD-R, Iomega Zip, or floppy disks.

RIDING THE RESOLUTION CAROUSEL

It is inevitable that you will encounter more than one type of resolution. For example, device resolution refers to the number of dots per inch (dpi) that a device, such as a printer or monitor, can produce or display. Device resolution on computer monitor screens can vary from 60 to 120 dpi. (*Note*: Don't confuse this with *screen* resolution, which refers to the number of dpi in the line screen used to reproduce halftone images.) A 21-inch monitor displays more pixels than a 13-inch model, and some monitors can even display various pixels per inch (ppi). If you don't change the magnification level, what you see at 64 dpi is simply a closer look at the same image. Because the pixels are larger it appears to be lower resolution. Monitor screen resolution, to confuse things further, is also measured in lines per inch (lpi). This last one is left over from TV.

Image resolution really refers to the amount of information that is stored in an image file and is often expressed in ppi. The image resolution of any graphic

What's a pixel? If you look close enough you can see them. This is an extreme close up of that same picture of Brenda, but when printed even at 13 × 19 inches or viewed on a large monitor these little digital squares are impossible to detect—especially when the print is viewed at the "normal viewing distance." The old rule of thumb for determining what's normal is that a print should be viewed from a distance approximately equal to the diagonal measurement of the print.

image ultimately determines how large a file is. This means that the higher the resolution, the bigger the file, and size determines how long an image will take to move, manipulate, store, or print. All this goes back to how many bits, bytes, kilobytes, and megabytes an image file contains, and completes the circular discussion of resolution that began with bits.

The bottom line on resolution is that you have to match the resolution of the image acquisition device and software to the output. Requirements for World Wide Web applications, because they are based on monitor resolution, are different from working with four-color magazine-quality output. By understanding resolution and what it means, you will be in a better position to evaluate equipment purchases and make the right choices.

GOOD RESOLUTIONS

Computer graphic communication uses a pastiche of buzzwords borrowed from the printing, design, and photographic fields, blended with a sprinkling of computer jargon. If some of these buzzwords seem strange to you, they're collected in a glossary that can be found at the end of this book.

In general usage, the word *resolution* refers to how sharp or (as some people put it) "clear" an image looks on a screen or when printed or output as film. Any discussion of resolution must first look at two items that ultimately refer to what most people will agree is resolution: bits and pixels.

A bit is the smallest unit of information a computer can process. Because computers represent all data (including graphics) by using numbers, or digits, they are digital devices. These digits are measured in bits. Each electronic signal becomes one bit, but to represent more complex numbers or images, computers combine these signals into 8-bit groups called bytes. When 1024 bytes are combined, you get a kilobyte, often referred to as "K." When you lasso 1024 kilobytes, you have a megabyte.

Pixel is short for "picture element." Visual quality—or resolution—can be measured by the width and height of an image as measured in pixels. A computer screen is made up of many thousands of these colored dots of light that, when combined, produce a graphic image. On the screen, combinations of pixels, called triads, produce all of the colors you see. A triad contains three dots, one each for red, blue, and green. In a CRT monitor three electronic "guns" fire three separate signals (one for each color) at the screen. If all the three guns hit a single location at equal intensity, it will appear white on the screen. If none hit a target pixel, it will be black.

The higher an image's resolution—the more pixels it has—the better its visual quality will be. An image with a resolution of 2048 × 3072 pixels has higher resolution than the same image digitized at 128 × 192 pixels. At low resolutions, images have a coarse, grainy appearance making them difficult to evaluate. Higher resolution is not without some cost: as the resolution of a device increases, so does its cost.

Bits are important to photo files because you often find a file or hardware device referred to as 24- or 30-bit devices. A 24-bit image has eight bits each for red, blue, and green. A 30-bit image has 10 bits for each color. More is always better.

TRADING PLACES

As in all computer applications, the resolution of a particular graphic image involves trade-off. As a graphic file's resolution increases, so does its file size. Larger file sizes mean your computer system requires more space per image. If you have been wondering why the "normal" hard disk size exploded from 100 MB to 100 GB, look to the megapixel race still ongoing in the digital camera marketplace.

You may have heard the graphics and image-manipulation programs are memory hogs. That's partially true. In order to work on a photograph, programs such as Adobe Photoshop require memory that is three to five times the size of the original image. To handle a 18-MB image file, you need between 54 and 90 MB of RAM. Fortunately, Photoshop has a built-in virtual memory scheme (called a

A scratch disk is any drive or drive partition with free memory. By default, use the hard drive where the operating system is installed as the primary scratch disk. By using Plug-ins and Scratch Disks preferences (Photoshop > Preferences > Plug-ins & Scratch Disks) you can change the primary scratch disk and designate a second, third, or fourth scratch disk to be used when the primary disk is full. Your primary scratch disk should be your fastest hard disk. For best performance, scratch disks should be on a different drive from any large files you are editing. Scratch disks should be conventional (non-removable) media and a local drive; they should not be accessed over a network. Drives that have scratch disks should also be defragmented regularly.

"scratch disk") that reduces RAM requirements by treating unused hard disk space as additional RAM. In this example, it means having at least 54 MB of unused hard disk space available. The program's Preferences menu lets you specify where the program should go to get this hard disk space, and you can have primary and secondary disks to use as scratch disks.

If you do not have enough memory or scratch disk space, *Photoshop* can give you a "Not Enough Memory to Complete that Operation" error message. Fortunately, there is an easy enough way to find out if you will have problems before you start work on an image. *Photoshop* displays information showing how much memory that particular image takes in the lower left-hand corner of any image window. By clicking on these numbers, you have the option of displaying File Sizes or Scratch Sizes. While File Size information is interesting, I recommend you keep the window set to show Scratch Sizes. The number on the left side tells you how much memory all open windows are using and the number on the right tells you the amount of RAM available. If the first number is larger than the second, the difference is the amount of Scratch Disk space required. If you don't have enough unused hard disk space—TILT!

The old drag racer's axiom that "there's no substitute for cubic inches" may be paraphrased to "there's no substitute to RAM." With RAM prices lower than they have been for a while, why not make a trip to the computer store and purchase a few memory modules for your computer? While you have the case off, why not stuff a 160-GB (or bigger) hard disk in there? You'll use it.

THE BOTTOM LINE

The Windows vs. Mac OS controversy is a quagmire and is the digital version of the Nikon vs. Canon arguments seen on the Web and wherever photographers gather. Most digital imaging programs are cross-platform and while some are Windows-only, the introduction of Apple Computer's Boot Camp software makes that a moot point. There is no doubt that Apple Computer hung on too long to hardware and software that was too closed. The Windows platform, on the other hand, was so open that often hardware and software components were not so compatible. No matter what system you decide on, one truth remains: Neither platform—Mac OS or Windows—is perfect, and when you make a decision between the two, you get all of the baggage that comes with either choice.

Do what you want with it. In the Mac OS or Windows debate what we have is the classic debate between intransigent forces. My Dad was a "Chevy man," but other than a 1976 Chevrolet Blazer, I've owned more Fords during my life. Don't lose sight of what imaging is all about: getting great images. The best hardware is whatever helps you get the best images. Just as a truly great photographer can create images no matter what kind of camera that he or she uses, the quality of a person's digital imaging solution isn't measured by what kind of computer they use.

This photograph of a vintage airplane was captured originally in *color* using a Canon EOS 20D with EF-S 10–22-mm lens. Exposure was 1/40 second at f4.0 and ISO 400. It was converted to monochrome using some of the techniques I'll show you in Chapter 7. The film "frame" was also added digitally using a Photoshop Action that I'll also introduce to you later. © 2005 Joe Farace.

A Bugs Life?

More than half the households in the US have a computer, but most of them have more than one user. This results not only in the inevitable turf wars about who gets to use it, but brings up security issues as well. According to the National Cyber Security Alliance (www.csoonline.com), 86% of US broadband users have confidential information stored on their computers, and 79% use the Internet to send sensitive information, but two-thirds don't have proper firewalls installed. Spyware, software that gathers information for outside sources and is installed without the user's knowledge, can be found on 91% of broadband users' computers. Yet, 86% of broadband users felt their computers were "very" or "somewhat safe." Where does this stuff come from? Fifty-seven percent of Spyware comes from music downloads and other from seemingly benign sources.

The Windows versions of Internet Explorer seems the most prone to these sorts of attacks so the first step is tighten up its security settings. (If you're already infected, it may be too late.) Start by opening Internet Options and go to the Security tab. In the ActiveX area, disable anything not marked as "safe and not signed." For ActiveX marked "safe and signed," set to the choices to "Prompt." This approach did not work 100% of the time for me, so I installed a *freeware* program called Ad-aware (www.lavasoftusa.com) that will "quarantine" Spyware files. The company offers upgraded versions for a modest fee but the freeware version worked for me.

Tools of the Trade

I love it when a plan comes together!

The times they are changing. You don't need a computer for digital imaging anymore. Digital minilabs make creating inexpensive prints from your memory cards or digital files as easy as shooing film, but just as the person who wants to create expressive images with film needs a darkroom, the digital photographer who wants to produce images that sing needs a digital darkroom. Much as the center

This photograph of the "Patriarchs" at Zion Nation Park was made with a Pentax K100D SLR, and was captured at 1/45 second at f/22 in Aperture Priority mode. The K100D was set at 200 and the Pentax smc P-DA 12–24 mm F4.0 ED/AL lens. © 2006 Joe Farace.

of the traditional darkroom is the enlarger, the heart of that digital darkroom is the computer. Connecting digital imaging peripherals to your computer may initially seem confusing but quickly settles down after you've identified what kind of devices you plan to connect. Most users will find that they are speaking fluent *computerese* in no time.

CANDID CAMERAS

If you've seen any digicam advertisement you already know that a camera's resolution is rated in *megapixels*. A *pixel* is another way of saying *picture element*. In mathematical terms a megapixel would simply be one million pixels. A digital photograph's resolution is measured by the image's height and width as measured in pixels. The higher the resolution—the more pixels it has—the better the visual quality. To determine how many megapixels a camera can produce, you multiply the maximum image file's length and width (in pixels) together. In the case of a camera that has a resolution of 2240 × 1680, it would be 3,763,200 pixels or 3.7 megapixels. As in many fields, some manufacturers sometimes liberally interpret how that rating is obtained.

While you can get analytical about it, I prefer to interpret megapixel ratings much as automotive horsepower ratings. The hybrid/electric Honda Insight delivers 68 economical horsepower while a Dodge Viper produces 450 horsepower. I don't care if either engine is rated a little higher or lower than what they *really* are, but those ratings tell me the Viper will blow the doors of the Honda, but both cars can easily take you to work or shopping.

The 7.5-megapixel Olympus EVOLT E-330 enables users to take pictures with resolution up to 3136 × 2352 pixels, and produces crisp, detailed image files in color or black and white. Photo courtesy Konica Minolta USA.

Some manufacturers of low end point and shot cameras tend to overstate their camera's capabilities or advertise *interpolated* resolutions (see Chapter 1 for the scoop on interpolation) that use a variety of trademarked names. Just as when evaluating film or flatbed scanners, you should look for the "raw" or optical resolution specifications of a camera when making a purchase decision. If you want to get down and techie with megapixels, visit the Megapixel Myths website (www.megamyth.homestead.com).

Most digital cameras use CCD (Charged Coupled Device) chips to capture light and convert it into images. In fact, some inexpensive cameras use camcorder chips that have *rectangular* pixels. In order to be displayed on a monitor, these pixels have to be converted into square pixels. This conversion can produce a noisy image, which shows up as a grainy image or as posterized areas. Square pixels are typically found on higher end digital cameras, but more and more inexpensive models use them as well.

Cameras, such as Canon's (www.powershot.com) EOS 5D, use a CMOS (pronounced "sea moss") chip. In the past, CMOS imaging chips were inferior to CCDs, limiting this technology's ability to penetrate the imager market. More and more digital SLRs are using CMOS because of the inherent advantages of low-cost *and* low-battery consumption. CCD chips have high photoelectric efficiency, which permit pixels to be tightly packed and produces high-resolution arrays on silicon dies, but they have higher manufacturing costs, greater power consumption, and lower

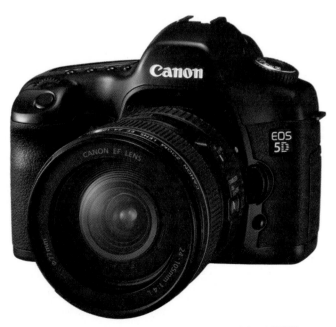

The EOS 5D has a full-frame 12.8-megapixel CMOS sensor, combined with Canon's DIGIC II Image Processor, a 9-point AF system with six assist points, a 2.5-inch liquid crystal display (LCD), and a magnesium-alloy body. Photo courtesy Canon USA.

production yields. CMOS sensors are built using the same kind of semiconductor process as computer microprocessor chips. As a result, many functions, such as digital signal processing, logic, and microcontrollers, can be integrated onto a single chip. The downside of CMOS is that low light performance may not be as good as an equivalent-sized CCD. But that's changed quickly, and is mitigated by larger pixel sizes, so it isn't a consideration when looking for a new digital SLR.

HOW MANY MEGAPIXELS ARE ENOUGH?

With the popularity of digicams, there's still confusion about how much resolution is enough. Unlike Mies van der Roh's comment about design, more is *always* better when it comes to resolution. I've seen stunning output from Nikon's (www.nikonusa.com) D1x 5.47 megapixel camera when printed at 24 \times 36 inches using an Epson Stylus Pro 10000 large format ink-jet printer, and fine detail was apparent even upon close examination. At some point, cameras might reach a point of diminishing returns; more megapixels may be provided, but nobody will be able to tell the difference when looking at output.

No matter what their maximum resolution may be, most digital cameras offer more than one resolution option allowing you several choices, depending on how the image will ultimately be used. Changes in resolution can be compared to image formats in traditional film cameras. An image printed at a large size that would be unacceptable if made with a 35-mm film camera will look much better if it has been photographed on 4 \times 5 or 8 \times 10 sheet film. The highest-quality digital image settings are made using the camera's maximum resolution and is your best choice if you want to make great looking 8 \times 10 inches prints. Good-quality images are, more often than not, 640 \times 480 pixel-sized photographs that are *more than adequate* for use on the World Wide Web, but may not make the best looking prints.

Just as important as image resolution is what file format is used to store the images. Most cameras store images in the compressed JPEG (Joint Photographic Experts Group) format, which applies compression to the file. Since JPEG is an inherently "lossy" format, some image data is invariably lost during the process, the best quality will be obtained by using the lowest compression ratios; or even better, *no* compression. Many digicams let you store images in a RAW format that delivers *every pixel* that was captured, undiluted by compression. Other cameras let you save images using the TIFF (Tagged Image File Format) that is immediately available for use by an image-editing program without requiring a special, camera-specific RAW interpreter plug-in for importing. (*Note*: If you got lost in that last paragraph don't worry, help is on the way. Chapter 3, *The X Files*, provides an in-depth look at image file formats and why you should even care.)

It's always important to match the resolution of the camera to how the image will be reproduced. Image resolution can be less critical when printing with an ink-jet desktop printer, and almost any contemporary digital camera will produce acceptable snapshot-sized images. Depending on the compression, a 3.3-megapixel camera will produce adequate quality for an 8 \times 10, and maybe

even an 11 \times 14 inch print depending on other components in its imaging path. They key to making your images look good is matching the image size to how large it will be used in your output.

DIGITAL FILM

So this guy walks into a bar and asks the bartender: "Waddya put in a digital camera to take pictures?" And the bartender answers, "Digital film" —old digital imager's joke.

The term *digital film* seems to upset students of semantics, digital purists, and even a few computer users, but it's usage—not academicians—that will determine how language evolves. Most first generation digital cameras offered only built-in memory for image storage. Once that was full, the files would then have to be downloaded from the camera onto your computer's hard disk, connected to the computer via a special cable. Having a fixed amount of built-in memory meant that once it was full and you wanted to capture more images, you either had to download images to a computer or delete a few that were already stored in the camera. What was missing with most of these early cameras was the ability to remove those captured images like you would a roll of film, and insert another storage device, creating what would be the digital equivalent of film. The industry rose to the occasion by offering what ultimately became a bewildering variety of storage media.

Unlike "real" film, whose photochemical nature imparts a distinct personality to each image by affecting its color, contrast, and grain structure, digital film is simply a *passive* storage media. The camera's chip creates all of these imaging characteristics previously attributed to film, so "digital film" simply stores digital photographs. Right now, memory cards are available in many different shapes, sizes, and capacities. Most modern devices are memory cards small enough to hide in the hand, and light as a potato chip. When they're full of images, you simply take the card out and slip another one into the camera, much like changing a roll of film—only without all that winding. Larger-capacity cards allow storage of more images, but also cost more. Best of all, although memory cards vary in capacity and price, almost any camera that accepts a specific format can use one of any capacity, much as a 35-mm camera accepts film in 24 or 36 exposure lengths (there are some limitations as a camera ages and technology changes, however).

Here's a look at most of the popular digital film formats:

CompactFlash: First introduced by SanDisk (www.sandisk.com) in 1994, these matchbook-sized memory cards are pin-compatible with PCMCIA (Personal Computer Memory Card International Association) card making it possible for companies to offer adapters allowing CompactFlash media to be used in older digital SLRs that were designed only for PC cards, as they are called these days. These adapters are especially useful for notebook computer users and provide a seamless way to transfer and unload images from digital cameras using CompactFlash. Type I CompactFlash cards measure 3.3 mm in thickness, while Type II are 5 mm.

SanDisk's Extreme III product line includes CompactFlash, Memory Stick PRO, and SecureDigital formats, and is targeted at high-megapixel resolution digital cameras that can take advantage of a significantly faster memory card. They have minimum write and read speeds of 20 MB/s and the cards range in capacity between 1 and 4 GB.

Microdrive: The Microdrive has a form factor identical to Type II (5 mm) CompactFlash cards, weighs only 16 grams, and provides lots of storage capacity in a compact, portable package.

Hitachi's Microdrive is really a tiny 1.0-inch hard disk drive, featuring a dramatically reduced footprint for integration into PDAs and digital cameras. With a maximum capacity of 8 GB, the 3600 RPM drives will hold 33% more than its predecessor. Photo courtesy of Hitachi.

SmartMedia: Toshiba's Solid-State Floppy Disk Card (SSFDC), usually just called SmartMedia, is a tiny flash memory-based storage card designed specifically for digital cameras and reminds me more of a Wheat Thin than their designers probably ever intended. The tiny SmartMedia card combines a flash memory chip with a 22-pin surface connector in a 45 × 37 mm package. SmartMedia cards are less costly than other types of memory storage devices and, as I write this, are about as extinct as a plesiosaur.

Memory Stick: Sony originally introduced the Memory Stick for its Cyber-shot series of digital cameras and uses the format in a wide range of consumer products, including MP3 music players. There are currently many Memory Stick formats including Memory Stick Pro, Memory Stick Duo, and Memory Stick Pro Duo. While mostly used in Sony cameras, occasionally dual-format digicams include Memory Stick as an option.

At one-third the size and half the weight of the standard-size Memory Stick card, Sony's 4 GB PRO Duo media is designed to store large amounts of high-resolution digital photos. All Sony Memory Stick PRO Duo media cards are sold with an adapter for devices with a standard-size Memory Stick media slot. Like all Memory Stick media products, the 4 GB Memory Stick PRO Duo card incorporates MagicGate copyright protection technology for secure distribution of commercial content. Photo courtesy Sony.

SD/MMC: The SD Memory Card measures 24 × 32 × 2.1 mm and allows cameras to be more compact and gives product designers new freedom. Next to the CompactFlash card it is the most popular memory card format for digital imaging. Unlike MMC (MultiMediaCard), SD media have an erasure-prevention switch to keep your data safe. When the switch is in the locked position, it will stop you from accidentally copying over or deleting data stored on your card. A mini SD card, measuring 20 × 21.5 × 1.4 mm is available as *smaller* form factor of the SD Memory Card and finds most use in cell phones—for now anyway.

Similar in size to MMCs, Lexar Media SD cards are designed for use in many digital devices including digital cameras, MP3 players, PDAs, cellular phones, and camcorders. Photo courtesy Lexar.

xD Picture Card: As if we need a smaller memory card format, the minuscule xD Picture Cards is brought to us by the same pack of geniuses that created SmartMedia. Like SmartMedia, their capacities are limited, but unlike SmartMedia they are a lot easier to lose.

The Olympus xD Picture Card is compact for smaller and more stylish digital devices. And it's just as easy using this format in non-xD devices as well, thanks to a number of adapters that will be available including a CompactFlash Adapter, SmartMedia USB Reader/Writer, and PCMCIA/PC Card Adapter. Photo courtesy Olympus.

HOW FAST IS YOUR MEMORY CARD

All memory cards are the same, right? All you need to do is buy whatever is cheap to capture your precious images. Wrong! Just as choosing the correct film for the assignment is important in traditional photography, choosing the right memory card is critical for digital capture. Here's why:

They're not all the same speed. Lexar was the first company to rate the speed of its flash memory cards and currently provides ratings for its Platinum and Professional lines. Most other memory card manufacturers also rate their products' speed, but what does it really mean? The rating refers to the speed (who woulda thunk it?) that data can be written to, or read from a flash memory card. Photographers often think their memory card's speed and performance only make an impact on digital capture when the card is in their camera, but speed-rated cards impact workflow while reading data onto a computer with a card reader as well. A "sustained speed rating" is important because it allows the photographer to capitalize on the camera's built-in functions, such as burst mode and video capture. When using a card with inconsistent, high-speed performance, either function can be interrupted.

One "X" represents the basic transfer rate of 150 Kb/s and increases are in multiples (e.g. 133X) signifying the card's overall speed, as in "133 times faster than the original transfer rate of 150 Kb. (*Note*: When people started storing data on CD-ROM discs, the same system was used.) An embedded high-speed controller allows a flash memory card to perform at its best, but the bottom line is that the higher the number, the faster the card.

THE BIG THREE

Kingston (www.kingston.com) may be better known for its computer memory than digital media, but offers a full slate of products including Ultimate 100X CompactFlash cards that are available in 1, 2, and 4 GB capacities. These cards offer a 20 MB/s read rate and a 16 MB/s write rate, or 100X. Kingston defines its X-speed by the *write* speed because read speeds for memory cards are higher than write speeds and they believe photographers "care more about how long it takes to write data to a digital camera" that read it. I think we care about *both* speeds because either way, time is money.

Lexar's 133X Professional CompactFlash Memory Cards have a 20 MB/s minimum sustained read and write capability and are available in 1, 2, and 4 GB capacities. The cards are bundled with Image Rescue 2.0 software and a 30-day trial version of the Photo Mechanic 4.3 image browser. Image Rescue can recover lost *or* deleted JPEG, TIFF, and RAW files even if you've erased them, reformatted the card, or if the memory card has been corrupted.

Kingston's Ultimate 100X cards carry a lifetime guarantee that a representative told me, "If it's broke, we will fix it or replace it." Photo courtesy Kingston.

Lexar's Pro cards are backed by a lifetime-limited customer-satisfaction warranty (see "When Good Cards Go Bad").

Although not specifically speed rated, SanDisk's Extreme III memory cards feature ESP (Enhanced Super-Parallel Processing) for high-performance producing 20 MB/s sequential read and write speeds. CF cards are available in 1, 2, 4, and 8 GB capacities.

Every SanDisk Extreme III CompactFlash card comes with RescuePRO software that lets you preview recoverable data before you try to retrieve it. SanDisk memory cards have a lifetime-limited warranty.

REAL WORLD TESTING

To see how fast these three cards performed under real world conditions, the crack Farace Testing Labs staff designed a test to see how fast the cards really are. Like *Consumers Reports*, the cards used for the test were not requested from the manufacturers specifically for this chapter so there was no chance any ringers were sent. Cards tested included a 2 GB Kingston Ultimate, a 2 GB Lexar Professional, and a 1 GB SanDisk Extreme II. The middle-of-the-road Canon EOS 30D was used to simultaneously capture a RAW file plus a large JPEG, giving the camera the largest possible amount of data to *write*. The results were a tie for first place between Lexar and SanDisk at 2 seconds each; the Kingston took 3 seconds. (JPEG *only* capture on all three cards was virtually instantaneous.) I leave it to you to decide if that difference is significant to your camera and type of photography.

SCANNERS

Like traditional image making, digital imaging begins with *capturing the image*. That process is composed of different steps starting with capture, but also

including manipulation, output, and presentation. Of these the capture phase is important because the higher the quality of the digitized image, the higher the quality of the output.

Although I've met a few people who have *only* made images using digital cameras, most photographers have captured an image or two (thousand) using a film camera during their lives. Scanners offer film photographers, who are moving into the digital darkroom, two advantages. First, you can create computer-ready files with the same cameras and film that you're already using. Second, scanners can digitize all of the images in your existing library of prints, slides, and negatives.

There was a time when the only way to digitize film was with a film scanner or a process such as Kodak's Photo CD. As the prices of flatbed scanners dropped through the floor and the "under $50" scanner became a reality, manufacturers began looking for ways to add value to their products. One of the first "new" features added was the ability to scan film in addition to prints and artwork.

If you've been around the digital carousel a while, you know that using flatbed scanners to digitize film is nothing new. Transparency adapters for flatbed scanners have been available as an option for some time. In most cases these adapters were nothing more than "light box" lids to backlight negatives or transparencies so they could be digitized by the moving CCD elements. This method produced a digitized image, but the adapter itself was sometimes cumbersome, and always expensive—sometimes costing more than the scanner. All that's changed. Transparency adapters have gone from expensive to inexpensive options and even standard equipment for some scanners.

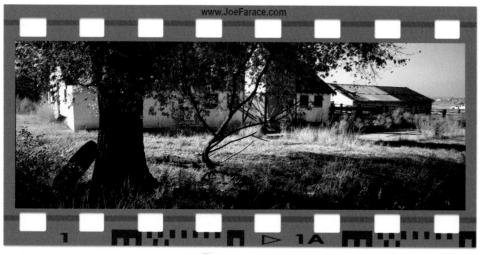

One of my favorite imaging formats is the *panorama* and one of my favorite ways to capture it is with a dedicated panoramic camera like Hasselblad's 35 mm Xpan that was digitized using Epson's Perfection 4870 PHOTO flatbed scanner. © 2003 Joe Farace.

PICK A SCANNER; ANY SCANNER AT ALL

Scanners convert prints, slides, and negatives into digital form by passing a light-emitting element across them, transforming the image into a collection of pixels that will be stored as a digital file. Depending on the original film or print format, there are two types of scanners:

1 *Flatbed scanners* look like small office copiers, and there are similarities in how they work. Shopping for a flatbed scanner is a matter of determining what type of images you want to digitize along with what format your final output will take. Asking yourself the maximum size of your original images will tell you how large the scanning area must be. Next, ask what the resolution of your output needs to be.

Recently, I've been using the Epson Perfection 4870 PHOTO to scan panoramic negatives. Yes, I tend to shoot negative film, color and C-41 black and white, for my panoramas.

2 *Film scanners* let you to scan slides, negatives, and transparencies. Film scanners are popular because they eliminate a generation by scanning the original film. Besides removing the print phase from the process you also save the cost and time associated with making a print. They are smaller than flatbeds and their cost reflects how many different film formats they can digitize. For example, 35 mm only scanners are less expensive than those can digitize medium or large format film. If you only shoot 35-mm film or slides, you shouldn't spend money for a larger, more expensive scanner that handles sheet film.

A typical desktop scanner uses an array of several thousand CCD elements arranged in a row, or a single chip. Three-pass CCD scanners—those that make three passes across an image to fully digitize it—use a single linear array and rotate red, green, and blue filters in front of the lens before each pass. Single-pass scanners use *three* linear arrays, individually coated to filter red, blue, and green light, and the same image data is simultaneously focused onto each array. Instead of CCDs, some flatbed scanners use contact image sensors (CIS) that bounce light off the surface of a print directly onto a closely mounted sensor, allowing the form factor of these scanners to be quite thin. An analog to digital converter (ADC) changes these signals into digital form and is rated by its color depth. An 8-bit ADC, for example, separates the visual information into 256 brightness levels.

SCANNER SLANG

There are two big myths about making great scans. The first one is that the process is so difficult that it is beyond the capabilities of the average person. The second is that it's really easy to make a great scan. Of the two, the second is truer than the first. The real secret, if there is any secret at all, is to examine all of the scanner software's options and make decisions appropriate for your output.

Scanners are usually rated by their color depth, resolution, and dynamic range. Color depth refers to the number of bits assigned to each pixel. These days even inexpensive flatbed scanners offer a 36-bit color depth that assign 12 bits to each red, blue, or green pixel. The more bits you have for each color, the more photorealistic the final scanned image will appear. Because 36- and 48-bit scanners capture more detail than 24-bit models, the resulting images are also easier to edit with image enhancement software.

A scanner's dynamic range depends on the maximum optical density that can be achieved by the hardware and the total number of bits that can be captured. This measurement can be liberally interpreted as the range of f/stops that can be captured from a digital photograph. The greater the density range and the greater the number of tones that can be captured, the better the final scan's image quality will be.

A scanner's resolution is determined by the maximum number of dots or pixels per inch it can read and can be measured as both *optical* and *interpolated* resolution. Film scanners often have a resolution of 2700 dpi or higher because resolution requirements are more critical, given the small size of the original. Having higher resolution and bigger files also allows some flexibility if the image is cropped.

KEEPIN' IT REAL

These days, scanners are measured by their *optical* as well as *interpolated* resolution. Optical refers to the raw resolution of the scanner that is produced by the hardware, while interpolated resolution refers to the maximum dpi specification the scanner and its driver software can produce for a selected image size. When the resolution specified exceeds the optical resolution, the software interpolates

the data by resampling the existing data using algorithms to fill in the area—adding pixels, really—between existing pixels. While the method of interpolation can vary depending on scanner manufacturer, Epson uses a method similar to the bicubic or bilinear interpolation a user can select in Adobe Photoshop. If you start with a poor scan that is not sharp or clear enough, interpolation is only going to make the image look worse—not better.

When a flatbed scanner has an "uneven" optical resolution specification, such as 600 × 1200 dpi, it is theoretically capable of capturing more data by a technique called "microstepping." A scanner head has 600 elements in 1 inch in the horizontal direction. Most flatbed scanners use a 5000 element CCD—600 dpi × 8.5 inch width equals 5100 pixels of data. The scanner head can move in 1/1200-inch increments in the vertical direction (back to front). When 1200 dpi is selected it can slow down the scanner. The scanner may pick up some additional detail in the vertical direction; however, software interpolation occurs horizontally to create a new square pixel.

Differences in quality at *two times* the original optical resolution should not be noticeable in color images. Sharpening the image using your favorite digital imaging program's Unsharp Mask filter will add edge definition and crispness to the image. Unsharp Mask controls are found in many digital imaging programs, including ACD Systems (www.acdsystems.com) ACD See 8 shown here. © 2005 Joe Farace.

The big question on many a scanner-user's mind is: Is an interpolated scan as good as a scan made on a scanner that has the matching optical resolution? Usually there is no real visible difference between a "raw" or interpolated scan. You would have to be zoomed in at a 1:1 pixel ratio or even 4:1 to see any difference in quality.

The question remains: How does someone shopping for a scanner know the quality of the interpolation? The short answer is: it depends on the manufacturer. To avoid direct comparisons, some scanner companies avoid explaining the methods used to provide interpolated resolution. The safest measure of quality for a scanner is the *horizontal* optical resolution. The best way to test a scanner is to evaluate the unit at its optical resolution using different kinds of originals, such as color photographs, transparencies, negatives, and even black and white line art.

This photograph of Brenda was made with a Canon EOS 5D, which has a resolution of 2844 × 4341 pixels. This camera has a full-size chip close to the size of a standard 24 × 36 mm film frame. Exposure was 1/125 second at f/6.3 at an ISO because the day was a lot more overcast than this sunny picture would otherwise seem to indicate. © 2005 Joe Farace.

TIP: Black and White in Color

It sounds obvious that you should scan color images in color, but it's also a good idea to scan black and white photographs using the driver's Color setting so you can pick up subtle tones in parts of the monochrome image. You can always convert it to grayscale later using your image-editing program.

On a Snowy January in 1945 in the Ardennes Forest on the German/Belgium border, a medic was involved in the "Battle of the Bulge." In this battle there were more than one million soldiers—500,000 Germans, 600,000 Americans, and 55,000 British—including my dad. It was a medic, much like this young man, who pulled my Dad from a mortar crater where he had been wounded and patched him up so he could return home after the war to my sisters and me. This image is an homage to all the brave young men and women of our armed forces.

TIP: Clean Mind, Clean Body: Take Your Choice

A clean original means less retouching later, so it's a good idea to keep a can of environmentally friendly air near the scanner to blow dust particles off slides or negatives. Keeping your negatives and slides clean is more important with film scanners than flatbeds. Because of the small original size, even the tiniest dust speck can end up looking like a boulder in the final scan.

DUCK SOUP

It's an alphabet soup out there: Enhanced Parallel Port (EPP), Universal Serial Bus (USB), and Small Computer System Interface (SCSI). To add to the confusion, some computers have different names for the *same* type of connection. Apple Computer calls their high-speed connection FireWire, but purists and Apple haters insist that it's Institute of Electrical and Electronic Engineers (IEEE) 1394 (which it is too), while Sony calls it iLink.

Does this trunk of a Lowrider remind you of what you think the insides of your computer looks like? Have no fear, mon frère. In this chapter I'll introduce you to the buzzwords and the hardware that makes your computer go "ping." © 2005 Joe Farace.

While it might seem obvious, the most important first step in setting up any peripheral device, such as a printer, is connecting it to your computer. For some digital imaging beginners this can be confusing because that printer may have one or more different kinds of connections or *ports* on its back, and it's more that likely there's no cable included in the box with the peripheral that you just purchased. Since you have more than one choice available, which one should you choose?

Serial: This is the kind of port that's used to connect peripheral devices such as modems and printers. The serial port sends and receives data 1 bit at a time. While found on both Windows and older Mac OS computers, serial ports were once the only way to connect devices to a Mac. Like its Windows cousins, Macintosh computers have abandoned serial connections in favor of the USB.

Parallel: Sometimes called EPP for Enhanced Parallel Port. This is a type of port found only on Windows computers and is used for connecting printers, modems, and other devices. The parallel reference means that data—several bits at a

time—is simultaneously sent and received over individual but adjacent wires. No longer in fashion, EPP has been replaced by USB in all new computers.

USB: USB connections are found on all new Mac OS and Windows computers and provide a faster connection than either serial or parallel connection (see "Comparing Interfaces" for speed ratings). USB was created in 1995 by a consortium that included Compaq, DEC, IBM, Intel, Microsoft, NEC, and Northern Telecom, and was designed to provide an interface between computers and various peripherals over inexpensive cables. USB supports daisy chaining (cabling devices together directly) allowing you to connect multiple devices through the one or two ports found on the host computer. The USB connection carries 5.0 volts of power allowing it to be distributed to all of your peripherals through a single, thin cable, which is how some low-power devices, such as memory card readers, get all of their power through the USB connection. USB devices are also "hot pluggable," meaning you can connect and disconnect equipment while your computer is running.

SCSI: This is an acronym for Small Computer System Interface and is pronounced "scuzzy." SCSI is an 8-bit computer interface that allows the connection of up to seven peripheral devices to a single SCSI port; although, depending on the computer, you can usually add another port. There are variations on the SCSI standard including SCSI-2 and SCSI-3, which are faster versions of the original. Unlike USB devices, SCSI devices are *not* hot pluggable and trying to treat them that way will result in system crashes, which is one of the 101 reasons it's been replaced by FireWire.

FireWire: The FireWire standard (a.k.a. IEEE 1394) is a fast serial bus interface originally developed by Apple Computer and Texas Instruments in the early 1990s and adopted as an IEEE standard in 1995. Like USB, IEEE 1394 enables plug-and-play peripheral connectivity and provides power to peripherals eliminating the requirement that every device have its own power supply. FireWire's major advantages over SCSI are simplicity and speed.

Ethernet: This is a form of Local Area Network (LAN) that connects computers from different manufactures and enables them to communicate. These days most computers must have an interface card or Ethernet capability built in. Ethernet only appears on professional and graphic arts printers, but can be added as an option on some of Epson's printers. Ethernet is also used to connect cable modems to computers.

THE IMPORTANCE OF BEING EARNEST

When you open the box, you may be surprised to find that a cable is not packaged with your printer or scanner. This was not always the case, but as device prices kept getting lower, manufacturers looked for ways to save a few bucks, and the cable was the first thing to go.

Choosing the right cable is not just a matter of buying a piece of wire that has the right connection on both ends. Let's start with the construction of the

cable: you should use a cable whose design eliminates cross talk, static, electromagnetic interference, and radio frequency interference. Other features to look for in quality cables are double shielded cables with low impedance wires and gold plated copper connectors. These cables provide better conductivity and shielding than bargain basement cables or terminators, and quality cables translate into more reliable, faster performance, with fewer errors during data transfer. Sure, these kinds of high-quality cables cost a little more, but aren't your images worth it?

Belkin's Gold cables, such as this FireWire model, have 24 K gold plated corrosion-proof connectors for maximum conductivity and clean transmission. Its foil and braid shield comply with fully rated cable specifications reducing electromagnetic and radio frequency interference and use impedance matched twisted pair construction to minimize cross talk, ensuring high-speed, error-free transmission. Oh yeah, and it has a lifetime warranty. Photo courtesy Belkin, Inc.

When connecting peripherals, make sure that you use a cable that delivers the most performance—especially when you're printing photographs. Many printers have more than one type of connection and some can have as many as three. If your printer has parallel and USB ports, use the USB connection, even if it means tossing away the parallel cable you used with your old printer. Some printers and a growing number of scanners have FireWire options. If speed is important to you, take advantage of these faster connections.

HUB CAP WORLD

Since some older computers have just two USB ports, what happens when you plug in your keyboard (the mouse plugs into some USB keyboards) and a card reader? All of a sudden, there's no room for your printer. Here come hubs to the rescue! A USB hub is a small device that plugs into one of your USB ports and allows you to plug *more* devices into it.

Hubs are available from many companies and are necessary when working with more than a few USB peripherals. The best hubs are those that offer AC power for those peripherals that draw power directly from the USB connection. Once you split the single USB path into four different directions, you may not have enough power for that last device—such as that USB drive you just inserted. AC powered USB hubs cost a little more than unpowered but are more practical for the serious digital imager.

Belkin's TetraHub USB 2.0 4-Port Hub provides 480 Mb/s for all Hi-Speed USB 2.0 devices and a dedicated 12 Mb/s per port for all connected USB 1.1 devices. Photo courtesy Belkin, Inc.

Comparing Interfaces

Performance may be one of the most important aspects in selecting which kind of computer connection you want to make. This chart compares various types of peripheral connections along with their data transfer rates in megabytes per second (MB/s) or megabits per second (Mb/s).

Serial port	0.115 Mb/s
Standard parallel port	0.115 MB/s
USB	1.5–12 Mb/s
USB 2.0	480 Mb/s
EPP	3 MB/s
IDE	3.2–16.7 MB/s
SCSI-1	5 MB/s
SCSI-2	10 MB/s
Ultra SCSI	20 MB/s
FireWire	12.5–50 MB/s
Ultra2 SCSI	80 MB/s
Wide Ultra3 SCSI	160 MB/s

MEMORY CARD READERS

While there are those, especially in the camera industry, who think photographers will connect their camera directly to computers using the cords they thoughtfully provided in the box with the camera, the reality is that the media and camera are often in different places at the same time: as in a situation where a long shoot is ongoing. Hence, the need for a card reader. All of the big three memory vendors offer a card reader with some similarities and some differences.

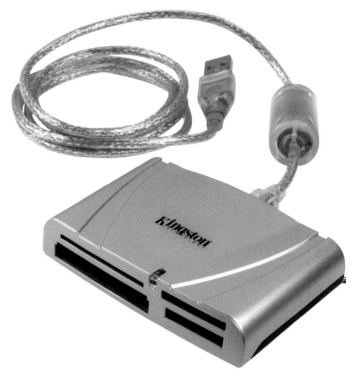

The Kingston USB 2.0 Hi-Speed 15-in-1 Reader comes with a 5-year warranty and free customer support. This sells for less than 25 bucks and supports CompactFlash Type I/II, SD, SD High Speed, miniSD, MMC, MMCplus, MMCmobile, MMCmicro (adapter required), RS-MMC, microSD (adapter required), Memory Stick, Memory Stick Pro, Memory Stick Pro Duo, SmartMedia, and the never popular Microdrive.

Lexar offers separate Lexar Professional CompactFlash Readers in both USB 2.0 and FireWire connections. The CompactFlash Readers are stackable and designed to connect multiple readers with a single connection. Up to four FireWire readers can be daisy-chained, and up to four USB 2.0 CompactFlash Readers can be connected via Lexar's Professional 4-Port Hub for *simultaneous* image file transfers. The readers support Lexar's ActiveMemory and LockTight technologies. With AMS, camera settings (in supported cameras) can be saved to the card to prevent having to re-enter these settings each time. LockTight prevents unauthorized people from accessing your image files.

Both Lexar models sell for a little over 60 bucks each, but stacking them and making simultaneous data transfers can save time for event photographers who need to get image files into the computer and printed in a hurry.

SanDisk's ImageMate 12-in-1 is a multi-card USB 2.0 reader that like all USB 2.0 devices is backwardly compatible with the slower USB 1.1 ports. The ImageMate 12-in-1 has the ability to write data to and read data from CompactFlash Type I/II, SD, miniSD, MMC, RS-MMC, Memory Stick including PRO, Duo, and PRO Duo, along with the mostly useless SmartMedia and xD cards.

SanDisk's $35 card reader can be used with or without a bundled and removable cradle. The cradle keeps it from getting lost on the desktop, but might be extra baggage on the road.

REAL WORLD TESTS

USB 2.0 has a raw data transfer rate at 480 MB/s and it is rated at 40 times faster than its predecessor, the once ubiquitous USB 1.1. FireWire is rated at 400 MB/s but there are differences in the way the systems are designed. Built from the ground up for speed, FireWire uses peer-to-peer architecture, and intelligent peripherals can negotiate bus conflicts to determine which device can best control data transfer. USB 2.0 uses the more traditional "Master-Slave" architecture in which the *computer* handles arbitration functions (that's why it costs less) for managing data flow to, from, and between peripherals. Some people claim that this difference makes FireWire *faster* but my real world tests bore out the raw Mb/s numbers. Using a 2 GB Kingston CF card with a mix of 83 RAW and JPEG images, the USB card readers transferred them to my hard drive in 26 seconds; the FireWire reader took 44 seconds. In all the testing done for this story, I attempted to reproduce what you could expect in real world usage, "your mileage," as the EPA says, "may vary."

When Good Cards Go Bad

Memory cards fail for lots of reasons. Sometimes it's the card's fault, other times the camera, and often it's (heaven forbid) the user who creates the problem. No matter whose fault it was, when my 4 GB Lexar Professional CompactFlash card failed I reached for Picture Rescue (www.datarescue.com) software that will usually recover images from reformatted cards, but it couldn't solve this particular problem. Next I tried ProSoft's (www.prosofteng.com) Picture Rescue, but it wouldn't work on this card either. The Image Rescue software included on every Lexar Professional CF card can recover lost or deleted JPEG, TIFF, and RAW files from erased, reformatted, or corrupted memory cards, but after recovering just a few files it stalled. Since Lexar Professional cards have a lifetime warranty, I contacted customer support, FedEx'ed my card off to Fremont, California, and waited with my fingers crossed. A week later (rescue time varies depending on their work load) I received a stack of CDs with 500 recovered images, and a replacement 4 GB CompactFlash card. My wife Mary (www.maryfarace.com) is considering a return to professional photography. When she saw this play out, it helped make up her mind about what brand of memory cards she would use to shoot weddings.

THE MOUSE THAT ROARED

Maybe it's time you gave your mouse a rest and switched to a graphic tablet. Long considered the province of the artist or designer, graphics tablets are also widely used the CAD (Computer Aided Design), digital photography, and presentation fields. If you are not currently using a graphics tablet, there are four reasons you should:

1 A stylus—or pen—is more natural to hold than a mouse, making the use of a graphics tablet one of the best ways to create original drawings and illustrations.

2 The human engineering aspects of a graphics tablets can, for some people, reduce the pain caused by carpal tunnel syndrome.
3 Presenters will find a graphics tablet and pen makes them more comfortable than using a one-, two-, or three-button mouse.
4 Graphics tablets are a much more accurate pointing and input device than a mouse.

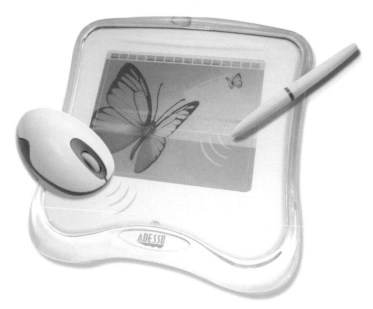

Adesso's CyberTablet 12000 has a large 12 × 9 inch workspace offers the kind of fine-tuned sensitivity needed for photographic retouching. For $169.99, it includes an ergonomically designed wireless graphics tablet with a wireless two-button scroll-wheel mouse. Photo courtesy Adesso.

Graphics tablets are often called *digitizing tablets* because they convert images, graphics, and drawings into digital information. This now-digitized visual data can be entered into the computer for storage, analysis, modification, or archiving. While the product is referred to as a tablet, there really are two parts. The tablet itself and a pen—or stylus—is used to "draw" on the tablet's sensitive surface. The tablet portion, which nowadays can be so thin as to be called a "pad," contains a mechanism for sensing where on the surface a stylus is positioned. Its bed is divided into a high-resolution matrix that can respond to active or passive actions. (Active response is when the element is drawn and passive is *after* it is drawn.) Digital information is represented as the X–Y coordinates of where the pen is placed. The accuracy of graphics tablets and their ultimate performance is defined by resolution, accuracy, and linearity.

Resolution measures the number of points per inch a tablet can recognize and how fine a distinction it can make between adjacent points. Typical tablet

resolutions vary from 25 to 1000 points per inch, but specifications for some high end CAD markets are higher. Higher-resolution devices naturally cost more, but tablets from the same manufacturer can cost as little as $129, or more than $2400—depending on resolution and size.

Accuracy measures the fidelity that the tablet is reproducing: the actual distance being measured vs. what happens on screen. A tablet that resolves 100 points per inch typically has an accuracy of 0.01 inches and units that resolve 1000 points per inch can exceed 0.005 inches of accuracy. By comparison, a human eye resolves approximately 5000 lines per inch at 10 inches. The average computer user's accuracy will be plus or minus 0.01 inches, but a skilled CAD operator can usually beat this.

Linearity tells you how much variability there is in the first two parameters across your field of work.

All graphic tablet documentation contains these specifications and can be used to compare one product against another. Just keep in mind that your drawing or illustration needs may be different from an engineer designing parts for a Boeing 777.

Graphics tablets come in many configurations. The first variable is the tablet itself. Tablet size varies from 4 × 5 inches up to 44 × 60 inches depending on the manufacturer and your application. When manufacturers specify a size they are referring to the *active* area of the tablet; that is, its usable area and not the unit's physical size. A tablet's actual size will always be slightly larger. One of the advantages of a flexible tablet is that it can be rolled out on any surface and left in place, acting not just as a tablet but also as a permanent desktop or work area.

Some graphics tablets allow an option to use either a stylus or a mouse-like device called a cursor or *puck*. Pucks are commonly used in the CAD industry with larger tablets. Yet some companies offer small pads with a puck option. Styluses are available in several flavors, included corded and cordless models. Cordless models are further subdivided by having those that require batteries and those that do not. Batteryless cordless styluses are preferred over pens that use batteries because—if you do not have a battery—it makes it impossible to have the pen run "dry" when on a critical deadline. Instead, radio waves are sent by the pad to the stylus and are returned for position analysis—much like radar. Every 20 microseconds, a grid of wires in the pad alternates between send and receive. Since the grid provides power through resonant coupling, no batteries are required (don't ask me how it works, it just does). In send mode, the signal from the pad stimulates an oscillation in the coil and capacitor circuit in the pen. In receive mode, the pen's circuit oscillations are detected and are analyzed by the software to determine not only position but also pressure being applied.

Each of these configurations has advantages and disadvantages. Corded pens may be less convenient than cordless models but because they're tethered to the tablet with an umbilical, you will never lose a stylus. Another advantage of corded

stylus is that they are less expensive. Some pens feature the latest hot button features—erasability and pressure sensitivity. To erase work, users can activate the erasing function by pressing one of the two buttons on the side of the pen, instead of having to flip the pen over. Erasability may or may not be something you need. If you feel you would like this feature, make sure it is implemented in a manner you'll be comfortable with and won't accidentally activate. A pressure sensitive stylus lets you control the width of each pen stroke. The harder you rub, the more you erase.

JUST WHAT I NEED

Anything you can do with a mouse, you can do with a stylus and graphics tablet. And there are some things a stylus does much better. Try writing your name with a mouse, and you will see what I mean. One area of clear stylus superiority is cursor placement. Instead of rolling a mouse to locate a cursor, just tap the pen on the tablet and that's where the cursor appears. Don't automatically assume a graphics tablet will make a perfect mouse substitute. Make sure the manufacturer includes software that lets the unit emulate your favorite mouse and has an easy, intuitive way to emulate mouse clicks.

If you're not already using a graphics tablet, maybe you should. In addition to producing freehand drawings, a graphics tablet and stylus make working with image-editing programs such as Adobe *Photoshop* easier and more intuitive than using a mouse. There are several good reasons why using a graphics tablet and stylus makes the creation of graphics easier.

First, you will find that the cordless stylus or pen that's part of every graphics tablet package—regardless of size—is more natural to hold than a mouse. Using a stylus and graphics tablet is one of the most natural ways to produce original drawings or illustrations because it's just like holding a pencil, pen, or hunk of charcoal.

Second, the human engineering aspects of a graphics tablet can, for some people, eliminate the danger of pain caused by repetitive motion syndrome. Any small step you take to eliminate the possibility of carpal tunnel problems is a good idea. Studies have shown that the biggest advantage a stylus has over a mouse is there is less posture deviation from neutral during pen use than is typically experienced during mouse use. Excessive hand extension, as well as more lateral rotation of the hand at the wrist, was observed of people using mice. By comparison, both deviations and extensions were substantially less with stylus use. The bottom line for your health is that using a stylus results in a more neutral and natural posture than using a mouse.

Third, a graphics tablet is a much more accurate pointing and input device than a mouse. It's tough to get more precise than a photograph, so your photo-manipulation tools should be as precise as possible.

The X Files: Don't Fight the Future

The Truth Is Out There!

Art, not matter how you produce it, requires tools and in this new millennium, the favorite tool for many artists is the computer. While it is hardware that makes it possible to create digital graphics, it is the *software* that enables the artist to harness the computer's energy and create illustrations, photographs, and drawings.

Don't let lost in the matrix of confusing image file acronyms. In this chapter, we'll take a look at everything you need to know working with digital imaging file formats. © 2004 Joe Farace.

To those computer users who don't work with graphics software on a regular basis the difference between programs such as Adobe Photoshop and Macromedia FreeHand (www.macromedia.com) may not seem significant. While digital designers use both programs to create art, that's the only aspect that Paint and Draw programs have in common. The real difference between these two different kinds of software boils down to the fact that Paint programs, such as Photoshop, work with *bitmapped* images, while Draw software, like FreeHand, works with *vector*-based images. Which brings up the question: Why do we need different kinds of graphics software anyway?

THE IPCRESS FILES

There are three basic classes of graphic image files: bitmap, metafile, and vector. A bitmap (sometimes called "raster") file is made up of a collection of individual pixels—one for every point on a computer screen. The simplest 1-bit files are monochrome images and are composed of a single color against a background. Images that display more shades of color or gray need more than one bit to define those colors. In fact, the more bits the merrier and the more colors that can be displayed and manipulated.

Paint software, such as Adobe Photoshop and Ulead's PhotoImpact (www.ulead.com), all work with bitmapped image files.

Graphics saved in vector formats are stored as points, lines, and mathematical formulae that describe the shapes that make up a drawing. That's why photographs are *not* typically saved in this format. When vector files are viewed on your computer screen or printed, these formulae are converted into a dot pattern and

displayed (or printed) as bitmapped graphics. Since all of the pixels that you see are not part of the file itself, the file can be resized without losing image quality. Some computer users call vector-format files "object-oriented," and you often see this term used in conjunction with drawing programs such as Adobe Illustrator.

A metafile is a multifunction graphic file type that accommodates both vector and bitmapped data within the same format. While seemingly more popular in the Microsoft Windows environment, Apple Computer's old standby PICT format is a metafile. Many kinds of graphics program will work with metafiles.

I AM A CAMERA

When talking about digital image files you'll first meet the word *compression*. Data compression enables devices to capture or store the same amount of data in fewer bits. It does this by discarding colors that may not be visible to the eye, but how well it does this ultimately determines image quality. All digicams use some kind of compression techniques to store images. The greater the compression *ratio*, the greater loss of quality you can expect. Lower compression produces fewer, better quality images. The highest image quality option is "no compression" or the Tagged Image File Format (TIFF) and RAW format many digital SLRs offer.

Joint Photographic Experts Group (JPEG) is an acronym for a compressed graphics format created by the JPEG (www.jpeg.org) within the International Standards Organization. (Because of the three-letter suffix convention used by Windows-based computers, this is often shortened to JPG.) All digicams use some kind of JPEG compression to store images. JPEG techniques *compress* an image file into discrete blocks of pixels, which are divided in half using ratios varying from 10:1 to 100:1. The higher the ratio, the greater quality loss you can expect. Lower compression produces fewer, better quality images. The highest image quality option is "no compression."

JPEG 2000

Not currently an in-camera option on any digital camera that I know of (but who knows what might hit the market by the time you read this) JPEG 2000 uses *wavelet* technology for greater data compression while offering better image quality than JPEG. Wavelet algorithms process data at different scales or resolutions. (For more information about wavelets, visit www.amara.com/current/wavelet.html.) Often less than 1% of the original data size is required for "very good" representation of your original image, making for small files with little data loss.

TIFF is a bitmapped file format originally developed by Microsoft (www.microsoft.com) and Aldus. A TIFF file (.TIF is used in Windows) can be any resolution from black and white up to 24-bit color. TIFFs are platform-independent files, so that files created on your Mac OS computer can (almost) always be read by a Windows graphics program. Some digital cameras, such as the Olympus E-500, let you capture directly in TIFF format. The upside: No processing is required. The downside: The files are always larger than RAW (more on RAW next) because they will white balance and other data.

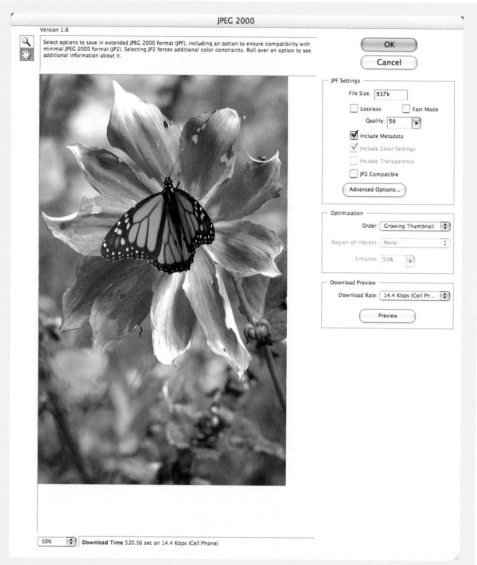

When you save a file in JPEG 2000 format using Adobe Photoshop CS2, this is what the Dialog box that appears looks like. Even if you've never used this file format before the controls and sliders that are used are self-explanatory, but you may have to *manually* install the JPEG 2000 plug-in in Photoshop's File Format folder because it is not part of the standard installation. © Joe Farace.

RAW files are the naked files themselves unaffected by anything other than your ISO setting. If you like you can think of them as a negative that needs to be processed and turned into the final photograph. RAW files contain all of the original data—the good, the bad, and the ugly—so you're gonna need some processing software to bring

the final image that was lurking inside that original capture to fruition.

For some beginners, there is some confusion about what RAW files are, how they work along with when, where and why you should use this form of image capture. That's why the next two chapters are dedicated specifically

The versatile Olympus E-500 digital SLT lets you capture images in JPEG, RAW, and TIFF file formats Inset photo: © Mary Farace.

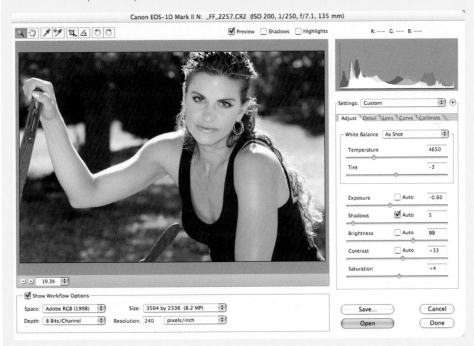

While the camera manufacturer's software continues to improve, the main reason I started using RAW capture on a routine basis was the availability of Adobe's Camera RAW. © 2005 Joe Farace.

to the RAW file format. Even if you think you know everything you want to know about RAW capture, you might want to, at least, skim these chapters for some tips. If, on the other hand, you want to increase you awareness of the advantages and techniques associated with RAW file format capture, you might want to read them in more detail.

THE GANG THAT COULDND'T SHOOT STRAIGHT

There is some loss of quality when JPEG files are captured but you can get more files per memory card with compressed images. Higher capacity memory cards are getting less expensive, but the last time I checked nobody was giving them away. RAW or TIFF files deliver the ultimate image quality from your digital camera, but you'll need to buy more and bigger memory cards.

So the big question remains is how to shoot'em but the answer ultimately is tied to how are you gonna use'em. If you just want a bunch of 4 × 6 prints of your vacation or some snapshots to e-mail to Aunt Midge, JPEG files will deliver what you need. If you are going to Yosemite to shoot images that you want to sell in art galleries or as stock images, shooting RAW just makes more sense. If working on images with computers is not your cup of tea, think about using TIFF, if your camera has that option.

The real question is "how much resolution do you need?" The ultimate test for image quality should be based on how a photograph is used and viewed. Once again, real-world comparisons are called for. A photograph made with the finest grain film and highest quality lens throws away most of its resolution when it is printed in a newspaper. Yet, the average person will find it difficult to tell the difference between a conventional 4 × 6-inch color print and an image made with a digital camera and printed on 4 × 6 Photo Paper by any inexpensive photo quality ink-jet paper. All of the above equipment is moderately priced, yet the results are truly photographic. This challenge introduces yet another variable—the experience of the viewer—into consideration when evaluating the quality of any photographic image.

What do I do? (In case anybody is interested.) Most of the time I shoot JPEG files event for publication, but that's based on shooting the 8.2 megapixel (3504 × 2336) images files that are possible with my Canon EOS 1D Mark II.

Like the EOS 1D Mark II, the N model has separate slots for Compact Flash and SD memory cards but adds a unique twist. It's now possible to record RAW image onto one memory card, and JPEGs on the other. This means you can capture color RAW files on the CompactFlash card, while recording JPEG files in *toned monochrome* on the SD card at the same time! It's also easy to switch between card slots. Just press the Card Select button to display a card selection screen.

This photograph of a Nissan Skyline was part of an assignment for *Modified* magazine. The Art Director's instructions were that I shoot large JPEG files for everything except those images that might be used across two pages. These, he asked, be shot as RAW. I shot everything as a JPEG file and this image ended up being spread across two pages and looked pretty good. Image captured with a Canon EOS 1D Mark II and 75–300 mm zoom lens. Exposure was 1/800th of a second at f/11 at ISO 200. © 2004 Joe Farace.

This portrait of Jamie Lynn was made with an EOS 1D Mark IIN and was captured in RAW mode on the camera's CompactFlash card. Exposure was 1/200th of a second at f/5.6 at ISO 200. © 2005 Joe Farace.

Buried in the EOS 1D Mark IIN menu is a set of "Picture Styles"—not modes—that includes six presets including, Standard, Portrait, Landscape, Neutral, Faithful, and Monochrome. You can further add digital filters and even tone the captured image—all in camera. Using the cameras built-in back-up mode I was able to simultaneously capture a full color RAW file as well as this digitally filtered and tined monochrome shot. © 2005 Joe Farace.

CROSSING DELANCEY

Regardless of what kind of operating system you use on, sooner or later there will come a day when someone will hand you a disc containing files designed for that "other" computer system. If you have the right tools, dealing with incompatible file formats doesn't have to cause you any distress. As you will soon discover, translating graphic file formats and moving files back and forth between Mac OS and Windows platforms is a lot easier than you might think.

Part of the problem of any kind of image conversion is that digital photographs come on an often-bewildering variety of file types. You will find them saved

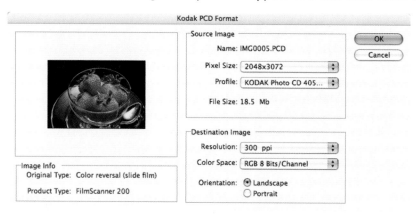

Kodak's Photo CD format *was* the closest thing yet to a Rosetta Stone for image interchangeability. Any Mac OS or Windows program that's compatible with the PCD format can read all of the image files that are stored on a Photo CD disc.

as PICT, TIFF, Windows Bitmap (BMP), PCX, and PCD along with some file types unique to Mac OS or Windows. Understanding what a particular file format's acronym means can take some of the stress out of the conversion process. Appendix A contains some of the computer acronyms, buzzwords, and terms you often find being tossed around when discussing computer graphics.

Kodak's Photo CD disc is compatible with both Mac OS and Windows platforms, but life is never that simple. Every time a hardware product or graphics software package is announced, the publisher feels obligated to create a new file format. When Apple Computer introduced their QuickTake digital camera, they also announced a brand new graphics file format just for the camera. Compounding the file conversion process is the fact that not all software programs write an existing file format in exactly the same way, producing variations or "flavors" of the so-called standard. For example, there are at least *thirty-two* variations of the TIFF format alone.

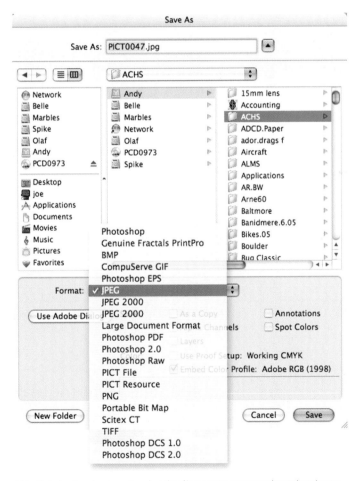

Adobe Photoshop is as close to a universal graphics file conversion program as there is, but when you run across a file you cannot open, it's time to reach for specialized file translation software.

When moving graphic files back and forth between Mac OS and Windows computers, the first tool you will need is software that allows your computer to read (or mount) disks formatted for the "other" machine. Luckily, Mac OS users already have what they need. Apple Computer's operating system lets it read any kind of Windows-formatted media you can throw at it.

On the Windows side of the disc/disk compatibility issue, DataViz's (www.dataviz.com) MacOpener is the best utility of its kind that I have ever found for Windows computers. MacOpener lets Window users use Mac OS floppy disks, CD-ROM discs, as well as removable media cartridges. When working with cross-platform programs like QuarkXPress, Adobe PageMaker and Photoshop, life has never been better or simpler. This is the best one hundred bucks any Windows user interested in file conversion can spend.

DataViz's Conversions Plus lets Window users use Mac OS floppy disks, CD-ROM discs, as well as removable media cartridges.

LOST IN TRANSLATION

Once you have the capability to read media from other computers, the next part of your translation quest involves using the proper file conversion software. The type of file translation software you will need is based on your personal

requirements. Are they average or heavy duty? If your file translation needs are only occasional, here's all the software you may ever need.

Mac OS users should get a copy of DataViz's MacLinkPlus that will translate Windows to Mac OS and Mac OS to Windows. In addition to converting graphics files, the package also translates word processing files. DataViz claims the latest version of *MacLinkPlus* supports more than 550 file translation combinations, and many of them are word processing, database, and spreadsheet formats. For Windows computers, DataViz offers Conversion Plus, which contains thousands of file translation options and even includes Mac Opener. The package also includes a copy of DataViz's e-ttachment *Opener*, a utility that solves problems that occur when you receive attached files as e-mail. This WYSIWYG utility lets you view and print almost any kind of file—even if you don't have the program that created it.

One of my favorite general-purpose Windows-only programs for graphic file translation is Corel's (www.corel.com) Paint Shop Pro XI.

When the file conversion process gets tough, I reach for DeBabelizer Pro for the Mac OS or Windows. There is not a file type that I know of that this program cannot open and convert. When you have a group of files to convert, you can collect them into a batch and write a script to convert them as a group. If you are

squeamish about doing your own scripting, don't be. The program's "Watch Me" command lets you go through the steps of converting a single file and automatically creates a script based on what you do. The program also includes a series of scripts that can be used to automatically process, filter, and color adjust World Wide Web-oriented graphics. Output can be delivered as GIF or JPEG files that have an optimized color palette for speedier viewing. For the average user Equilibrium DeBabelizer Pro LE is a low-cost introduction to DeBabelizer and supports 100 Web, print, multimedia, and legacy formats such as TGA (Targa.) DeBabelizer LE provides home digital imaging enthusiasts and business users access to professional image optimization and conversion tools and can be ordered online at DigitalRiver.com for $99.95.

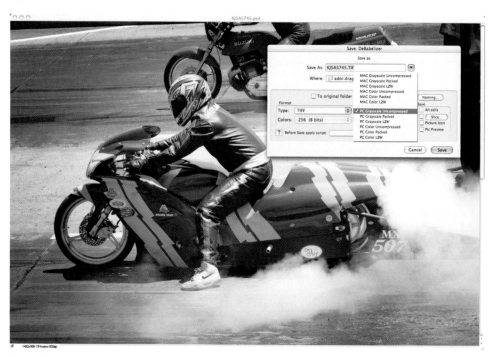

When the file conversion process gets tough, I reach for DeBabelizer Pro for the Mac OS or Windows. There is not a file type that I know of that this program cannot open and covert. © 2005 Joe Farace.

One reference book that I've found to be indispensable for people who must translate graphic files from one platform to another: "The Encyclopedia of Graphics File Formats," published by O'Reilly & Associates (www.oreilly.com) contains detailed descriptions of the different kinds of graphics file formats used by Mac OS, Windows, and UNIX computers. Some of the explanations may be too detailed for the average user, but you can use what you need and ignore what you don't. A CD-ROM includes vendor file format specifications, graphics test images, coding examples, and graphics conversion and manipulation software.

All of the programs I have mentioned easily handled the many different graphics files I threw at them, but none of them are perfect. The last time I counted, there were more than 100 different graphics file formats for Mac OS, Windows, and UNIX and no single program translates *all* them. Most Windows-based translation programs are biased in favor of converting DOS and Windows formats than Mac OS files, and the same is true of Mac OS conversion programs. The only solution for seemingly impossible file conversions may be to obtain the original, creating application and save the file in a more "portable" format. As a last resort, you can take the file to a service bureau, and for a modest fee, they may be able to convert it into a usable format.

The reality of file conversion is that, like everything else in computing, some file translations are easy and some aren't. The best way to increase your file translation skill is practice, practice, and practice. When you get stuck, go back and make sure you understand the basic principles before trying to pound a square file onto a round disk.

REVENGE OF THE SITH

In 1839, Louis Jacques Mandé Daguerre introduced photography, as we know it, to the world. The reaction of popular media of the day to the daguerreotype was

To create this faux cyanotype I photographed Lorie using only the window light coming through my back door. (The Cyanotype was invented by Sir John Herschel in 1842 and was the first successful non-silver photographic printing process. It's *blue*, hence the name.) Image was captured directly in monochrome using the Canon's EOS 30D blue toning capabilities. Exposure was 1/125th of a second at f/2.8 at ISO 320. Camera was in Shutter Priority mode and deliberately underexposed by one-third stop to increase shadows and blue saturation. © 2006 Joe Farace.

that "from this day forward, painting is dead." Obviously this didn't happen. Just as conventional photography didn't kill painting, digital cameras won't kill silver-based photography either. What photography did do—and what digital imaging is doing—is to replace another medium in certain applications.

Film—especially color film—is not inherently more archivally stable than any other media. There are many variables that affect the stability of silver-based images including the age of the original film before it was exposed, how is was stored before processing, how it is processed, the freshness of the chemistry used in processing, and how is it stored after being processed. Any miscues in any one of those steps will have an effect of the long-term stability of the images. It is true that black and white film can be handled from start to finish using materials and processes that guarantee archival quality, but because of the inherent instability of the dyes used in color film. It is much more difficult to do when working with color images. The stability of some color films, notably Eastman Kodak's Kodachrome family of transparency films, is better than the company's other color film stock.

Like it or not, the digital genie is out of the bottle. Despite the faults, problems and missteps, companies are making with the way new digital cameras are brought to market; there is no turning back. Many users simply do not require the permanence of film, and prefer the speed and convenience of digital cameras. As I wrote in *ComputerUSER* a long time ago, every change in imaging technology—from the Daguerreotype to the ill-fated Advanced Photo System—has been one of convenience, not of quality. Far from being toys, digital cameras expand the democratization of photography like no technology ever before. For any neo-Luddites reading this, I have four words of advice: "Get used to it."

Before Opening RAW Files

And the flying saucer men, that's the Ministry of Justice?

Before opening the door to RAW nirvana, it's nice to have some idea of what's on the other side. When processing RAW image files, you're gonna have to deal with a few technical decisions regarding such subjects as *bit depth* and *color space*. If you're not already familiar with these terms, this chapter provides some background to help you make decisions about what's best for your photographs.

One way to extract the maximum image quality from cameras that don't have lots of megapixels is to use RAW capture. The Canon EOS D30 that I had converted to capture images in digital infrared has a three-megapixel maximum resolution. By using RAW capture, I managed to extract the maximum image quality from those three megapixels. The completed IR image was later colored in Adobe Photoshop CS2 to create the tonalities you see here. © 2005 Joe Farace.

Note: The most important thing to keep in mind when reading this section is that I've tried to provide enough information about the choices you can make while working with RAW image files so that you can make up your own mind about how to produce the best looking images from your photographs. This is no "my way or the highway" approach here. Every reader's image files and needs are different and out of necessity your choices and decisions will be different from mine. From time to time I may tell you how I prefer to do something, but that in no way represents the only way to accomplish anything; it's just my *preference*. You may develop your own. My advice is to use all of the information that's contained in this section to explore the capabilities of RAW image files to create your own unique vision.

GETTING STARTED WITH RAW

I've been shooting with digital SLRs and digicams with RAW capture capability for some time, but only occasionally used that format when making photographs. Why? At the time, most of the software provided or sold to you by the camera manufacturers for the explicit purpose of working with RAW files were simply not that good, and were more often than not difficult and non-intuitive to use. Fortunately, this is finally starting to change.

This photograph was captured as a CRW (Canon Raw Format) file. It is an 8-bit file or 16 bits? Can you tell the difference? Image was made with Canon EOS D60 at 1/180 second and f/9.5 in Program mode at ISO 100. Lens was EF 22–55 f/3.5-mm zoom lens at 22 mm. (Pssssst: it's an 8-bit file.) © 2004 Joe Farace.

The process of converting from RAW to *whatever* format became more intuitive with the availability of Adobe Camera RAW. All of a sudden the Adobe software provided a logical progression from RAW capture to a working image onscreen. Once the jump into Camera RAW was accomplished, the next question became how many bits are enough?

I'LL BE BACK WITH YOU IN A BYTE

Computers are *digital* devices because they represent all data (including photographs) by using digits or numbers. These digits are measured as *bits* or binary digits. Binary is a mathematical system based on working only with the numbers one and zero. This is an ideal method for computers because electrical signals can be represented by current being either positive or negative, or off or on. Each electronic signal therefore becomes one bit, but to represent more complex numbers or images, computers combine these signals into 8-bit groups called *bytes*.

Monitors such as this KDS LCD (liquid crystal display) monitor have the capability to display millions of colors, but if you put your nose up to the screen you might see the digital equivalent of grain—*pixels*, or picture elements. © 2004 Joe Farace.

If you look closely enough at any traditional photographic print, you'll see silver grain. Isn't that what Antonioni's classic film "Blow-Up" is about? When the hero enlarges a photograph to mural-sized proportions he's unable to tell if the object he is looking at is a gun or several clumps of grain. If you get close enough at a photograph on a computer screen, you might see the digital equivalent of grain called *pixels* or picture elements. A computer screen is made up of thousands of pixels arranged in clusters or *triads*. Each triad is a combination of three colored dots placed close to one another. On the screen, combinations of these pixels produce all of the colors you see.

As we covered in another chapter, in a typical CRT (cathode ray tube) glass monitor three electronic "guns" fire three separate signals (one for each color) at the screen. If all three guns hit a single pixel's location at equal intensity, it will appear white on the screen. If none of the guns hit a target pixel, it will be black. Similarly, the number of bits of data associated with each pixel determines the visual quality of a photograph and is measured as *bit depth*, not dynamic range, as it's often mistakenly called. Bit depth refers to the number of bits assigned to each pixel, and thus how many varying colors can be applied to each pixel.

SHOULD I WORK WITH 16- OR 8-BIT FILES?

The simplest answer to that question is that the more bits you have, the higher quality you'll get. Think of the decision as another version of the one facing film photographers. If a landscape photograph made with 35-mm film looks great, it will look even better on 4 × 5 sheet film, and even better than when shot with an 8 × 10 view camera. Capturing these larger film images isn't easy. You can hardly pack an 8 × 10 view camera in the same case as a Canon EOS 1v, and as the physical demands increase so does the cost of processing these large film images, and storage becomes an issue too. Get the picture?

Large digital capture files create more issues too. The secret in making it all work is to find a balance between image size and quality that fits your workflow and expectations. Just as it did in computer selection, cost comes into account too. Much as an 8 × 10 Sinar view camera costs more than a Canon EOS 35-mm SLR, the digital tools needed to work on large image files are going to cost more too.

EIGHT OR SIXTEEN?

The upside of working with 16-bit images is better image quality. I should say *theoretically* better, because it's still up to you to capture a properly exposed and sharp image. The oft-heard quip, "just shoot it; I'll fix it later in Photoshop" doesn't work if you're striving for maximum image quality. Since you start with a larger

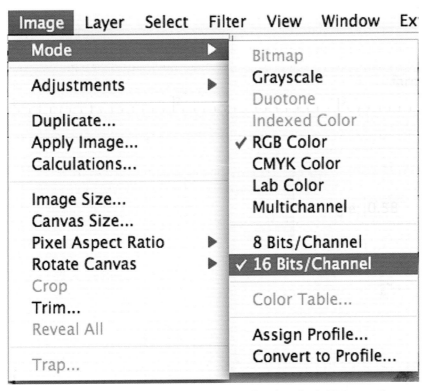

An 8-bit image offers 8 bits of data for each pixel and provides you with a palette of 256 colors. A 16-bit image provides more than 32,000 different colors for each pixel. In Adobe Photoshop, converting back and forth between 16- and 8-bit file formats is just a menu pull away (Image > Mode > 16 bits/Channel).

image file, there is less image degradation that can be created by the inevitable rounding errors that occur when a file is processed in an image-editing program. Image manipulation using 16-bit techniques take advantage of Photoshop's floating-point operations (that's the math stuff that happens inside the program) that produce smoother histograms and tonal transitions.

The downside of working in 16-bit mode is that fewer tools, especially third-party (see Chapter 9) Photoshop-compatible plug-ins, or "power tools," will work in that mode. Then there is the "Incredible Hulk" factor. Bigger files take more space and demand more computing resources. That bargain computer you bought at Crazy Charlie's Flea market ain't gonna work that fast with 16-bit files, so you're gonna need a state-of-the-art microprocessor in that computer, BIG hard drives, and recordable DVD drives to store all of those image files. At some point you will need to do something you may not be able to accomplish at 16 bits. When that happens you should save a copy and convert it into 8-bit mode, retaining your original 16-bit file in the project folder.

Filter	View	Window	Extensis	Help

Last Filter	⌘F
Extract...	⌥⌘X
Filter Gallery...	
Liquify...	⇧⌘X
Pattern Maker...	⌥⇧⌘X

Artistic	▶
Blur	▶
Brush Strokes	▶
Distort	▶
Noise	▶
Pixelate	▶
Render	▶
Sharpen	▶
Sketch	▶
Stylize	▶
Texture	▶
Video	▶
Other	▶

Alien Skin Eye Candy 5: Textures	▶
Alien Skin Image Doctor	▶
Alien Skin Xenofex 2	▶
Andromeda	▶
Auto FX Software	▶
B+W Outdoor Set	▶
B+W Portrait and Family Set	▶
Dfine 1.0	▶
Digimarc	▶
Digital Anarchy	▶
Extensis™	▶
FixerLab Filters	▶
Flaming Pear	▶
Focus Magic	▶
Grain Surgery 2	▶
Kodak	▶
nik Color Efex Pro 2.0: stylizing filters	▶
nik Color Efex Pro 2.0: traditional filters	▶
nik Sharpener Pro! 1.04	▶
PhotoTune	▶
PictoColor	▶
Pictographics	▶
SilverOxide	▶
theimagingfactory	▶

Here's what the Filter menu looked like in Adobe Photoshop when a 16-bit file was opened. As you can see, many of Adobe's, as well as most third-part compatible plug-ins, are not available and are "grayed out."

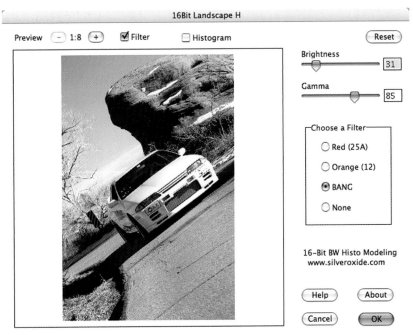

SilverOxide (www.silveroxide.com) offers a family of Photoshop-compatible plug-ins allowing digital images to emulate the tonalities of "real" analog film, such as Kodak's classic Tri-X, or my favorite Panatomic X. Their 16-bit Landscape filter includes typical filter options, such as red, orange, and the ubiquitous none, but a new purely digital filter called BANG (Blue Algorithm Neutral Gray) acts like a polarizer. © 2004 Joe Farace.

SPACE: NOT NECESSARILY THE FINAL FRONTIER

Computer monitors are RGB, meaning they build images out of red, green, and blue dots. This is known as additive color. Most popular desktop printers use CMYK inks to build images on paper. CMYK stands for cyan, magenta, yellow, and black, and is typically referred to as subtractive color. The software that drives the printer uses an RGB model to interpret the colors to CMYK, so you're gonna need some help.

Standard RGB (sRGB) was developed to match a typical computer monitor's color space, and is the default for Microsoft Windows XP and other software on the Windows platform. It is also the color space tucked inside most digital cameras.

The Adobe RGB color space is designed for printing using CMYK inks and includes a wider range of colors (gamut) than sRGB. Some digital cameras, especially SLRs, give you a choice of sRGB or Adobe RGB. Take time to look up how to change color space in your camera's Users Guide.

ColorMatch RGB was originally based on the Gamma of the Radius PressView Monitor and is a color space that is smaller and less uniform than Adobe RGB (1998). Those photographers with archives of old scanned images will find this color space useful.

ProPhoto RGB has a larger gamut than Adobe RGB, which itself cannot represent some of the colors that can be captured by the newest digital SLRs. ProPhoto RGB has a large gamut that's especially useful if your devices can display saturated colors.

All of these color spaces, except ProPhoto RGB, show some *clipping*, especially in the red channel, which means if you choose one of the other color spaces you will lose some data. Yet, most labs want sRGB files because their digital printers can output any pixel data as long as it fits inside their standard gamut space. Out-of-gamut colors will not be printed, and simply disappear. Try to avoid bouncing back and forth between color spaces because every time you convert a file you lose some data. If you want to use a color space that's not listed in the Space menu, choose ProPhoto RGB, and then convert to the working space of your choice *after* the file opens in Photoshop.

Some photographers, especially those working under repeatable studio conditions, find that having camera profiles created for their specific camera is the best solution, and Camera RAW 3.0 is the first version that will let you do that before opening the image in Photoshop. You can read more about that in a later section of this chapter.

OTHER VOICES, OTHER OPTIONS

With the introduction of 8GB CompactFlash cards (even if they aren't all *that* cheap) and the availability of lots of different RAW format processing tools, it might seem that most serious photographers will only shoot RAW files. So why should we even care about other options such as the JPEG 2000 format mentioned in a previous chapter? It's like this Bunky, out here in the real world sometimes size *does* matter. Files have to be distributed, e-mailed, and archived, and even with Terabyte-sized hard drives, some kind of compression strategy is going to be required.

Pixmantec (www.pixmantec.com) RawShooter essentials 2006 and RawShooter premium 2006 1.02 offers many new features and is compatible with the most digital SLRs including the Nikon D200, Canon EOS 5D, 1Ds Mark II, and 1D Mark II N, Sony R1 and other brands and models. RawShooter essentials 2006 is a *free* download. RawShooter Premium 2006 includes the ability to make side-by-side comparisons of similar images taken seconds apart. It has an Integrated Downloader that quickly transfers RAW files from a card reader or other source to a target directory for instant viewing and color correction. Other features and functions include Interpolation, Noise Suppression software, Batch Renaming, Vibrance, and Color Balance Correction tools. A FastProof feature quickly (1 second per file) produces low-res proofs for approval. FastProofHQ creates high-resolution TIFF and JPEG RAW conversions as fast as one file every 2 seconds.

dpMagic miniLab (www.dpmagic.com) is a free product that allows adjusting, correcting, and converting RAW images and is based on industry standards like

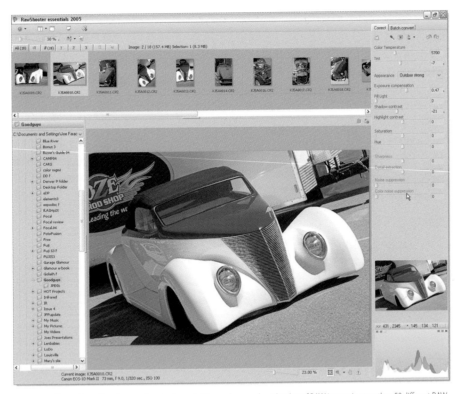

RawShooter Essentials enables photographers to view, prioritize, and process large batches of RAW images in more than 50 different RAW formats. During conversion, you can apply image adjustments, including color and exposure corrections, sharpening, and noise suppression. The result is a set of TIFF or JPEG files that can be opened in anybody's digital photography software where more advanced image enhancements can be made.

XMP. miniLab provides a non-destructive RAW workflow and lets you preview, adjust/correct, and save changes into XMP file without touching RAW originals. With dpMagic Plus ($9.95) you can preview RAW images as thumbnails or in full-screen viewer, execute a slideshow, and view a histogram. Immediately after installing dpMagic, your system becomes aware of new file types. You can switch views in your folder to Thumbnail view and see thumbnails. Start a slideshow and you can flow through RAW files as if they were JPEGs. dpMagic CE provides basic Windows Shell extensions such as thumbnail support for RAW files.

Adobe's Lightroom consists of four modules. When you launch Lightroom it opens in Library mode for photo management. There's even a digital loupe to check sharpness and a comparison feature that lets you select the best shot and assign a rating to your faves. Lightroom supports more than 100 camera RAW file formats, DNG, TIFF and JPEG, and after importing your photos, they're placed into a "Shoot" and displayed on the left panel. The Library module includes a Quick Develop palette that lets you make minor corrections on color balance, brightness, and contrast along with a Convert Photograph to Grayscale tool that's a lot better than what's built into Photoshop. A Slideshow module enables you to

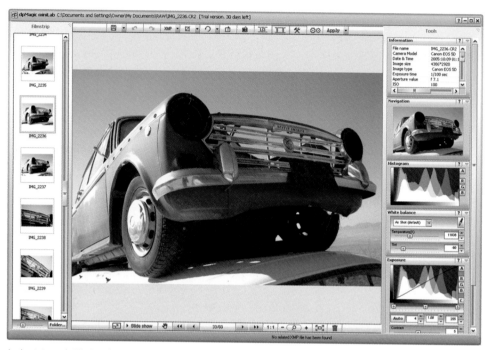

A subscription to the Windows-based dpMagic CE that supports RAW images produced by many digital cameras and costs $19.95 a year.

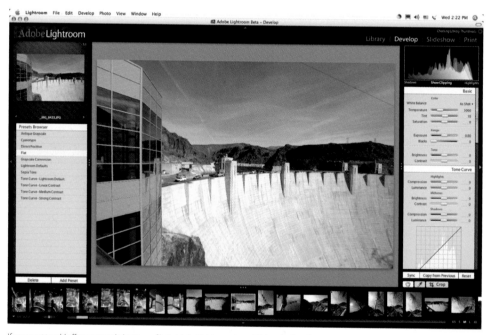

If you want to add effects or tweak the image file in Adobe Lightroom, just click into the Develop module where you can perform image adjustments, which unlike Photoshop, includes some built-in image tweaks. © 2006 Joe Farace.

create slideshows for onscreen viewing and exporting, and includes an interface with controls that let you create slick presentations as good as PowerPoint, only easier to assemble. The Print module provides many ways to set up your output, offering a set of templates as well as control palettes that exceed Photoshop's built-in capabilities.

EXIF 2.2

Exchangeable Image File (EXIF) format is an international standard that lets your digital SLR encode capture information, such as shutter speed, aperture, and the date and time the image was captured, into a JPEG file. Most, if not all digital cameras store images using EXIF-compressed files that use the JPEG DCT (discrete cosine transform) format which means the image data can be read by any application supporting JPEG, including Web browsers, image editors, desktop presentation programs, and document creation software.

JPEG algorithms, especially when used to compress sRGB files and used with a consumer-level image enhancement software, deliver much less color information than was originally captured by your camera's sensor. EXIF 2.2 is designed to preserve the color range (gamut) that is normally reduced when using sRGB. In order to take advantage of these enhanced capabilities, your image-editing software must be able to open, edit, and print files captures using EXIF 2.2. Printers and software that support the Print Image Matching (www.printimagematching.com) standard take advantage of EXIF 2.2, which has been widely adopted.

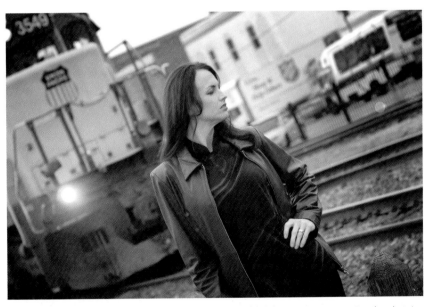

This black and white photograph of Ashley Rae was made near the railroad track, but near an in-town crossing where the train is going slowly. A long lens was used to add compression so she is standing on a public street, *not* anywhere unsafely near the railroad tracks. © 2004 Joe Farace.

You can read EXIF data in Adobe Photoshop in Photoshop CS2's Bridge image browser. When selecting any image file, its metadata will be displayed on the left-hand side of the screen. Here you can see the image data for the black and white photograph of Ashley Rae with complete technical details of how it was captured using an Epson RD-1 digital rangefinder camera.

sRGB Color Space: You Pays Your Money and Takes Yer Cherce

Many digital SLRs give you a choice of capture in sRGB or Adobe RGB (a.k.a. Adobe RGB 1998). What's the diff? sRGB was created in 1999 with a goal of producing color *consistency* between hardware devices. It defines a gamut of colors that represents each color well and can be used by CRT monitors, liquid crystal display (LCD) screens, scanners, printers, and digital cameras. sRGB has been incorporated into many Web browsers to make sure the colors on Web pages match the color scheme of the operating system. Because of the color consistency it creates, most hardware devices that work with images now use it as the default setting. All of which sounds very inviting, doesn't it?

Adobe RGB is designed for photographers whose work will appear in print and offers a broader range of colors than sRGB. If you want to get down and funky with the deals, download the full Adobe RGB specifications at www.color.org/adobergb.pdf. If you want to really make yourself crazy, you can Google "sRGB vs. Adobe RGB" and read opinions about it from a wide range of viewpoints. Being a pragmatist, I suggest you do the same thing with this color space argument as you do with the 8-bit vs. 16-bit controversy. Shoot some tests, make some prints, and then decide. This is the way we worked back in the film days and the methodology is still valid today, even if the tools are a little different.

PERFECTION?

Eugene Delacroix once said "Artists who seek perfection in everything are those who cannot attain it in anything." Opinions are far from unanimous on every aspect of digital image capture, with some dissenters on 16-bit capture arguing that there is no discernable difference between it and 8-bit images. Here's my take on the whole deal: for many applications, an 8-bit image file may be all you need and, perhaps, the best of both worlds is to capture in 16 bits but work in 8. All of these decisions regarding color space and bit depth need to be part of your decision before you begin to think about opening a RAW file. If you want to see one way to open RAW files, turn the page. . .

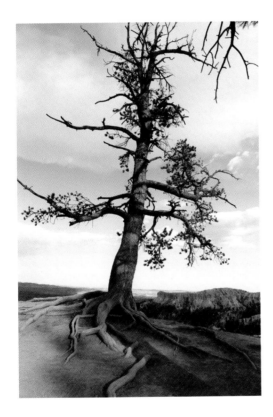

This photograph was made near dusk at Bryce Canyon Utah using a Pentax K100D and was shot as a PEF (Pentax RAW) file. Exposure was 1/500 second at f/8.0 and ISO 400. The Pentax 12–24-mm zoom lens was set at 19mm. © 2006 Joe Farace.

Working with RAW Files

RAW formats vary from camera to camera and every manufacturer uses its own proprietary RAW file format (some have *two*) for storing image data. Sometimes a company will *terminate* support for a discontinued camera's RAW format, leaving photographers high and dry. That's why Adobe defined a non-proprietary format for RAW called Digital Negative (DNG) that can be used by hardware and software developers to provide RAW processing in the future. So far, Leica's Digital Modul-R, Hasselblad H2D, Ricoh GR Digital, and the Samsung Pro815 use DNG as their native RAW format. Is this a trend? Let's hope so.

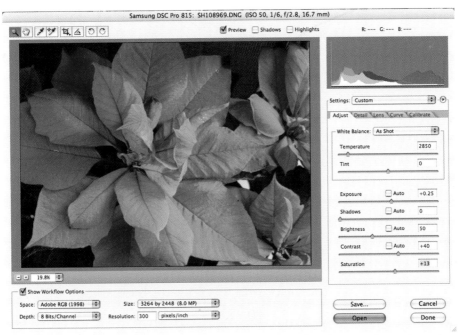

You can view the Samsung Digimax Pro815's RAW files with the bundled Digimax Master software that integrates browser, viewer, and image-editing functions. Or any program, including Adobe Camera Raw, that opens a standard DNG file. ©2006 Joe Farace.

LETS GET RAW

RAW file processing has entered the same era as traditional film processing at its height, when practitioners jealously guarded formulae for processing film. They would never reveal, for free anyway, that precise blend of Rodinal, grain alcohol, and rainwater, along with a shot of Dr. Pepper—shaken not stirred—that was required for perfect processing.

In today's digital world, the primary buzzwords are workflow and "mine is better than yours." The software tools are now dictated by the hardware—camera and computer—that you use. All you need is software that provides a way to manage everything from image management to processing to output. The Windows-based ACDSee Pro Photo (www.acdsystems.com) manages to do that in one affordably priced package. ACD Systems claims "lightning-fast RAW image previews," and for the first time the claims meet reality. That includes pro support for RAW formats from Nikon, Canon, Konica-Minolta, Olympus, Fuji, and Pentax cameras, and support for Adobe's DNG format.

To process a RAW file in ACDSee Pro, just highlight it and click the RAW Processing button in the toolbar. A separate window opens with tabbed controls, not unlike Adobe Camera Raw (ACR), but there are slightly fewer tabs—Exposure,

In ACDSee Pro, you bounce back and forth between unprocessed and processed images by clicking on two tabs at the top of the image preview window. You can also save settings as presets so you can use them repeatedly, and process multiple RAW images in a single step with batch RAW processing. ©2006 Joe Farace.

Color, and Detail—and fewer controls. There *are* tools for adjusting white balance, exposure, sharpness, or noise, and for the less geeky among us, that's a good thing. A histogram shows Red, Blue, and Green channels along with Luminance.

THE 800-POUND GORILLA

RAW file support is directly built into Adobe Photoshop CS2. (With Photoshop 7.0, ACR plug-in must first be installed.) The latest version of ACR contains many new features that will enable you to get even better results from your files staring with automatically selecting and assigning your specific camera model. Access to Camera Raw is through Bridge. (File > Open in Camera Raw.)

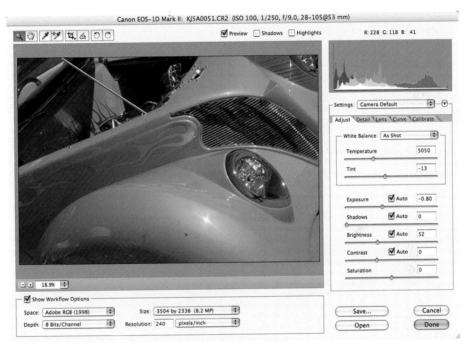

The first thing that users of previous versions will notice about Camera RAW 3.0 is that there are more icons across the top left-hand side of the dialog box than before. In Photoshop CS there were just three icons; Photoshop CS2 has eight! Photograph © 2004 Joe Farace.

The first three tools are the same ones found in previous versions of Camera RAW: Clicking the Zoom tool (a.k.a. Magnifying Glass) inside the preview window allows you to zoom in and out of the details on a RAW file. Holding down the Option key (Mac OS) or Alt (Windows) while clicking reverses the zoom effect. The Move (Hand) tool does its same job of dragging the image in the preview window around after you've used the Zoom tool. My favorite tool was always the White Balance Tool; clicking anywhere that is neutral on the image in the preview windows brings the image into a "normal" white balance. It is always my first step before doing *anything* else with a RAW image file. The Rotate Image icons (90° Clockwise and CounterClockwise) have been moved from their previous location

to keep all the tools together. You'll find them at the end of the line. In between is the new stuff.

WHAT'S NEW PUSSYCAT?

The first new tool is the Color Sampler tool whose icon looks a lot like the White Balance Tool. In fact it displays different Red, Blue, and Green values when clicking on up to three places in your image. When used in conjunction with the White Balance Tool it helps you determine neutral colors or show where a certain neutral color may be heading—warmer or cooler.

The next two tools provide functionality that's already available in current and previous versions of Photoshop, but add a new twist or two. The Crop tool gives ACR so much more functionality than the previous version that it starts to feel like a separate application, much like Bridge. You can only show the cropping area (the rest of the image is grayed out) and the actual crop is not applied until after you've finished other adjustments and click Done. The Straighten tool accomplishes the same goals as the Measure tool does in Photoshop but permits cropping the image, so you don't have to use the Rotate command to complete the operation and *then* crop to remove extraneous white space.

There are three new buttons to the left of the new tools. Preview lets you toggle back and forth between your original RAW files and any adjustments you make with the slider (we'll get to them, don't worry) on the right-hand side of the

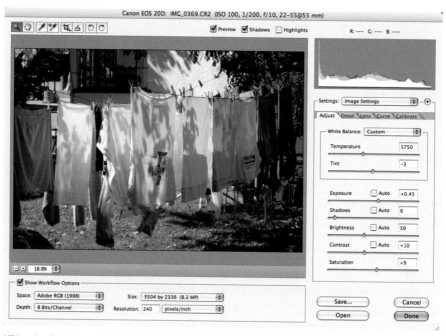

ACR has a box for the Gamut Clipping warning for Shadows and shows the affected areas in *blue*. © 2004 Joe Farace.

Camera Raw dialog box. Next are check boxes to show the Gamut Clipping warning for Shadows, Highlights, or both. Clipping is the shifting of pixel values to either the highest highlight value (255) or the lowest shadow value (0). Areas of a photo that are clipped are either completely white or completely black and have *no* image detail. Both boxes can be checked together so you can see warnings for Highlights *and* Shadows.

What's missing from previous versions? There used to be check boxes allowing you to choose between using "Basic" or "Advanced" modes for using Camera Raw. Both of these choices are *gone*. My guess is that Adobe Systems thinks that if you are experienced enough to use ACR you're an advanced user.

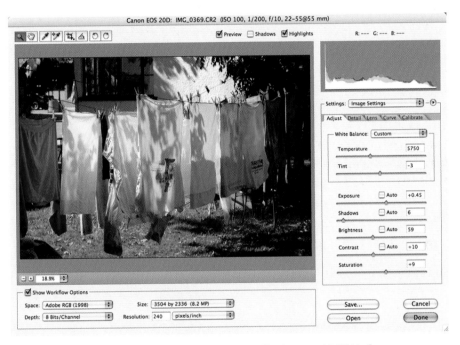

ACR has a box for the Gamut Clipping warning for Highlights and shows the affected areas in *red*. © 2004 Joe Farace.

SHOW WORKFLOW OPTIONS

Before getting to what the Show Workflow Options checkbox gives you, take a second to look at the plus and minus buttons above it. Clicking either of these buttons will make the image in the preview window larger or smaller depending on which button you click. I think you've already figured out what each one does. There is also a pop-up menu with presets allowing you to get to where you to make the preview image the size you want in a hurry. "Fit in View" is my favorite but you can also have preset viewing options from 6% to 400%.

The first choice you face when unlocking Show Workflow Options is assigning a color space to the file. If some of the terms used to describe color space are new

Don't be bashful, click the Show Workflow Options check box—you know you want to—but when you do, you come face to face with yet more choices. Let's get the fear and loathing over with and jump in to see what all this gobbledygook really means.

to you, don't panic. You can find them in the previous chapter and the Glossary in the back of this book. The Color Space choices available in Camera Raw's pop-up menu are Adobe RGB (1998), ColorMatch RGB, ProPhoto RGB, and sRGB (IEC619664-1). Next you face two simple choices: Whether to assign a 16- or 8-bit color or bit depth to your image. The information to help you make your decision about which bit depth to use is covered in the previous chapter, so if you skipped over it to come here to get the good stuff, jump back a few pages, and find out the advantages and disadvantages of either choice.

CROP SIZE: DOES MATTER

This pop-up menu shows the choices available in making your image resolution smaller (downsampling) or larger (upsampling). Photoshop itself provides a way

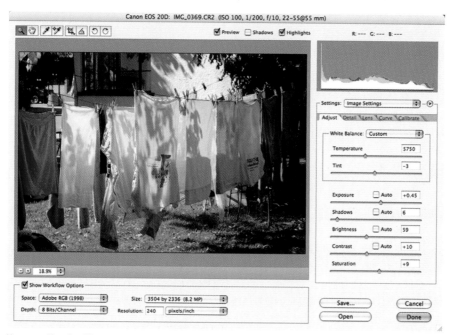

You *can* use Photoshop CS's Image Size command to upsample your image instead of doing one big jump. Try doing it in successive steps, increasing each step by 10%, using Bicubic Interpolation. Some Photoshop users have called this process "Stair Interpolation." Better yet, why not just upsample using Camera Raw? But, hey, it's your choice.

to make larger images using the Image Size (Image > Image Size) command and there are third-party solutions including the useful Genuine Fractals (www.ononesoftware.com) Photoshop-compatible plug-in. Most users will find that using Camera Raw's upsample will produce acceptable results, especially if starting with files from mid-sized (8 megapixels) or larger image files.

RESOLUTION: OF THE MATTER

Two choices are provided here: one if you want to measure your pixels using English measurements, and the other if you want to use metric. The key is not how you measure but what you measure.

What's the difference between "dots per inch" (dpi) or "pixels per inch" (ppi)? PPI and dpi are measures of resolution:

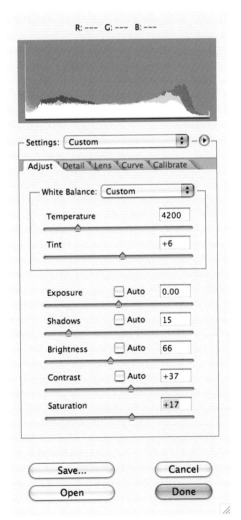

At the top of Camera Raw, you'll find a *color* histogram. The histogram simultaneously shows all three channels (Red, Green, and Blue) of the image and is automatically updated as you make changes to the settings below. The histogram displays the tonal range of the entire image and gives an overall snapshot of the image's tonal range, or *key*. A low-key image has detail in the shadows; a high-key image has detail in the highlights; and an average-key image has detail concentrated in midtones. An image with a full tonal range has a number of pixels in all of the areas. Being able to identify the tonal range helps determine what appropriate tonal corrections are needed—if any.

PPI relates to the smallest point that can render varying levels of tone and is the number of PPI in your image file that affects print size and output quality. If there are too few PPI, the pixels will be large and your image will appear "pixilated." The "correct" ppi to use depends on print size. Larger prints are viewed at a different distance than smaller ones, so a lower PPI can still work.

dpi is simply how many *dots* of ink per inch can be output by the printer. The higher the dpi, the better the print's tonality will be. Transitions between colors will be smoother, but your printer may be rated 2880 dpi, while the ppi could only be 300. This is why the suggested file resolution for printing photographs on an ink-jet printer is most often around 300 PPI (or sometimes as low as 240 depending on the printer).

SETTINGS? NOT MORE SETTINGS?

Camera Raw's Settings pop-up menu lets you chose one of the following options: Selected Image Settings uses data from the selected RAW image file. When a batch of RAW images is selected, this setting becomes the "First Selected Image." The settings for the first image in the selected batch will be applied to *all* the images in the batch. Camera Default Uses the saved default settings for a specific digital camera. Previous Conversion uses settings from the previous image made with that same camera. Custom lets you create unique one-time-only custom images that you don't want to save for the future.

When a RAW image file is opened with Camera Raw, settings are stored in the Camera Raw database file or a *sidecar* (Extensible Metadata Platform) file. It lets Photoshop remember the setting for each individual Camera Raw image file so that when you open a RAW image the next time, all the settings sliders default to the same values used the last time to open that specific RAW file. Image attributes such as target color space profile, bit depth, pixel size, and resolution are *not* part of the stored settings.

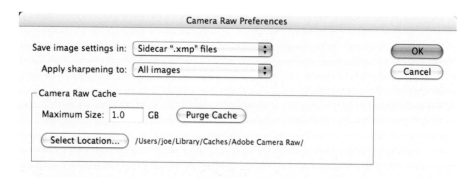

TIP: You can determine where the settings are stored using the Camera Raw Preferences by clicking the fly-out menu next to the "Settings" pop-up menu and selecting Preferences. These sidecar XMP files can be used to store IPTC (International Press Telecommunications Council) caption data or other metadata.

You can save ACR settings for a specific camera or specific lighting conditions and reapply them on other RAW images. You can also save a settings file that contains only a subset of the Camera Raw plug-in settings. When this subset file is then loaded, only certain sliders are updated. This lets you create settings presets for custom white balances, specific lens settings, and so forth. Using the Bridge (Edit > Apply Camera Raw Settings) you can also update all or a subset of the settings applied to Camera Raw images.

After making adjustments in the Camera Raw dialog box, do one of the following: You can Save Settings (or Save Settings Subset) from the fly-out menu to save the current settings and *add* them to the Settings menu, allowing them to be applied to another image. You might want to save as "Set Camera Default" to set a default setting for other images from the same camera and you can even have multiple defaults for different cameras.

Load Settings...
Save Settings...
Save Settings Subset...
Delete Current Settings

Export Settings

Set Camera Default
Reset Camera Default

Preferences...

After you tweak all the settings in Camera Raw 3.0, you can save them in an XMP file that can be applied to images made at the same time, and the customized setting will appear in the Setting menu that can be accessed via the fly-out menu below the histogram display.

To save a settings subset:
 Step 1: Choose Save Settings Subset.
 Step 2: Specify the settings to be saved by choosing an option from the Subset menu or select/deselect settings from the "Settings" list.
 Step 3: Click Save.
 Step 4: In the Save Raw Conversion Settings dialog box, name and save the file. Other settings in the menu include Camera Default that uses the saved default settings for a specific camera and Previous Conversion that the settings from the previous image of the same camera. Up to 100 file names can appear in the Settings menu.

Later on the process can be reversed to *apply* any saved Camera Raw settings. All you have to do is choose the name from the Settings pop-up menu.

THE ADJUST TAB

Under Settings are the four tabs that contain the "meat and potatoes" of ACR including Adjust, Detail, Lens, Curve, and Calibrate.

For most users, Adjust will be the only tab that they will ever use and contains controls for color and exposure. Unlike the last edition, some of the sliders (Exposure, Shadows, Brightness, and Contrast) in ACR contain an "Auto" check box that, when selected, automatically sets these parameters; and it does a pretty good job of it too. The terminally geeky will want to turn them off, but every time I tried, I ended up with near identical slider settings. Let's start at the top of the list of sliders and work our way down.

Digital cameras record the white balance at the time of exposure as metadata. ACR reads this data and uses it as the initial setting when opening an image file. This usually comes close to being the correct color temperature, but you can fine-tune the adjustments if it's not quite right. The Adjust tab in the Photoshop Camera Raw dialog box also has three controls for making adjustments to remove a color cast from the image.

White Balance sets the color balance of the image to reflect the lighting conditions under which the photo was originally made, but you may prefer to customize the white balance using the Temperature and Tint sliders that are located below this pop-up menu. Camera Raw reads the original white balance settings of most digital cameras, and leaving the White Balance menu set to "As Shot" uses the camera's white balance settings. For cameras whose white balance settings are not recognized by ACR, setting the White Balance menu to As Shot is the same as choosing Auto. The Photoshop Camera Raw plug-in reads the image data and automatically adjusts white balance.

Other choices from the pop-up menu include Daylight, Cloudy, Shade, Tungsten, Fluorescent, Flash, and Custom, which lets you create a specific White balance for this image. You might try one of these if the image's color is obviously not correct using the As Shot and auto options, but I have found that they seldom produce positive results. You may find that using the Temperature and Tint sliders (below) are a good combination when used with any of the automatic settings. Don't take my word for it. Experiment and make up your own mind.

Temperature lets you fine-tune the white balance to a custom color temperature using the Kelvin color temperature scale (see "Who is This Kelvin Guy"). Moving the slider to the *left* corrects for a photo taken with a lower color temperature; Camera Raw makes the image colors bluer to compensate for the lower (yellow) color temperature of the ambient light. Moving the slider to the right corrects for a photo taken with a higher color temperature; the plug-in makes the image colors warmer (yellow) to compensate for the higher (blue) color temperature of the ambient light.

Tint is a less complex slider and lets you fine-tune the white balance to compensate for green or magenta tint in your photograph. Moving the slider to the left (negative) adds green to the photo, while moving the slider to the right (positive) adds magenta.

To adjust white balance quickly, select the White Balance tool in the top left-hand side of Camera Raw, and then click an area in the preview image that should be a neutral gray or white. When you do, the Temperature and Tint sliders automatically adjust to make the selected color exactly neutral.

This digital infrared image of a classic Buick Skylark convertible was photographed in black and white mode with a Fujifilm FinePix S3 Pro digital SLR mounted on a tripod. Exposure, in manual mode at ISO 1600, was f/11 and 4 seconds, using a Hoya CR72 filter. Final exposure settings were determined by viewing the file's histogram on the camera's preview screen. ©2005 Joe Farace.

Who is This Kelvin Guy?

I am constantly amazed at the misinformation about the Kelvin scale. On the Internet, a power company states the "History of Kelvin temperature originally comes from the incandescent lamp." Duh? Long before Edison invented the incandescent light, Lord Kelvin, an Englishman, proposed a new temperature scale suitable for measuring low temperatures. During the nineteenth century, he suggested that an absolute zero temperature, where all heat is removed from matter, should be the basis for a new scale. His idea was to eliminate the use of negative values when measuring low temperatures using either Fahrenheit or Celsius scales. In honor of Lord Kelvin's contributions, this system is called the Kelvin scale and uses the unit "Kelvin" or sometime just "K."

There's an old computer adage that goes: "Garbage in, Garbage out." You can't use any of ACR's controls to make up for a hopelessly under- or overexposed image file. If your digital camera has a histogram feature, use it to home in on exposures *while you're shooting*! If it doesn't have a histogram, use the camera's auto bracket control, or put the camera in Manual mode and bracket exposures for critically important photographs. One of Farace's laws of the Computing Universe is that "The best captured files make the best photographs."

The Exposure slider adjusts an image's brightness or darkness. Moving the slider to the left *darkens* the image, while moving the slider to the right *brightens* the image. The values are in increments equivalent to f-stops. A + 1.50 adjustment is similar to increasing the aperture one and a half stops. A − 1.50 adjustment is like reducing the aperture by one and a half stops.

RAW Tip

Holding the Alt (Windows) or Option (Mac OS) key while moving the Exposure slider gives you a preview of where the highlights become completely white or black, with no detail or are *clipped*. You can adjust the slider until the highlights (not specular highlights) are clipped, and then back off on the adjustment. Black indicates areas that are not clipped, and color indicates areas that are being clipped in only one or two channels.

The most critical areas of RAW processing involve White Balance and Exposure. Many of the other controls in this tab are replicated in Photoshop CS prime, so that you can make these adjustments later without the loss of gamma that occurs during RAW processing. These other controls include: Shadows, Brightness, Contrast, and Saturation and the next chapter shows ways to adjust these image factors using Photoshop prime's controls or using third-party Photoshop-compatible plug-ins.

AND NOW FOR THE REST OF THE STORY

Shadows control what input levels will be black in the final image. Moving the slider to the right *increases* the areas that are mapped to black. Using the Shadows slider is similar to using the black point slider for the input levels in the

Photoshop Levels command. (Image > Adjustments > Levels.) Sometimes this produces the impression of increased contrast.

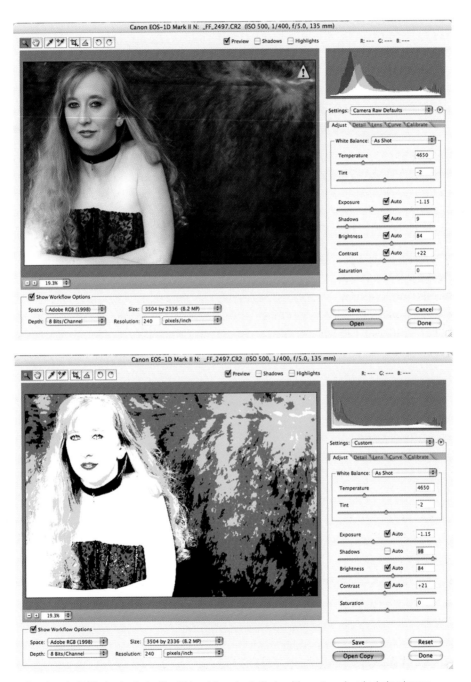

Holding down the Alt (Windows) or Option (Mac OS) key while moving the Shadow slider previews where the shadows become *completely* black with no detail. Move the slider until the shadows begin to get clipped, and then back off slightly on the adjustment. Color indicates areas that are being clipped in one or two channels, while white indicates areas that aren't clipped.

The Brightness slider adjusts the brightness or darkness of the image, similar to the Exposure slider. Instead of clipping the image in the highlights (areas that are completely white, with no detail) or shadows (areas that are completely black and no detail), Brightness *compresses* the shadows and expands the highlights when the slider is moved to the left. A good rule of thumb, but by no means the only way, is to use this slider to adjust the overall brightness or darkness after setting the white and black clipping points using the Exposure and Shadow sliders.

Contrast adjusts an image's midtones. Higher values increase midtone contrast, while lower values produce an image with less contrast. Generally, you use the slider to adjust the contrast of the midtones *after* setting the Exposure, Shadow, and Brightness values.

Saturation adjusts the color saturation of the image from *minus 100* (pure monochrome) to *plus 100* (double the saturation) and is similar to controls that you would find inside Photoshop CS2 prime. The only reason you might want to apply these last three corrections inside ACR instead of later is when converting a RAW file to an 8-bit image. Another good rule of thumb is to make global changes to the image file in ACR and local changes later inside Photoshop CS2.

THE DETAIL TAB

The Sharpness slider is a variation of Photoshop's Unsharp Mask filter, which locates pixels that are different from the surrounding pixels based on the *threshold* you specify and increases the pixels' contrast by the amount you specify. When opening a RAW image file, ACR calculates this threshold based on your camera model, ISO, and exposure compensation, but you can choose whether sharpening is applied to all images or just the previews.

Almost all digital images, whether captured by scanner or digital camera can stand a little sharpening, but the edge-sharpening techniques used by Photoshop CS2 can create as many problems as it corrects. I prefer to not sharpen in ACR (or in camera for that matter) and use some of the techniques covered later in this book. Adobe Systems' official recommendation is *not* to use Camera Raw sharpening if you plan to edit the image extensively later, and then only use Photoshop's sharpening filters as the *last step* after all other editing and resizing is complete. I recognize that some of you may want to sharpen right now, so if you wanna do it, here's how it works:

Step 1: Click the Magnifying Glass tool to zoom the preview image to at least 100%.

Step 2: Move the slider to the right to *increase* the amount of sharpening and to the left to decrease the amount of sharpening. A zero setting turns *off* ACR's sharpening. For cleaner images set the Sharpness slider to a low value. (Nothing is uglier than an oversharpened image.)

Using either Luminance Smoothing or Color Noise Reduction will reduce an image file's noise. Luminance Smoothing reduces *grayscale* noise, while Color

Noise Reduction reduces *chroma* noise. (Chroma is a measurement of the relative purity of a color.) Moving the slider to zero turns off its noise reduction. When making adjustments to either Luminance Smoothing or Color Noise Reduction, first zoom in on the image for a close-up look so you can see the effect of the noise reduction.

Digital Noise

The chips in all digital cameras add noise to images. Like grain in film, digital noise is worse at high ISOs and more noticeable in areas of uniform color, such as skies and shadows. Since noise can be objectionable in an image, there are more than 20 different DNR (Digital Noise Reduction) software products in additional to what's built into Camera Raw. Chapter 9 will introduce you to a several other alternatives for fixing noise after a RAW file has been opened with your favorite digital imaging program.

At 600% magnification, but visible at smaller sizes, the noise from compact digicams such as Canon's SD-10 are noticeable at ISO 400. Surprisingly at ISO 200 the noise is significantly less. So the old rule of thumb for film applies to digital imaging as well: To maintain the maximum image quality, always use the lowest ISO settings that are practical. ©2003 Joe Farace.

THE LENS TAB

Chromatic Aberration is a common lens defect where the lens elements focus different frequencies (colors) of light differently, so there are controls in the Lens tab to address this problem. One type of chromatic aberration results in the different colors being in focus, but each color's image is a slightly different size. This type of aberration results in color fringing in areas both away from and toward the image's center. The fringing can appear red on the side of an object toward the center of the image, and cyan on the side away from the center of the image. The Fix Red/Cyan Fringe and Fix Blue/Yellow Fringe sliders adjust the red and blue channels making them larger or smaller to remove fringing and increase corner sharpness. Some, especially wide angle lenses, create vignetting, or a darkening

of the corners. Panoramic cameras, such as the Hasselblad Xpan offer "Center" filters that are lighter in the corners and darker in the center to even up the exposure across the image area.

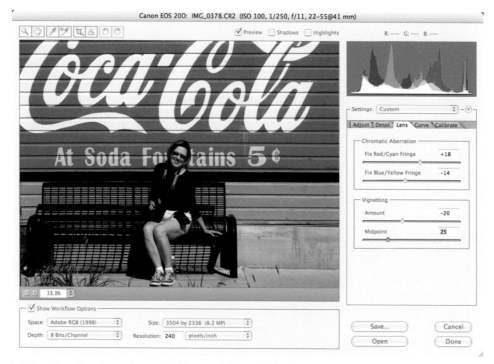

In the Lens tab, two Vignetting controls are provided: Amount and Midpoint. To lighten the photograph's corners, move the Amount slider to the right (positive) side. To darken an image's corners of the image, move the slider to the left (negative). Move the Midpoint slider to the left (lower value) to apply the Amount adjustment to a larger area away from the corners, or move the slider to the right (higher value) to restrict the Vignetting Amount adjustment closer to the corners. You can enter a value in the Amount and Vignetting Midpoint text boxes. ©2004 Joe Farace.

Hiding behind the new "Curve" tab is a version of Photoshop's Curves control that layers an adjustable curve overlaying a histogram of the image file. The Tone Curve pop-up menu lets you apply some presets, including Linear, Medium Contrast, Strong Contrast; or you can use Custom, which lets you yank the curve at any point to fine-tune based on what you see in the preview window.

CALIBRATE, CALIBRATE, DANCE TO THE MUSIC

The Calibrate tab has been revised in Camera Raw 3 starting with a pop-up menu that lets you apply a Camera Profile from *within*, instead of waiting until the image is opened in Photoshop CS2. Every digital camera is unique. Most camera manufacturers apply some sort of correction to the files, but apply the same corrections to every camera. So why not create a camera profile? Some experts say digital cameras can't be profiled, but based on variations in the hundreds of cameras that I've tested, I respectfully disagree (see "Profiles in Cameras").

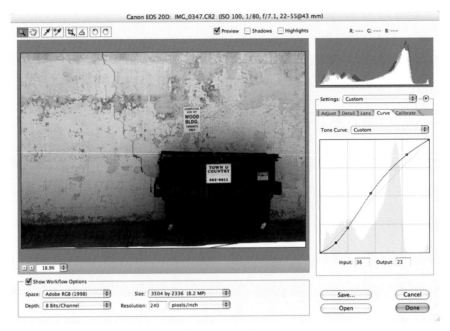

You can also enter specific numeric values in Input and Output boxes. Don't know what values to enter? As you move the mouse over the curve, the pointer becomes a crosshairs that when placed over different areas of the curve change the values shown on the Input and Output boxes. ©2004 Joe Farace.

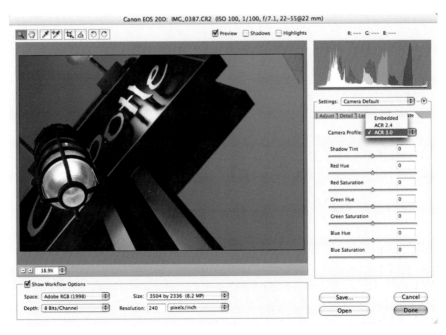

Even after adjusting highlight white balance with the Temperature and Tint sliders, there still might be a color cast in the shadows. The Calibrate tab's Shadow Tint sliders change the color in the shadows but the colors it adjusts depends on your camera's sensor and white balance. Moving the slider to the left (negative) adds green, and moving the slider to the right (positive values) adds magenta.

The Calibrate tab also has Hue and Saturation sliders to adjust Photoshop Camera Raw plug-in's built-in camera profile to render *other than* neutral colors differently. Adjust hue first and then adjust its saturation. Moving a Hue slider to the left is like a counterclockwise move on the color wheel and moving the slider to the right is similar to a clockwise color wheel move. Moving the Saturation slider to the left *desaturates* the color and moving the slider to the right (positive value) increases the saturation. Watch the preview image as you make the adjustments until the image looks correct.

Profiles in Cameras

Integrated Color (www.integrated-color.com) offers two profiling packages including commercial versions that include a batch reference file made from a group of targets, and Coloreyes 20/20 that uses a custom reference file for its target. The Commercial version is aimed at the average photographer but large format photographers who want critical color or Fine art reproduction will find that 20/20 is more accurate.

I used the Commercial version to create a profile for my Canon EOS 10D. If you can read and follow instructions and use only *one* light source—an Elinchrom monolight in my case—you can light the target and make an even exposure of the target. Lighting setup may take some time, but after you've got the shot, the software will cook up a profile quicker than your Starbucks *barista* can whip up a latte. The software calculates the difference between what the camera saw and what the reference file says the color is supposed to be. The profile is based on using a custom color balance, so Integrated Color includes a Digital Gel Card that lets you shoot the card, color balance the camera, and apply the profile with complete consistency between shots and even under different lighting conditions. The chart includes six other smaller patches that you can use to warm up or cool off your image when applying your profiles.

Every digital camera is unique. So why not create a camera profile for your specific camera? In additional to gray, the Digital Gel Card in the Coloreyes 20/20 package includes six color patches that you can use to warm up or cool off your image, when applying your profiles.

CONVERTING TO BLACK AND WHITE

Many digital SLRs have the ability to directly capture digital images as mono-chrome files, but because there is image processing involved in producing the

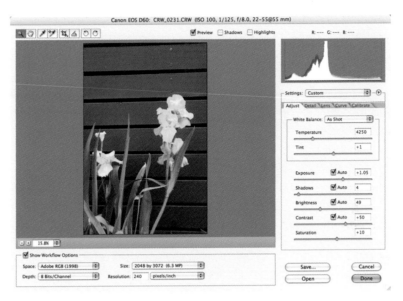

RAW files are unmanipulated and so when Camera Raw shows one of them to you for the first time it's in color, like this image made with a Canon EOS D60. © 2005 Joe Farace.

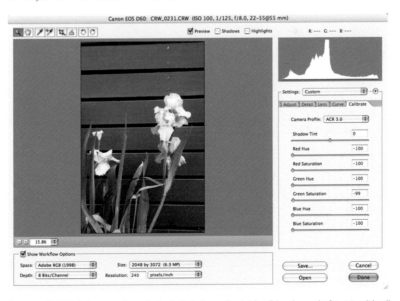

Turning a color RAW file into monochrome is simple: Go to Camera Raw's Adjust Tab and move the Saturation slider all the way to the left. Bingo, here's a black and white RAW file. Is this the best way to make a monochrome image from a color file? *Note*: See Chapter 10 for more than you ever wanted to know about creating monochrome digital images after the file has been converted into a file format other than RAW. © 2005 Joe Farace.

monochrome it is captured as a Joint Photographic Experts Group (JPEG) file. Some SLRs, such as Canon's EOS 30D, offer the ability to capture RAW and JPEG files at the same time, so one of my favorite techniques is to shoot RAW (color) images along with a large JPEG (monochrome) file at the same time.

TRANSFERS: GATEWAY TO PHOTOSHOP

Bridge provides many ways to bring single or multiple image files into Photoshop for final preparation and editing of the photograph. You can start by creating a Photoshop Action to open RAW image files and saving the files in formats like Tagged Image File Format (TIFF), PSD, JPEG, Large Document Format (PSB), and PDF.

Before you can save documents in PSB format, the "Enable Large Document Format (.psb)" option must be enabled in the File Handling section of Preferences.

One of the most useful and fun features of Adobe Photoshop is called Actions. (You'll learn more about Photoshop Actions in Chapter 9.) The Actions palette lets users record a sequence of image-editing steps as an "Action" that can be saved, then applied again at a future time. This Action can be applied to a selection in an image, another image file, or—in a batch operation—to hundreds of different image files. For example, you can create an Action that lets you acquire batches of images from a digital camera, allowing an entire set of photographs to be automatically imported, retouched, and saved. The order in which tasks are executed can be edited by dragging-and-dropping.

Actions can be saved and shared with others and are completely cross-platform. If you create an Action on your Mac OS computer, anyone using the Windows version of Photoshop can load and apply your original Mac OS Action. If you create an Action on your Mac OS, anyone using the Windows version of Photoshop can load and apply your original Mac OS action to *their* images.

To create an Action to open RAW files:

Step 1: Click the New Action button in the Actions palette or choose New Action from the palette menu. Enter a name for the action in the dialog box that appears.

Step 2: Click the Record icon. Open a RAW image file, and perform whatever operations you want to be a part of this Action. If you record the Action with a preset Image Settings, all of those settings (from the XMP sidecar file) will be used when playing back the Action. If you plan to use the action with the Batch command (more later), you may want to include a Save As operation and choose the file format to which you would like to save the image.

Step 3: Click the Stop button. The action you've created can be used every time you want to open one or more RAW image files.

BAKING A BATCH OF CHOCALATE CHIP ACTIONS

In Photoshop CS2, you can also use the Batch command or Create Droplet command to open one or more RAW files.

Step 1: Choose File > Automate > Batch from within *Photoshop*.

Step 2: In the Play area of the Batch dialog box, choose the Action you created to open your RAW image files from the Actions menu.

Step 3: After choosing Folder from the Source menu, click Choose. In the Choose a Batch Folder dialog box, choose a folder of RAW files.

Step 4: Select Override Action "Open" Commands so the Open commands in the action refer to the batched files rather than the filenames specified in the action. Deselect Override Action "Open" Commands only if the action is to operate on open files or if the action contains Open commands for specific files that are required by the action.

Step 5: Select Include All Subfolders to process files in subfolders.

Step 6: Select Suppress File Open Options Dialogs. This prevents the Camera Raw dialog box from opening for each Camera Raw image file being processed.

Step 7: Select Suppress Color Profile Warnings to turn off the display of color policy messages.

Step 8: Choose a destination for the opened files from the Destination menu. It's best to choose either "None" to leave the files open, or Folder to save the opened files to a specific folder preventing accidentally overwriting any files.

Step 9: Click OK.

Opening the Software Toolbox

What's in your toolbox?

Shopping for digital imaging software can be confusing. There are under-$30 programs that claim, "We're as good as Photoshop!" Even Adobe Systems got into the act with their Windows-only $29 Photoshop Album, but at least they don't claim it's as good as their flagship product, although many digital imagers are quite happy with the $99 Photoshop Elements. Confused yet? Do you need the "real thing," or one of the clones?

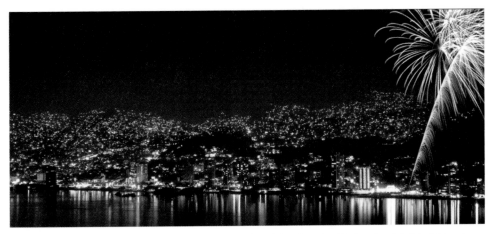

This digital photograph of Acapulco Harbor was made at night during the Winter Solstice fireworks celebration using a Leica D-Lux2. It is made up of *three* separate image files that were combined using Adobe Photoshop CS2, but I could have used any image-enhancement program that lets me use Layers to make this seamless montage. Layers, as you will discover later, can be an extremely useful tool. © 2005 Joe Farace.

SEND IN THE CLONES

There are many different products to choose from and many alternatives ranging from low-priced, entry-level image enhancement software to professional level packages. There is even *freeware* image editing software—no kidding. Sorting out which one is right for you is a matter of analyzing your needs. Start by making your own checklist.

For digital imaging newbies, Adobe Photoshop Album has a great $29 starter set of tools. It has everything the casual photographer needs, in one easy-to-use product. You can share your photos with family and friends, fix flaws in seconds, and view all your photos in one convenient place. © 2005 Joe Farace.

How are you going to use the software? The first thing you need to do is define your digital imaging objectives. Your long-term goals may be different, and when it comes to software, by the time you've enough experience to make use of all of the features in a program that can handle these lofty aims, several generations of software will have passed, and perhaps even new, superior products introduced. Focus on your short-term goals. Do you want to create images for the Web? Family snapshots that can be shared on sites like SmugMug (www.smugmug.com)? Does your interest lie in printing fine art images to sell at

art shows and galleries? Perhaps you need to provide professional clients with press-ready images? Make a list of your goals. If you're not familiar with the equivalent digital terms, express them in traditional photographic language.

WHAT KIND OF COMPUTER?

While programs like Adobe Photoshop run on Mac OS, Windows and UNIX systems, other equally capable software, such as Corel's (www.corel.com) PaintShop Pro, is only available for Windows, and Binuscan's (www.binuscan.com) PhotoRetouch Pro is designed specifically for the Mac OS.

While making your checklist, be sure to include the relevant specifications of your computer system. Most software boxes have "System Requirements" printed on the outside, telling what hardware is needed to run the program. Consider these recommendations to be *minimum* requirements. Some software companies list both "Minimum" and "Recommended" system requirements. Take these recommendations seriously. Often a minimum system will encounter problems working with larger image files, so be prepared to make a few upgrades to your system—or even replace your computer—when you've narrowed your search down to the "perfect" program. Usually, however, all you may to do is make

One of Ulead (www.ulead.com) PhotoImpact's most interesting innovations is that it offers two workspaces: Basic Photo Mode uses a condensed tool set for everyday photo-editing, while Advanced users can choose from Standard, Photo, Graphics, or Web modes.
© 2005 Joe Farace.

One of Ulead (www.ulead.com) PhotoImpact's most interesting innovations is that it offers two workspaces: Basic Photo Mode uses a condensed tool set for everyday photo-editing, while Advanced users can choose from Standard, Photo, Graphics, or Web modes. © 2005 Joe Farace.

a few minor upgrades, such as adding memory or a larger hard drive. With prices for both of these items at commodity levels, the cost of such upgrades shouldn't create overdrafts in your checking account.

HOW MUCH DOES IT COST?

The price of the product can be a good indication of its capabilities. Don't buy more program than you can really afford, unless you are 100% sure it's the only program for you. You can save some money by purchasing software from a mail order dealer because the company that produced the software, not the retailer who sells it, will provide post-sales support. Look for bargains too. Shop at used computer stores who also sell software. You can often purchase older versions of pro level programs at pennies on the original cost, and even if it doesn't have all of the newest version's capabilities, it may have all of the features you originally put on your list. Look for deals on upgrades or *sidegrades* from competing software. If you already own a digital imaging program, sometimes a company offers lower prices on a new version of their software to lure you away from what you're currently using. A wise shopper can save money using any and all of these practices.

More and more companies provide a "tryout" or demo version of their software that you can use to see if you like it. Demo software typically has a few features turned off, usually the ability to Save or Print or Save and Print, but you can open files and play with images. Demo software can be time limited or access limited.

You may use the program for 30 or 45 days before it automatically uninstalls or you can use the program for a limited number of times before it deactivates. Books about digital imaging often include CDs with demo software; and check out the software company's website. If there are demos available, download them and give'em a try.

Freeware and Shareware

Some programs are available in demo or trial versions that can be downloaded from the Internet and work for a limited number of days. Shareware is a variation of the "demo" concept and allows you to download the program and, if you find it useful, can send the almost always modest fee to the programmer. The difference between it and a demo program is that it is fully functional, but may be limited by a time period or how many times you can use the product. Shareware is based on two ideas: The talented people who create these utilities and applications believe users should be able to try their programs before they pay for them. The second part is an honor system that trusts users to pay for any program they use regularly. If you keep any shareware programs on your hard disk, remember to send in your shareware payment. Only your support, in the form of a check, will make sure these authors improve their programs and create new ones. Freeware is shareware without a price tag and is available from companies that produce commercial software, as well as individuals who produce useful imaging utilities.

IMAGE FILE FORMATS HANDLED?

Almost all image-editing programs handle all of the popular image file formats, such as TIFF (Tagged Image File Format), BMP (Windows Bitmap), JPEG (Joint Photographic Experts Group), or Kodak's not-so-popular Photo CD. This is less a problem than it used to be, but you should take the time to make sure that the program supports formats you work with. Look for this information on the outside of the software box or visit the company's website to find out what formats the program accepts. The more formats a program supports—both import and export—the more capabilities it has to serve as an image file converter. This feature will be especially important when moving image files back and forth between Mac OS and Windows computers.

Whatever Happened to Flashpix?

In 1995, Kodak, Microsoft, Hewlett-Packard, and Live Picture designed a new image file format called FlashPix. FPX is a multi-resolution format where the photograph is stored as a series of independent arrays, each representing the image at different resolutions. The only problem was that FlashPix *died* leaving many of us holding discs of images in FPX format that couldn't be opened. Being too lazy to rescan my negatives, I looked for an easier solution and found a free one! IrfanView (www.irfanview.com) is a fast and innovative *freeware* graphic viewer for Microsoft Windows that not only lets me view my FlashPix files but can batch convert them into other formats including TIFF. Some programs, such as ACDSee 7 let you view FlashPix files and will convert them, but only extract the low-resolution array. IrfanView gives you the original FlashPix scan's full resolution.

IrfanView is a *freeware* graphic viewer for Microsoft Windows that not only lets me view my old and obsolete FlashPix files but can batch convert them to other image file formats as well. © 1996 Joe Farace.

DOES IT ACCEPT PHOTOSHOP-COMPATIBLE PLUG-INS?

One of the best features of many digital imaging programs is they are designed with an open architecture allowing them to accommodate small software modules called "plug-ins," to extend the host program's features. Plug-ins are stored in a specific folder or directory on your hard disk that your image-editing program checks each time the software loads. That's why, when you launch a program like Adobe Photoshop, you see the names of the plug-ins briefly displayed on its "welcome screen."

Adobe Systems created the most popular plug-in standard for Photoshop. Compatible plug-ins can be used with many other programs, including Ulead Systems' PhotoImpact, Corel's Painter and PhotoPaint, and MicroFrontier's Color-It!, Enhance, and Digital Darkroom. Even freeware image-editing programs, such as NIH Image support Photoshop-compatible plug-ins. The judicious choice and use of plug-ins lets you increase the functionality of many off-the-shelf image-editing programs, allowing you to customize them to fit your specific kind of projects. Demo versions of many plug-ins are available for download from the companies' websites, so be sure to test drive any plug-ins that appeal to you. Be

sure to read my Digital Innovations column each month in *Shutterbug* magazine, where a "Plug-in of the Month" is named each month.

There are eight classes of plug-ins, but only *four* really impact the average user: Import, Format, Filter, and Export. Import plug-ins open image files. Some programs call them "Acquire" but they accomplish the same thing, allowing you to interface scanners, frame grabbers, digital cameras, even other image file formats. Format plug-ins provide support for reading and writing additional image formats your digital imaging program may not support. These appear in the pop-up menu in the Open, Save As, and Save dialog boxes. Filters modify selected areas of an existing image. Special effect plug-ins appear in the program's Filter menu, which is why these plug-ins are often called "filters." Export plug-ins can output an image to printers lacking driver support or save images in compressed file formats for use of the Internet. Since some export plug-ins relate to color separations, they usually appear in the graphics program's Export menu. There's more on using plug-ins, or as I call them "power tools," later in Chapter 9.

PictoColor's (www.pictocolor.com) iCorrect EditLab Pro 5.0 is available as both a Photoshop-compatible plug-in and a standalone application, eliminating the frustration often associated with color-correcting photographs. Its SmartColor Wizard uses four toolsets. As you progress through from left to right, the tools will *not*, and *cannot* affect any tools applied on the left. This step-by-step process alleviates the frustration of correcting one part of the image while throwing off another. After one pass through the tools, you're finished. © 2005 Joe Farace.

USING DIGITAL IMAGING SOFTWARE

Often overlooked in the rush to get new software is what to do after you've installed it. In order to get the most from your digital imaging software, you have

to spend some time learning how to use it. The secret? When my friend Vern asked how I learned so much about Photoshop, here's what I said:

A guy goes up to a street person in New York City and asks him how to get to Carnegie Hall. Instead of a flood of expletives, the person tells him "Practice, man, practice." That's what I did with Photoshop: I spent 1 hour a day just playing with the software. My goal was to have *no goal* and to experiment with every one of the program's features using my own images, but not caring if I produced anything usable—only seeking experience. "The journey," as Steve Jobs once noted, "is the reward." After 18 months of practice I learned a heck of a lot about Photoshop. You should practice with your image-editing program of choice too. You don't have to spend 5 to 7 hours a week pulling menus and applying filters, but you should take the time to learn about creating digital images that are fun to make and fun to look at.

Taking all of the time to specify what your digital imaging goals are means that your chance of finding the perfect image-editing program is a goal that can realistically be reached. Spending time learning how to use all of the program's capabilities means you will be able to extract the maximum value out of your investment, but don't be afraid to periodically evaluate your objectives and look for another, more capable program as your skills increase.

Adobe Photoshop is at once apparently simple and complex to use. The tools are there but after you open and image, waddaya do? Hang in there, partner, that's what we're gonna do next. © 2004 Joe Farace.

A PEEK INSIDE THE TOOLBOXES

Like a real toolbox, digital imaging software usually contains tools for creating and editing images. The first time you start the application, a toolbox appears somewhere on the screen. Some programs let you move the toolbox by dragging

it or even hiding it. Some tools in the toolbox let you type, select, paint, draw, sample, edit, move, annotate, and view images. Other tools in the toolbox allow you to change foreground and background colors or work in different modes. Many times you can expand some tools to show *hidden* tools by clicking on a small triangle, or something similar that indicates the presence of hidden tools. These tools often appear as a "flyout" menu that, like the name implies, flies out to reveal other tool choices. You can also often find information about any tool by positioning the mouse pointer over it.

Some of the most important and yet easy-to-overlook tools are the *selection* tools. While special effects filters may be more sexy to discuss first, most digital imaging programs almost always require that all or part of an image needs to be isolated, or *selected*, before an effect can be applied. The Standard or Rectangular Marquee tool is used to make a rectangular selection. This simple but useful tool is sometimes called the marquee tool because of the dashed lines that it makes around a selection (looking like the flashing lights around an old movie marquee). Let's use the Standard (Rectangular) Marquee to combine two images into one better one.

Photographing outdoor holiday lights can be a challenge, because some parts of the image are always going to be brighter than others. In just a few steps we'll use the Standard (Rectangular) Marquee to combine the best parts of two images to make an even better one where the sum of the parts will really be better than the whole.

Toolboxes almost always look something like this one used by Ulead's PhotoImpact, a Windows-only image-enhancement program. Here you see the flyout window for the Selection tool showing the Standard (rectangular) Selection Tool, because that's the first topic we're gonna discuss and demonstrate.

Sometimes the Selection or Select tool is in a menu, as it is in ACDSee Pro (www.acdsystems.com), and is available as a rectangular selection tool as compared to *irregular* selection tools that will be coming up later. ©2005 Joe Farace.

Step 1: Open the first image files.

This image of Brighton Colorado's City hall was captured with a Canon EOS 1D Mark II at ISO 200 with an exposure of 8 seconds @ f/13 at an ISO of 200. © 2005 Joe Farace.

Step 2: Open the second image files.

This image of Brighton City hall was made at 2.5 seconds because the tree and city hall sign were too overexposed in the first exposure. © 2005 Joe Farace.

Using Photoshop's rectangular Selection tool, I selected an area covering the space from right of the trees to the flag pole then copied the selection onto the Clipboard.

Step 3: Using the Standard (Rectangular) Marque I selected an area that covers everything from right of the large tree on the flagpole. Then I used the Copy command to copy the selection to the Clipboard.

Using Photoshop's Paste command, I placed the copied section on top of the first image in an new layer. Next I used the Eraser tool to blend the top and bottom layers.

Step 4: I then used the Paste command to place the new section on *top* of the first image file. This creates a new Layer; but don't freak out yet, there will be lots more on Layers in the following chapter. Because it is a Layer, you can use the Eraser tool to erase the edge where the two images overlap, combining the best of both images into a single believable one. The only other tweaking of the image was a little burning and dodging as you might do in a traditional darkroom. © 2005 Joe Farace.

Other Selection Tools

The Lasso Tool is another selection tool that is useful for drawing *freeform* segments of a selection. Adobe Photoshop also offers Polygonal Lasso and Magnetic Lasso tools that let you switch between drawing freehand and straight-edged segments. The Magnetic Lasso tool is especially suited for making freeform selections because it traces the edges of an object and consequently works best on areas with clearly defined edges. The Polygonal Lasso tool is useful for drawing straight-edged segments of a selection border.

This toolbox in Adobe Photoshop CS2 shows the Lasso tool options that are available, but the Lasso has been accessible in Photoshop and other imaging programs since its earliest version. You don't have to use the latest version of any software program, as you will see in the next segment.

PAINTING TOOLS?

Painting tools such as the brush and the eraser may not be considered "photographic" tools in the strictest sense of the word, but they are useful for both their stated purposes and for working with selections; and as we'll see in the next chapter, with layers.

The Brush tool, a.k.a. Paint Brush tool in Adobe Photoshop, and the Pencil tool work like traditional drawing tools by applying color with brush strokes. Brush strokes are softer. In most image-editing programs you double-click the Brush Color swatch to open a Color Picker to select a color, but my favorite method is to select the Eyedropper tool and click in the preview image to a choose a specific color. Drag in the image to paint. The options bar for the Brush tool contains many other options. You can customize the brush by entering values for the size (diameter) and hardness. Specifying Opacity determines to how much of the

image, under the brush stroke, remains visible. In selection mode, after you create a rectangular selection with the Marquee tool, you can enter Quick Mask mode in Photoshop and use the Brush (press B: Mac OS or Win) tool to expand or decrease the selection.

The Air Brush tool is a good choice when even the soft edges of a Brush tool aren't soft enough. For some programs the Air Brush is a separate tool, in others it is an option available in the Brush palette. It applies gradual tones to an image, simulating traditional airbrush techniques.

The Eraser tool is one of my favorites and has many uses. While on the surface it may seem like a simple tool—it erases what it touches—there's more to it than that. In practice, the Eraser tool changes pixels in the image as you drag through them. If you're working in the background or in a layer with transparency locked, the pixels change to the background color; otherwise, pixels are erased to *transparency*. A variation, called Magic Eraser, is available in Adobe Photoshop CS2 that automatically changes *similar* pixels. If you're working in the background the pixels change to the background color; otherwise, the pixels are erased to transparency. You can choose to erase contiguous pixels only or all similar pixels on the current layer or image file.

THE MAGIC WAND

So I ask my friend Bob, "What version of Photoshop do you use?" and he says "two." "Ya mean CS2," I reply. "Nope," he says, "I use Photoshop 2.01!" So as you can see there's different digital imaging strokes available for different folks, as you will see in this explanation of how the Magic wand tool worked in Photoshop 5.5, and continues to work today in many different imaging applications.

The Magic Wand tool lets you select a consistently colored area (e.g. a blue flower) without having to trace its outline using the Lasso tool. You specify a color range, or *tolerance*, in color tones for selection.

Step 1: Using Adobe Photoshop and the Photo CD Acquire Module, I opened an image of a vintage streetcar.

This Photo CD image of the front of an old streetcar was originally photographed on color negative film and digitized with Kodak's Photo CD process. The Magic Wand tool was used to select the yellow background area. Photo © 2000 Joe Farace.

Step 2: You can use any selection tool to select the part of the photograph you want to alter. In this case I used the Magic Wand tool to select part of the vintage streetcar. While the Magic Wand is usually a pretty good selection tool, it works

best when the area selected is more homogenous than this one. You will notice that some smaller, light areas were not selected, nor was the shadowed area in the lower right-hand corner. Not to worry. That's why Quick Mask mode, a powerful but little understood Photoshop selection tool, was used.

The Magic Wand, with Tolerance set at 32, was used to select as much of the yellow area as possible. © 2000 Joe Farace.

Step 3: Click on the Quick Mask button (or press the Q key) that is located just below the foreground and background color boxes near the bottom of

After clicking the Quick mask button, the unprotected (and not selected) area of your image is covered in a mask-like overlay. © 2000 Joe Farace.

Photoshop's tool palette. When you do that are not selected will be covered with a color overlay which covers the *unprotected* area.

Step 4: Now we get to the real power of masking. This mask area can be expanded by using any of the painting tools or contracted by using the Eraser. When you create a Quick Mask, Photoshop creates a temporary channel in the Channels Palette to indicate that you're working in Quick Mask mode, but the joy of Quick Masking is that you do all editing in the standard working window. To edit this mask, I chose the Eraser (press E) tool and used it to remove portions of the mask I wanted uncovered. I started with the shadow area in the lower right-hand corner, and then used the eraser to remove small bits of mask that covered the front of the streetcar. For the really small parts, I increased magnification with the Zoom (Magnifying Glass) tool, so I could get into all of the nooks and crannies.

Using the Eraser tool, I removed portions of the image file that I wanted exposed. © 2000 Joe Farace.

Step 5: When the mask covers just the areas that I wanted, I clicked the Standard Mode button (next to the Quick Mask button) to turn off the Quick Mask. When you do that the unprotected area of the Quick Mask is now surrounded by the standard selection marquee—a.k.a. "marching ants."

Step 6: At this point, you can apply any changes that you want to the selected area. Using the Selective Color dialog box (found under Image/Adjust/Selective Color) I tweaked the primary yellow color to produce a golden yellow that's similar to what was used by the streetcars of the Baltimore Transit Company in their heyday.

After cleaning up the mask, the author clicked the Standard Mode button converting the mask into a selection. © 2000 Joe Farace.

Using the Selective Color (Image > Adjustments > Selective Color) command the author manipulated the original color of the streetcar.

Step 7: When the colors are how I wanted them, I clicked OK to finish the Quick Masking and color adjustment process. While only subtle changes were made using this technique, an effect—or plug-in—could be applied to any Quick Masked area.

The final image created with Quick Mask has a bolder yellow color suited to the author's vision for the photograph. © 2000 Joe Farace.

Understanding Layers

Sirius Black was, and remains to this day … Harry Potter's godfather.

When working with most image-editing programs, digital images can be composed of several parts. The base of an image file is its *background*, which you can think of as the paper used in a conventional wet darkroom. Layers are like additional emulsions on top the surface of that paper that allow you to create effects without interfering with what is on the other coatings.

This little Harry Potter wannabe looks like a "straight" shot, but was created using multiple layers that appear to produce no visible effect, unless you compared it to the original. In this case, the layered manipulated image looks natural, which is just what I wanted to accomplish. Image was originally captured with a Canon EOS 1D Mark II and EF 75–300 zoom lens. Exposure was 1/100 second at F/5 with an ISO of 320. © 2005 Joe Farace.

LAYERS OF CREATIVITY

One of the easiest ways to understand a digital enhancement program's layers function is to imagine a photograph that has sheets of clear acetate stacked on top one another. Any kind of image—text, graphics, or even another photograph—can be placed on a layer. Where there is *no* image on a layer, you can see through it to the layers below the clear areas. You can change the composition of an image by changing the order and attributes of layers. At the bottom of the stack of layers is the background. The number of additional layers and effects you can add to an image is only limited by your computer's memory.

The advantage of using a program's layers function is that you can manipulate *part* of the completed image without affecting any of the other parts. This can be as simple as adjusting color or can include manipulation. Adobe Photoshop offers an additional type of layer called an adjustment layer that allows you to apply tonal and color corrections to all of the layers underneath it. This let you try different combinations of how layers react with one another and when you achieve the desired result on-screen, you can merge the adjusted layers.

THE LAYERS PALETTE

A program's Layers palette shows and lists all layers, groups, and layer effects for an image file. You can use the Layers palette to show and hide layers, create new layers, and work with groups of layers. You can also access commands and options in the Layers palette menu. It features a visible display of all of the layers in an image starting from the topmost to the background.

The Layers palette is used to create, hide, display, copy, merge, and delete layers from a document. In Photoshop, you can create new layers by using the New Layer button that is at the bottom of the Layers palette or simply by dragging and pasting a selection into your image. You can also copy layers between two open images. Layers can be added by using the New Layer button at the bottom of the palette or the New Layer command, which can be found by clicking on the black triangle in the upper-right-hand corner of the palette.

Here is the Layers palette shown for a two-layer photograph. This is the top layer and is called "Layer 1" but most image-editing programs will let you change the name, which can be helpful if you have more than two or three layers. © 2004 Joe Farace.

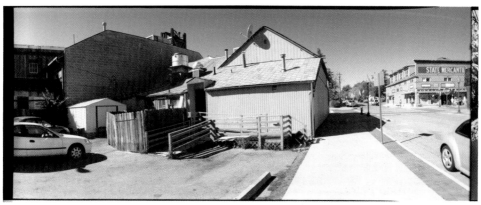

This is the background layer, which was shot in Louisville Colorado using a Horizon 202 panoramic (film) camera.

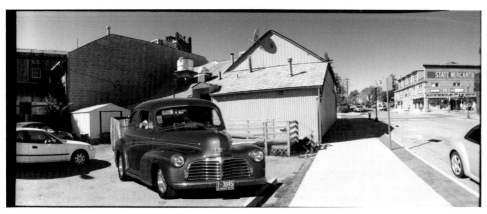

The car was shot in Colorado Springs using a Canon EOS digital SLR but was combined with the background layer to make it appear as if it were in Louisville. Note the shadows are going in the same direction. That's a key component when combining images. © 2005 Joe Farace.

ADJUSTMENT LAYERS

Photoshop's Adjustment Layers lets users perform color adjustments without affecting the original image's data. This allows you to experiment with different adjustments, such as hue and saturation, brightness and contrast, and overall color balance, and gives you the option to undo or refine any of these adjustments later. The following image commands can be applied with an adjustment layer: Levels, Curves, Color Balance, Brightness/Contrast, Hue/Saturation, Selective Color, Invert, Threshold, and Posterize.

Adjustment Layers can be powerful tools because they let you experiment with color or tonal adjustments to an image without permanently modifying that image. All of your changes or adjustments are made to the layer that acts as an overlay through which the underlying image appears. Creating an Adjustment Layer for Levels as an example, is as simple as going to Photoshop's Layers menu and choosing New Adjustment Layer > Levels.

An adjustment layer does not make permanent changes to the underlying image pixels and can be modified any number of times without degrading image quality. Adjustment Layers can be hidden or discarded at any time, or moved up and down in the Layers palette. They can also be applied with the same opacity and blending mode controls for image layers.

The Input sliders are under the curve and there are three controls: Shadows (the black triangle), Midtones (the gray triangle), and Highlights (the white triangle). To add sparkle to the highlights—and increase overall contrast—move the Highlights slider to the left. When you do, the Midtone slider comes along for the ride. To darken shadows, move the Shadow slider control to the right. To tweak the overall photograph, use the Midtones slider.

The New Adjustment Layer is also found in Photoshop's Layers pop-up menu, but when you select Levels, you get a dialog box that looks like the same dialog box that we have all come to know and love (if you haven't, you will). It allows you to adjust the brightness and contrast of an image using Layers, and since only the *layer* is affected—the original image is untouched.

SIMPLE USE OF LAYERS

Layers can be used for many simple projects that dramatically improve an image's overall look. In Chapter 8, I'll show you how to create various soft-focus effects, and

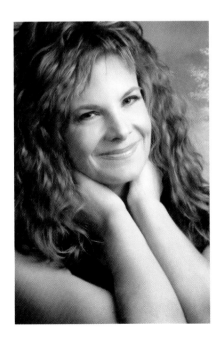

Mary is not a professional model but she has a sparkling personality that comes through when she's photographed. This portrait was softened by creating a Duplicate layer (Layer > Duplicate layer) then applying B+W's (www.schneideroptics.com) Soft Focus filter to that duplicate layer, then Fading it (Edit > Fade Soft Focus) to keep it from getting too soft. I used the Erase tool and erased the areas around her eyes allowing them to be sharp (on the background layer) while keeping the rest of the image in soft focus. © 2005 Joe Farace.

most of them can be done directly to an image file's background, but you might want to try a layer for even greater image control. Start the process by making sure your image file is as good as it can be, then add a duplicate layer (Layer > Duplicate Layer). Apply a filter to the duplicate layer, *not* the background image below. Then lower that layer's Opacity setting to let part of the bottom layer show through. For even more control you can erase part of the duplicate layer to let 100% of parts of the original file show through. Use the Eraser tool to erase the blur/soft focus (on the duplicate layer) around the subject's eyes to allow the sharpness of the background layer to show through. This is an especially good trick for portraits because the sharpness of the subject's eyes are critical to getting the viewer's attention, so this technique gives the *impression* of sharpness while maintaining overall soft focus.

TWO FACES OF JAPAN

My approach to travel photography is *interpretive* rather than realistic. One of the techniques I like to use for these interpretations is to tell a story by combining two or more images into a single photograph.

While traveling in Japan I was struck by how newer, more modern elements of Japanese society coexisted with traditional ones, sometimes in close proximity. This thought was in the back of my mind when I made a photograph out of my hotel window, but the final concept for *"Two Faces of Japan"* didn't occur to me until few days later when I made another photograph and saw how the two might blend together. The concept was to use Adobe Photoshop CS2 along with a few digital manipulation techniques to combine both image files into a *single* photograph.

As with most of my other digital imaging projects, I apply the "20-minute" rule. It's my opinion that if you can't make what you see on the monitor look like what you originally conceived it in your mind's eye *within 20 minutes*, chances are you never will; but like any creative activity, you gotta go with the flow:

Step 1: This first picture was made from my hotel window either before I went to bed or after I got up; I was too jet-lagged to remember, and the camera's Exchangeable Image File (EXIF) data is set for my home in Colorado. The lens was pressed flat against the window to minimize reflections inside the room, where I had already turned off all the lights. I made a total of three shots and liked this one best on the basis of sharpness, composition, and exposure. © 2004 Joe Farace.

The next night I had dinner with friends at a traditional restaurant on the outskirts of Tokyo. As we came out, the area behind the restaurant was dark but illuminated with torches. I used the same EOS Digital Rebel and 18—55 m EF-S lens set at 18 mm to make a series of exposures of the scene in front of me. Both of the images used in this montage were made in low light conditions at ISO 1600.

For the first image, I used a Canon EOS Digital Rebel with an 18–55-mm EF-S lens that was set at 18 mm. A high ISO at 1600 gave me a shutter speed (1/30 second) that I could hand hold. This particular image was captured in Program mode and I made a few test shots ending up with an aperture of f/3.5 to get what I saw out the window.

This second photograph was shot ISO at 1600 and produced a shutter speed (0.3 seconds) that I couldn't really hand hold, but the camera was steadied on a wooden post. Aperture was f/3.5. I made several images and bracketed exposures; this was the best one, but the image is not critically sharp. © 2004 Joe Farace.

Step 2: The first thing I needed to do was bring both images into a similar tone. One was cool and the other was warm, so I decided that making the sunrise image warmer while cooling off the firelight would work best for my concept. One of the easiest methods for accomplishing this kind of color correction is using a Photoshop-compatible plug-in such as PhotoTune's (www.phototune. com) 20/20 Color MD.

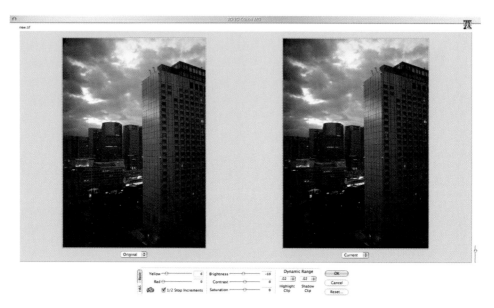

After launching 20/20 Color MD (Filter > PhotoTune > 20/20 Color MD) you're presented with a series of *pairs* of images and asked to click the one you like best. After nine mouse clicks, you're finished color correcting the file. © 2004 Joe Farace.

After I cooled off the color using 20/20 Color MD, I liked the traditional image's density, but wished it were a littler sharper. Since I planned to use this image *horizontally* across the bottom of what would a *vertical* photograph, I knew having it reduced in size would give the impression of greater sharpness, but I wanted to make it look as sharp as possible.

PhotoKit Capture Sharpener Expert by PixelGenius

Please Select a Sharpener Set and Effect:

OK

Cancel

Sharpener Set: Digital Mid-Res de-JPEG...

Help

Sharpener Effect: Medium Edge Sharpen

Info

One of the best image sharpening solutions I've found is PhotoKit Sharpener, a set of Photoshop-compatible plug-ins that sharpen images based on the way the images are captured—film or digital. The plug-in's deceptively simple menu lets you choose how the image was captured and select the kind of sharpening effect you want; PhotoKit Sharpener does the rest.

Step 3: Before I went any further I resized (Image > Image Size) my hotel room image to 300 dpi producing a file that measured 6.827 × 10.24 inches images. If you were printing on an ink-jet printer and wanted a larger image size, you could make it 240 dpi.

Because I wanted to add the horizontal image to the bottom of the photo—in the wooded area surrounding that particular hotel—I used the Canvas Size (Image > Canvas Size) command to provide additional white space at the bottom of the photograph where I could place the horizontal photograph.

With both photographs open, I dragged the traditional image onto the skyline photograph in the space I just created. When I dragged the file it created a *new* layer and automatically resized that file to match the resolution of the original file. This gave me a two-layer photograph: the architectural "new" image on the bottom layer and the traditional "fire light" image on the top layer. Using the Move (it looks like a *hand*) tool with "Show Transform Controls" (in the Options bar) checked, I dragged the photo to resize it, filling up the *width* of the canvas.

Step 4: To make the two images blend, I used Photoshop's Burn tool to darken the bottom of the hotel room image, then moved the second image layer up and down to see where it fit best. To make this process a little easier, I changed the second layer's Opacity setting to 50%, so I could see through it to the bottom layer.

While I used Adobe Photoshop CS2 to create this montage, any image enhancement program that supports layers and Photoshop-compatible plug-ins should work. I also used the Mac OS version of the products mentioned, but all of this software is also available for Microsoft Windows. Trial versions of the plug-ins are available for download, so why not give one or more of them a try for *your* next digital montage?

When it looked like a close fit, I used the Erase tool to erase parts of the top layer to make the two layers blend together seamlessly. © 2004 Joe Farace.

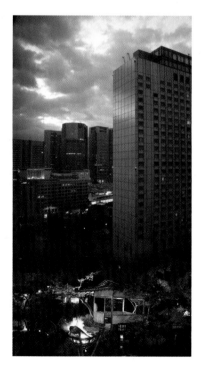

Then I reset the layer opacity back to 100% and flattened the images (Layer > Flatten Image) to produce a single layered photograph. © 2004 Joe Farace.

SPEED THRILLS

I love import drag racing and have been know to take my Volkswagen GTI 337 down the drag strip just for the fun of it. Living in Colorado we don't have much of a winter racing scene—except for the ice racers, of course—but that doesn't mean that even cars parked indoors at a car show can't look like they're racing. Let me show you how to do it in just four steps:

Step 1: This photograph of Mazda RX-7 drag racer was made at the International Auto Salon in Los Angeles using a Canon EOS D-60 digital SLR with 16 mm Sigma lens attached. Even while making it, I recognized several things that needed to be done with this image to make it better, but the most important was eliminating the cluttered background.

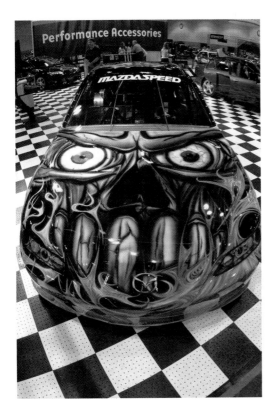

The exposure was 1/60 second at f/16 with an ISO setting of 800. Color balance was set on Auto and it did an acceptable job with the mixed lighting sources in the LA Convention Center.

Step 2: I think it's a good idea to make an image look as good as possible before starting any manipulations and in this case it meant improving the overall color. I opened the image file in Adobe Photoshop CS and applied PictoColor's (www. picto.com) iCorrect EditLab, one of the best power tools available for fine-tuning color.

PictoColor's iCorrect EditLab correction and color management software is available either as a Photoshop-compatible plug-in or stand-alone application and using it is as simple as 1-2-3-4, which is how the tabs in its interface are set up. Just waltz through the tabs, gradually improving how the image in the preview window looks as you go.

Since I shot the RX-7 at a relatively slow shutter speed, I decided to sharpen the image just a bit too. One of the best solutions—maybe *the* best—for image sharpening that I've found is PhotoKit Sharpener set of Photoshop-compatible plug-ins that sharpen based on the way that the image was captured and works great whether the original was film or digital.

The interface for PhotoKit Sharpener is simple: you select the kind of sharpening effect you want and how the image was captured from two pop-up menus and PhotoKit Sharpener does the rest.

Step 3: Now that I had the image of the RX-7 looking good, the next step was creating a Duplicate Layer (Layer > Duplicate Layer) that I labeled "Zoom."

All subsequent effects will be applied to the duplicate layer, leaving the original image (below) untouched.

Step 4: In the Layers window, click on the Zoom layer to select it. Then apply the Radial Blur filter (Filter > Blur > Radial Blur) while making sure the Zoom button in its dialog box is checked. Three qualities of blur are available and I choose "Best" because it gives more subtle shadings; but be aware that, depending on your computer's power, "Draft" and "Good" blurs are rendered much faster.

The amount of zoom is set in pixels and determines the length of the blurring. Use the preview windows to move the "Blur Center" point where the zoom will originate. I selected the area near the Mazda logo on the hood.

Step 5: Still working on the Zoom layer, use the Eraser tool to clear out areas allowing part of the car in the Background layer below to show through.

I began by using the Eraser at 100% opacity (selected for the Options bar) to outline the car, but then used lower opacity levels to erase portions of the inner car to make it look like it's in motion while it's really parked.

As a final tweak to the photograph, I created a Curves Adjustment Layer which allowed me to increase contrast in shadow and highlight areas and punch the image up a bit.

You can use this technique, along with other kinds of blurring techniques, such as Motion Blur (Filter > Blur > Motion Blur) for sports including track and field, horse racing, and even rodeo. The trick, if there is any, is determining how long the zoom or motion blur trail is and how much to erase and at what opacity. The best thing is that there is no right or wrong way to do this and there are *no rules* except to have fun!

While I used Adobe Photoshop CS to create this digital drag racer, any image enhancement program that supports layers and Photoshop-compatible plug-ins will work. I used the Mac OS version of the products mentioned, but all this software is also available for Microsoft Windows. Trial versions of the plug-ins are available for download, so why not give one or more of them a try for *your* next sports image?

MAKING COLLAGES AND MOSAICS

The terms "collage" and "mosaic" are often confused. A *collage* is an artistic composition of materials and objects pasted over a surface, often with unifying lines and color. On the other hand, a *mosaic* is a picture or decorative design that's made by setting small colored pieces, as of stones or tiles, into a surface. Here are some examples.

Salvage or junkyards are my favorite places to make photographs. This image was captured with a Canon EOS 1D Mark IIN with an exposure of 1/800 second at f/16 with an ISO of 800. © 2005 Joe Farace.

Using the junkyard photograph as a basic, Panos FX (www.panosfx.com) Mosaic Action was used, which is a one-click operation (information on what Photoshop Actions are and how they work will be found in Chapter 9). If this image proves anything, it's that complex images are not the best subjects for creating Mosaics. Maybe a collage might work? © 2005 Joe Farace.

This is not exactly a collage; it is more specifically a photographic mosaic since all of the pieces work together to form a single image. This was created with another Panos FX Action called Synthesis. You see, there are a few ways to create a true collage using an image-editing program, but this is one of the easiest. © 2005 Joe Farace.

CREATE COLLAGES

You can use general-purpose image-editing tools to produce a collage, but there are some special purpose tools including ArcSoft's (www.arcsoft.com) Collage Creator. It's a Microsoft Windows-based application that turns ordinary digital pictures and text into personalized works of art. The program includes everything one needs to turn regular digital photos and text into great-looking scrapbook pages suitable for printing, adding to a scrapbook, sharing with friends, or hanging on the wall. And because it's all done with your computer, each masterpiece can be printed over and over again.

ArcSoft's Collage Creator is a digital scrapbooking application that turns digital pictures and text into personalized art work. The program includes everything one needs to turn digital photos and text into great-looking scrapbook pages suitable for printing, sharing with friends or hanging on the wall.

Collage Creator lets you crop and assemble digital pictures any way you want and add creative photo edges and special effects with one click. You can also choose from over 300-clip graphics for all occasions.

Traditional and Non-Traditional Tools for Digital Methods

I love it when a plan comes together!

One of the most interesting promotional items created for my book "The Photographer's Digital Studio" was a cartoon drawn by the brilliant artist John Grimes which showed trays of developer, stop, fix, and wash, with floppy disks being dipped in and out of each one. The caption was "A common mistake in digital photography."

Years ago I labored many hours in a wet darkroom to produce a composite image showing what an historic statue would look like when moved to a different location. Digital imaging software would have let me do a better job in less than an hour and I wouldn't have to spend time working in the dark with smelly chemicals.

Part of the reason that some people even ask the question "why digital?" is that many believe digital imaging is somehow *different* from traditional photography. That's not really true. I think that there are no more differences between the two methodologies than you would find than when comparing photographers working with large format view cameras to someone grabbing snapshots with a point-and-shoot camera. Nowhere is this more evident than in the names and operations of some of the tools found in most digital imaging programs.

This photograph of a big horn sheep made at the Denver Zoo looks unmanipulated, but has been enhanced in Adobe Photoshop using the same kind of burning and dodging techniques I would have used in the traditional wet darkroom years ago. If you are not familiar with burning and dodging I'll show you how to apply these tools manually in this chapter and how to use power tools in the following chapter. This image was captured with Fuji's S3pro and an 80—200-mm Nikon lens. Exposure was 1/250 second at f/4.0 at an ISO of 400. © 2005 Joe Farace.

RETOUCHING TOOLS AND HOW TO USE THEM

Since photography began, portrait photographers have used various photograph techniques, from retouching negatives with pencils and dyes to applying artwork, and even airbrushing prints to improve on nature's little imperfections. Years ago, I did a portrait session that used a golf course as a background; the best image of the couple is one that had a foursome strolling by in the background. I paid an artist to airbrush the golfers out, but today I would have been able to use Photoshop's Clone Stamp a.k.a. Clone Paintbrush tool in Ulead's PhotoImpact to replace the foursome with some golf course grass using just a few digital brushstrokes.

The Clone/Rubber Stamp tool allows you to take a sample of part of an image, and then apply it over another image or part of the same image. When you use the Clone Stamp tool, you set a sampling point on the area you want to apply over another area. The Clone Stamp tool is useful for duplicating an object or removing a defect in an image. In Photoshop this is done by Option-Click (Mac OS) to define a source. On the Windows platform that keystroke combination is Alt-Click. Because you can use any brush with the Clone Stamp tool, you have a lot of control over the size of the area that can serve as a source. More importantly you can adjust (usually lower) the opacity and flow settings to apply the cloning with a softer touch that is especially important with photo retouching. Let me show you what I mean.

Kellie makes a beautiful bride but shooting in some lighting conditions will produce unattractive shadows under a subject's eyes, and there are a few tiny wrinkles that can be removed to produce an idealized bridal portrait. Here the Clone Stamp is set to sample an area at the top of her cheekbone. © 2004 Joe Farace.

You can think of it as digital makeup. I used the Clone Stamp with an Opacity setting (see the settings in the Options bar) of 16%, so what I stamp lightly covers the dark areas under her eyes and the tiny wrinkles but does not completely replace the skin tones that are already there. Now I move to the other eye. © 2004 Joe Farace.

Repairing old faded and damaged photographs used to be the province of the specialist artist. Now anyone with a little patience to learn a few new digital tools and tricks can use image-editing programs to fix old scratched photographs and make them look like new again. Best of all, the original print is left untouched by the process.

Since the other eye was slightly darker, I increased the Clone Stamp with an Opacity setting of 23% and used the same lightly dabbing brush strokes. If one click doesn't do it, try another but if you're re-clicking the mouse too much it might be time to raise the opacity or switch to the Healing Brush (more on that later). © 2004 Joe Farace.

Here's the final image. I used a smaller diameter brush to cover a few small imperfections along with some burning and dodging of the background to complete the final photograph of a young bride in the courtyard of a historic church in Brighton, Colorado. Image was captured with a Canon EOS 20D with an 85 mm f/1.8 lens at ISO 200. Exposure was 1/200 second at f/2.5. © 2004 Joe Farace.

THE BAND-AID TOOL

Lots of image-editing programs have a Clone or Rubber Stamp tool and most of them work the way I just showed you in the above example. Adobe Photoshop adds a tool called the Healing Brush, a.k.a. Band-Aid. Like the Clone/Rubber

Helen has a natural beauty but like all of us she's not perfect. (Cindy Crawford once said, "Even I don't look like Cindy Crawford when I get up in the morning.) To retouch the few freckles on Helen's face the Healing Brush is the prefect tool." © 2004 Joe Farace.

The Healing Brush could be considered an "intelligent" Clone tool because it matches what is under the brush stroke rather than just plopping the same pixels over top of it. But is it not perfect, and I find it works bets for dust spotting. Yes, dust can get into digital interchangeable lens SLRs, and the Healing Brush will cure it fast. If you apply the brush to a light area that's close to a dark edge you might not get results that you like; in that case, the Clone tool will be your best friend. © 2004 Joe Farace.

Here is the finished result of Helen with just some Clone and Healing Brush retouching. Oh, and a little burning of the tree trunk on the left. For those of you unfamiliar with this traditional darkroom technique, let me show you how it works next. © 2004 Joe Farace.

Stamp, the Healing Brush paints with sampled pixels from an image or pattern but also matches the texture, lighting, transparency, and shading of the sampled pixels to the pixels being "healed" so that the repaired pixels blend seamlessly into the rest of the image.

TRADITIONAL TOOLS FOR DIGITAL METHODS

Back during the Cretaceous era while studying photography at the Maryland Institute of Art, I was privileged to have Jack Wilgus as an instructor. One of my fondest memories of Jack was his facetious comment about how some of the best photographs were made by students in the break room. Not *real* photographs, mind you, but all of those comments from my erstwhile colleagues about the great photographs they were going to make—someday. While some of those images may have actually gotten made, I'll bet few of them actually produced the photographs that they talked about so excitedly with their friends, and Jack's comments resonate with me today.

Photographers, both amateur and professional, often get so wrapped up in what they have successfully been doing for so long that they forget to explore new directions of the kind that attracted them to the art form in the first place. We digital imagers, for example, can spend so much time being mesmerized by the pixels on our computer monitors that we often forget to make time to create

some *new* photographs, something that's *different* from the last batch of images that we captured. I think it's a good idea to not only take time to smell the roses, but photograph them as well.

BURN AND DODGE

You can use image-enhancement tools to produce traditional photographic techniques like "burning" and "dodging" to improve a photograph's appearance. For new photographers, or those not familiar with darkroom work, burning is a term for selectively darkening part of an image to hide a distracting element or bringing out something hidden by highlights. Dodging is the reverse process and selectively lightens part of an image. Photographers hold back light to lighten an area on the print (dodging) or increase the exposure to darken areas on a print (burning).

Burning and dodging are done using the Burn Tool that looks like a hand with a little opening in it. In the traditional, wet darkroom photographer often used their hands to make opening that would selectively *add* exposure to part of a print while it was being exposed under the enlarger while blocking the rest of it. The Dodge Tool looks like a little black lollipop on the Tool Bar. These were usually fashioned with a stick and a piece of black paper cut to a desired shape.

Whichever you choose, you begin by selecting the tool. Then you place your brush over the area of an image you want to darken/lighten, and click. As you move the tool around, the effect is applied to your image.

Here is the original photograph of an historic WWI airplane made in a museum. While the upper half of the image has the proper exposure, the bottom half is a bit washed out. The Burn tool was selected and was applied to the ground under the pane to darken the ground. © 2005 Joe Farace.

For the finished image, a much larger brush was used and applied gradually in soft strokes horizontally across the image frame with gradually repeated strokes of the Burn tool from light to heavy toward the bottom of the frame. As a finishing touch, contrast was increased to punch up the colors and density too. © 2005 Joe Farace.

Burn and Dodge Power Tools

There are a number of power tools (see Chapter 9 for more details) that extend Photoshop's capabilities and one of the most useful is called PhotoKit. Pixel Genius' (www.pixelgenius.com) PhotoKit is a photographer's toolkit that includes 141 effects offering digital versions of traditional analog photographic effects that range from automatic burning and dodging, to toning, to adding black edges to your images. A simple dialog calls up the PhotoKit tool sets, but there is no real plug-in interface, no sliders, and no preview window. PhotoKit is optimized for images between 8–18 MB and is useful on larger sizes, but some of the effects don't translate to small Web-sized files. You can download a fully operational Mac OS or Windows version and try it for 7 days.

PhotoKit by Pixel Genius LLC

Please Select a Set and Effect

PhotoKit Set: Burn Tone Set

PhotoKit Effect: Burn Bottom 1/2

OK Cancel Info

One of the advantages of using Pixel Genius' PhotoKit is that burning and dodging are applied as a separate layer so that you can change the Layer's Opacity (see the previous chapter for information on using Layers).

THE CROPPING TOOL

Photographers have been "cropping" images since the beginning of the media, so it's not surprising that there is a digital equivalent. In traditional photography, cropping is the act of changing the shape of the image by removing a part of the

While Crop tools vary in how they appear when applied, Adobe Photoshop's version of this useful tool creates a gray subdued area around the cropped area allowing you to have a preview of what will be *left* in the photograph, while still letting you see what's being left behind. © 2003 Mary Farace.

Not all photographs are perfect, but the Crop tool is the perfect tool to eliminate all of the extra information in this snapshot and focus on the most important subject—the cute child in his Halloween costume. © 2003 Mary Farace.

image on any or all edges of the photographic frame to focus attention on the real subject of your photograph and eliminate distractions. You can also use cropping tools to change the shape of the image from portrait (vertical) to landscape (horizontal) orientation.

Cropping Tip

You can always crop an image after you make it to produce the exact image you had in your mind, but when you do there is a price to be paid. You are tossing away pixels. This is what's wrong with the so-called "digital zoom" functions of many digital point-and-shoot cameras. Yeah, you get the image you want, but the resolution is much less. So take a tip from me: Crop in camera when you can. If you have a Zoom lens, use it to crop the image exactly the way you want before tripping the shutter. If you don't have a zoom lens, use your feet to move around to get the subject framed the way you want. Often taking a single step closer to your subject will improve the composition more than you might otherwise think. (Don't believe me? Try it!) If neither of these alternatives works with a given photographic situation use the Crop tool sparingly, but remember there is no free digital lunch. Every pixel you crop out is one that is lost forever.

LIGHTEN/DARKEN

One of the most useful tools for determining correct exposure is built into your camera, especially digital SLRs somewhere in its "INFO" mode. It's called the

The histogram in the center of the Levels dialog box shows how pixels are distributed in an image by graphing the number of pixels at each intensity level. It displays the relative number of pixels in the shadows (left), midtones (middle), and highlights (right). On this histogram you can see there is a lot of space on the right hand side indicating a *lack* of light. You can adjust Levels by moving the white triangle on the right toward the left, as I have done here.

histogram. (This will vary with each camera and some may not even have one; most digital SLRs do. Read your camera's manual to find where the histogram is located.) Don't let that geeky word scare you. A histogram is a graphic representation of tabulated frequencies. Okay, that sounds geekier. In digital photography, a histogram is a display of the tones in the image file from the darkest shadow to the brightest highlight. Traditional darkroom practitioners might think of it as a digital Zone System with Zone Zero at the leftmost part of the histogram and Zone X at the extreme right. There are two ways to use histograms: One while shooting, by looking at the histogram you can see on the camera's LCD screen, and the second is later when viewing the image in an editing program (of course, by then, it's usually too late to re-shoot).

LEVELS AND CURVES

The Levels and Curves command found in many digital imaging programs on some levels could be called more intermediate, than basic tools. They are also less "traditional" than some of the others in this chapter, but since they relate to changing an image's brightness or darkness, I want to introduce them now. Unlike burning and dodging, which darken or lighten selective areas of an image, the Levels and Curves commands light or darken the entire image.

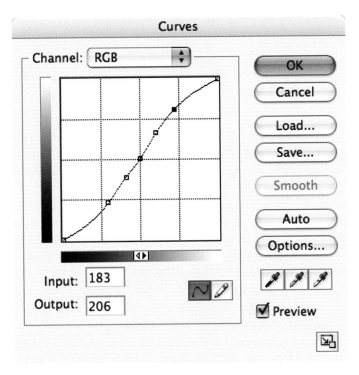

Changing the shape of the curve in the Curves dialog box alters an image's tonality. Clicking of the curve and pulling it upward lightens the photograph and pulling it downward darkens the image. The steeper sections of the curve represent portions of an image with more contrast. Conversely, flatter sections of the curve represent areas of lower contrast. In this example, I clicked in the middle of the curve and added five additional adjustment points.

The first thing I do with any digital image is using Photoshop's Levels command to set highlight and shadow points. The Image > Adjust > Levels menu presents you with a histogram that shows the image's range of darkness and brightness. At the opposite ends are black and white triangles and in the middle is a gray one. They can be moved back and forth under the histogram's peaks and valleys to interactively enhance the image. The Levels dialog box includes Eyedropper tools that let you click on equivalent color tones in the image to adjust white, gray, and black points. Often all you need to do is click on a point that *should* be white (or black or middle gray) to bring the image into balance.

Like Levels, Curves lets you adjust the entire tonal range of an image. Unlike Levels, which has only three adjustments, Curves lets you adjust up to 14 different points throughout an image's tonal range from shadows to highlights. You can also save settings made in the Curves dialog box for use in another image.

Changing the shape of the curve in the Curves dialog box alters the tonality and color of an image. Bowing the curve upward or downward lightens or darkens the image, depending on whether the dialog box is set to display levels or percentages. The steeper sections of the curve represent portions of an image with more contrast. Conversely, flatter sections of the curve represent areas of lower contrast. Most importantly, both Levels and Curves can be applied as an Adjustment Layer in Photoshop.

BRIGHTNESS AND CONTRAST CONTROL

The Brightness/Contrast command lets you make simple adjustments to the tonal range of an image. Unlike Curves and Levels, which apply proportionate (non-linear) adjustments to the pixels in an image, Brightness/Contrast makes the same amount of adjustment to every pixel (a linear adjustment). That's why photo *artistes* usually don't recommend using the Brightness/Contrast command for high-quality output because some image detail can be lost. Sometimes I can't just resist, and make minor tweaks to brightness and contrast.

The Shadow/Highlight command is useful for correcting photographs with strong backlighting or correcting subjects that have been slightly washed out because they were either too close to the camera flash or slightly over-exposed. This adjustment can also be useful for lightening shadow areas in an otherwise well-exposed image file. In Adobe Photoshop, the Shadow/Highlight command does *not* lighten or darken an image; it lightens or darkens based on the surrounding pixels in shadows or highlights. That's why there are separate controls for the shadows and the highlights. There's a Midtone Contrast slider, Black Clip option, and White Clip option for adjusting the overall contrast of the image. So as you can see, this control panel is also a more useful tool for increasing an image's contrast than using Brightness/Contrast slider controls.

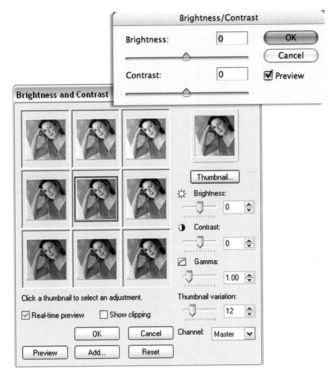

The *yin and yang* of Brightness and Contrast controls can be seen in this small control panel used by Adobe Photoshop CS2 and the larger, simpler interface used in Ulead's PhotoImpact. Which one is best for you? The one that helps you work fast and makes you most comfortable is the best choice. This is not a one control panel fits all situations. © 2004 Joe Farace.

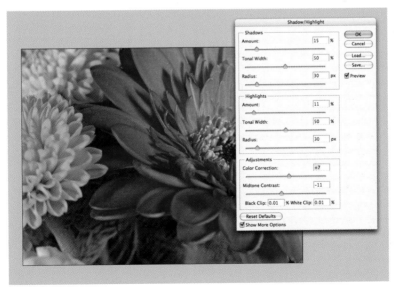

You can reuse Shadow/Highlight settings for other, similar images by clicking the Save button to save the current settings to a file and later using the Load button to reload them. © 2005 Joe Farace.

NON-TRADITIONAL TOOLS

The first thing your eyes see when looking at an image is sharpness, then brightness, and finally warmth, but there are *degrees* of sharpness. Some photographs may be "acceptably" sharp, while other, more carefully focused images made with a camera on a tripod and at small apertures, might be termed "critically" sharp. OK, I can hear some of you now: "All of my images are sharp!" But it's been my experience that, depending on how they are captured, some digital files are sharper than others.

UNSHARP MASKING

One of the biggest advantages digital imaging has over traditional photographic techniques is the ability to sharpen images. Many image-editing programs, such as Adobe Photoshop CS2, contain a Sharpen command that works by raising the contrast of adjacent pixels, but sometimes this increases apparent sharpness at the expense of overall contrast. Some photographs can handle additional contrast before loosing highlight detail, while others can't. A better bet is to use the

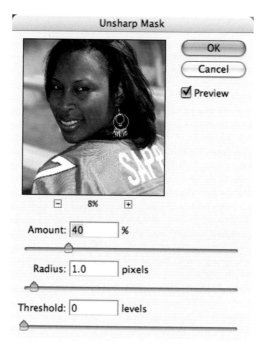

Adobe Photoshop's Unsharp Mask's preview window allows you to see the sharpness of the finished image before it's sharpened. The dialog box's movable "hand" drag the image to choose a particular portion of an image to see the effect of your sharpening efforts. Click and hold to see the original, then release to show what the current settings will do to the image. Clicking on the Plus box zooms into the image and clicking on the Minus box zooms the preview window out. © 2005 Joe Farace.

unlikely named and wonderfully practical Unsharp Mask (Filter > Sharpen > Unsharp Mask) command that's found in Photoshop and many other image-enhancement applications to *sharpen* a photograph.

In Adobe Photoshop, Unsharp Mask's dialog box provides three sliders that let you control sharpness *and* unsharpness. The Amount slider displays the actual percentage of sharpening that will be applied to your photograph. Don't be afraid to apply more than 100% to high-resolution files, but lower-resolution images can fall apart fast if large amounts are used. The Radius slider determines the number of pixels surrounding the edge pixels for sharpening. Lower values *only* sharpen the edge pixels, while higher values sharpen a wider range. The Threshold slider determines how different sharpened pixels must be from their surrounding area in order to be considered *edge* pixels. The default value of zero sharpens all pixels in the image.

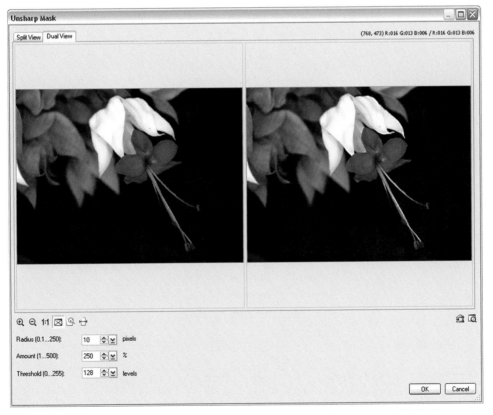

Not all Unsharp Mask commands work the same way. In Ulead's PhotoImpact, the Unsharp Command uses "before and after" Windows and offers a split window to make a different kind of comparison between sharpened and unsharpened versions of your photograph. © 2005 Joe Farace.

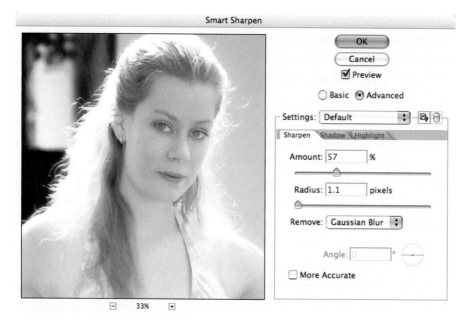

Photoshop CS2 adds a *new* command to the Sharpen menu called Smart Sharpen (Filter > Sharpen > Smart Sharpen). Its dialog box is similar to Unsharp Mask but includes an advanced Mode featuring three tabs, including Shadow and Highlight. The first two sliders under the Sharpen tab are Amount and Radius, which act as they both did in Unsharp Mask; but in place of Threshold, there's a pop-up menu that lets you control sharpness for a specific kind of lack-of-sharpness problem including Gaussian, Motion, and Lens Blur.

Sharpening tip

Here's a useful tip for dealing with color fringing that might occur when applying Unsharp Mask. After sharpening the image file, go to the Fade command (Edit > Fade Unsharp Mask) that appears only after a filter is applied in Adobe Photoshop. Don't change the Opacity setting—leave it at 100%—but select Luminosity from the pop-up menu. Any color artifacts should then be gone!

EXTERNAL SOLUTIONS TO AN INTERNAL PROBLEM

nik Sharpener Pro 2.0 (www.nikmultimedia.com) is a Photoshop-compatible plug-in that lets you apply sharpening to parts of an image with selective brush strokes; or else you can apply sharpening to the whole image and selectively brush it out. The Advanced menu contains five sliders that can be associated with

different colors. You pick the color and each slider lets you increase or decrease the sharpening applied to image areas with that color! Sharpener Pro 2.0 is compatible with the image rendering characteristics of different printing processes such as traditional halftone, dye sublimation, ink-jet, digital photographic, and even between ink-jet printer manufacturers.

nik Sharpener Pro 2.0 is a Photoshop-compatible plug-in that lets you apply sharpening to any part of an image with selective brush strokes, which is a good reason to have a graphics tablet handy. © 2005 Joe Farace.

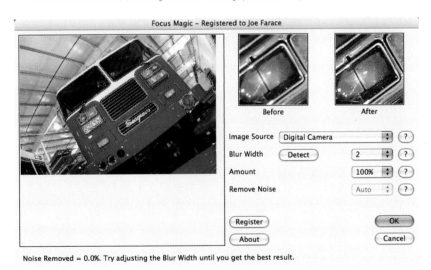

Holding a camera at slow shutter speeds is easier for some photographers than others, that's why a sturdy tripod is a useful accessory when image sharpness is critical. Acclaim Software's Focus Magic is a Photoshop-compatible plug-in that can reinstate as much of the original "in focus" image as possible, allowing it to recover detail from photographs blurred by movement. © 2005 Joe Farace.

Acclaim Software's (www.focusmagic.com) Eric Schwerzel believes 60% of blurred photographs are caused by *motion* and developed a Photoshop-compatible plug-in called Focus Magic to recover detail from photographs blurred by movement. Focus Magic is not a miracle worker, but it improves images for which there is otherwise no hope, which earned it a place in my personal list must have plug-ins. A free version that allows up to 10 images to be sharpened can be downloaded from Acclaim's website.

SHARPNESS vs. BLUR

Blur is different from soft focus and can be created by an object moving while the camera's shutter is open, by moving the camera, or maybe both at the same time. Streaking light images use an age-old technique produced by making photographs of headlights and city lights while riding in a car at night and using slow shutter speed settings on your camera. Digital blurring of an image is typically accomplished through software averaging of pixel values to soften edge detail.

One classic technique is to zoom the lens slowly during an exposure time of about one second and you can surround your subject with streaks. You can turn a blah photo one exploding with color. This trick works anywhere, but this particular example was shot through the streets of Akihabara in Tokyo. This technique can be hit and miss with film, but it's a snap with a digital SLR and you can instantly adjust your aperture or shutter speed to achieve precisely the effect you want. The camera used was a Canon EOS Digital Rebel and 18–55-mm lens. Exposure was 1 second at f/8.0 at ISO 100. © 2003 Joe Farace.

Soft focus is created with a lens that is *not* corrected for spherical aberration. It produces a diffused look that's achieved by bending some of the light away from the subject so it's *defocused* while the rest of the photograph remains in focus. Highlights are dispersed onto adjacent areas but the image looks focused, while some of its components are just enough out-of-focus to appear softened. Lines are slightly fuzzy and small details seem to disappear. Capturing soft focus effects is also possible by using camera (analog) or digital filters.

One of the easiest ways to achieve a soft focus look is by using special optics such as Canon's EF 135 f/2.8 SF lens. This photograph of Dottie was made with a Canon EOS 5D and Canon's soft focus lens. Exposure in Program mode was 1/200 second at f/7.1 at ISO 200. An exposure compensation of plus two-thirds stop was added to lighten the model's skin and enhance the soft focus effect. © 2005 Joe Farace.

DIGITAL BLUR AND SOFT FOCUS

Most image-enhancement programs have a least *one* blur command built in. One of the newest and most fun filters found in Photoshop CS is Lens Blur (Filter > Blur > Lens Blur). This filter can blur an image to give the effect of a narrower depth-of-field so that some objects in the image stay in focus while others are blurry. The way this digital blur appears depends on the iris shape you choose. You can change blades of a virtual iris by curving them (making them more

circular) or rotating them. You can check the effect on screen by clicking the plus button in the control panel to magnify the preview.

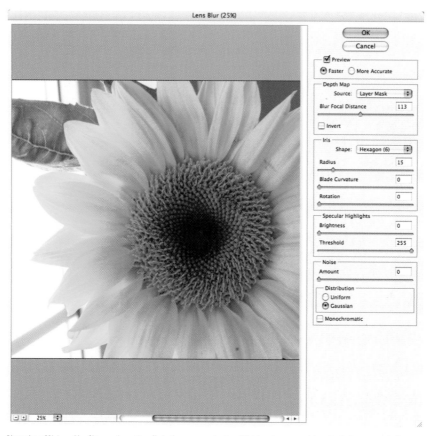

Photoshop CS's Lens Blur filter produces the effect of a *narrower* depth-of-field so that some objects in the image stay in focus and other areas are blurred. Just select any part of the photograph to determine which areas are blurred and which are not. © 2005 Joe Farace.

Nik Multimedia's ColorEfex Pro 2 suite of Photoshop-compatible plug-ins contains a Classical Soft Focus filter that mimics soft focus camera filters used in conventional photography—think Zeiss Softar here—and adds diffusion to an image while preserving detail. The control panel's Soft Focus Method pop-up menu lets you select the type of blur, that can range from a subtle soft focus effect to more pronounced diffusion. The Diffused Detail slider controls the amount of random detail to maintain the appearance of some sharpness and prevent banding. While many photographers traditionally use soft focus techniques for portraiture, I like to use it for images of vintage automobiles to add to that "old car" look. So use it how you like: don't be bound by any "rules."

While many photographers use soft focus techniques for portraiture, I also use if with vintage automobiles to add to an "old car" look. James Bond fans know that his *real* vehicle of choice was a 1930 4.5 liter Bentley convertible coupe, not an Aston Martin. Fleming introduces the car in the 1953 novel "Casino Royale," but the Bentley made its first movie appearance in "From Russia with Love" in black, not the gray Fleming described or the green model depicted here. © 2005 Joe Farace.

The ScatterLight Lenses 1.2 Photoshop-compatible plug-in produces a broad scope of realistic patterned and diffusion lens effects that range from subtle soft focus effects to more dramatic effects that scatter and focus light over the brightest areas of an image. ScatterLight Lenses has four different categories. Dream Optics pulls and scatters light from highlighted areas to create dreamy highlights throughout the image. SoftFocus uses various optical lens patterns for softening portraits. SoftDiffuser adds diffusion or fog. StarLight focuses light over the brightest areas of your image to create a starlight effect.

My current favorite soft focus/blur power tool is the Craig's Action (www.craigsactions.com) Shadowsoft and Grainy Photoshop Action set. (Get more scoop on one-click Actions in Chapter 9.) This is a collection of monochrome—black and white, blue, sepia, and green—Photoshop Actions that lets you create and control *toned* softness effects, with options for some delightfully grainy enhancements. While originally designed for Wedding and Portrait photographers, these Actions are fun to use with commercial or artistic images. Shadowsoft and Grainy Actions can be run as a one-click operation and are customizable to fit your personal style.

I love this picture of Brenda, but felt it need just a touch of soft focus to give it that Hollywood look of the 1950s Technicolor epics. To accomplish that goal, I applied Andromeda Software's ScatterLight Lenses plug-in, specifically the Dream Optics filter that pulls and scatters light from highlighted areas to create dreamy highlights. © 2005 Joe Farace.

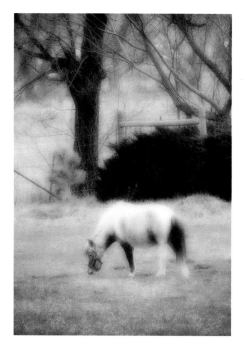

One of the easiest and maybe best ways to create soft focus/blur effects is the Shadowsoft and Grainy Photoshop Action set (www. craigsactions.com). This is a collection of Photoshop Actions that let you create and control *toned* softness effects in color or monochrome. The basic Shadowsoft Action was applied to this pastoral image made of a miniature horse (yup, this little guy is about the size of a big dog) with an Olympus E100RS. The image you see is a one-click effect. © 2005 Joe Farace.

There are no rules of thumb about *how much* blur or soft focus to apply to any image. My best advice, as Emeril says, is to "season to taste," but that doesn't mean you can't have a few Photoshop tricks up your sleeve.

First of all, don't be afraid to yank those control panel sliders to the extreme ends to see what effect this produces. Even after you apply a filter, there's always the UNDO command waiting in the wings, and I promise that no pixels will be harmed while performing this maneuver.

Second, don't forget the FADE option. After applying any filter, you can reduce its effect by applying the Fade command (Edit > Fade . . .) that becomes available only at that time. Use the slider to apply the Filter at anywhere from 1% to 99% to create the desired soft focus or blurry effect.

Power Tools

It's true! The camera does put on pounds! Memo to myself: Move up liposuction appointment.

Power Tools are small bits of software that can be Photoshop-compatible plug-ins, Photoshop Actions, or graphics utilities that make a digital photographer's life a little easier for creating practical or special effects. Much like an electric screwdriver makes household projects faster than an old-fashioned hand tool, software Power Tools let you produce imaging projects quicker and with less fuss, than doing it "the hard way."

This photograph of the Colorado Belle hotel in Laughlin, Nevada was made with a Leica D-Lux2 point and shoot camera. The moon was made from a separate exposure made at a different time and place and was placed on a separate layer. The "digital water" was created using Flaming Pear Software's Flood, a Photoshop-compatible plug-in. © 2005 Joe Farace.

PHOTOSHOP-COMPATIBLE PLUG-INS

One of Adobe Photoshop's most useful features is an open architecture that lets it accommodate small software applications—called plug-ins—that extend the program's capabilities. The use of plug-ins lets digital imagers increase the functionality of graphics programs and allows them to customize their software to match whatever kind of projects they're working on. But don't let the name fool you. You don't need Adobe Photoshop or even Photoshop Elements to use compatible plug-ins. Adobe Systems defined the standard, but compatible plug-ins can be used with many other image-editing programs including Ulead Systems' PhotoImpact, Corel's Painter, PhotoPaint, and PaintShop Pro. Even many freeware image-editing programs support Photoshop-compatible plug-ins. No matter which program's menu they appear under, the interface for the plug-ins that you see in this and all of the other chapters *will remain the same*.

There are eight different types of plug-ins, some you might care about, some not, and even two that don't have a traditional interface. Color Picker plug-ins are used in addition to the program and system color pickers and appear whenever a user requests a unique or custom color. Import, formerly called "Acquire," plug-ins interface with scanners, video frame grabbers, digital cameras, and even other image formats—such as Kodak Photo CD. Import plug-ins are accessed through

LaserSoft's (www.silverfast.com) SilverFast DC VLT is an Acquire plug-in that also lets you archive your photos, add comments to image files, lay out albums and contact sheets, and print pictures in variable sizes. DC VLT works with JPEG, TIFF, and RAW files to adjust the color balance, saturation, smoothness, and sharpness instead of using the camera's automatic settings. In addition to these formats, DC VLT also supports the now all-but-forgotten Photo CD as well as the emerging DNG formats. © 2005 Joe Farace.

Photoshop's File/Import menu. Export plug-ins appear in the program's File/Export menu and are used to output an image, including creating of color separations. Export plug-ins can also be used output an image to printers that lack driver support or to save images in compressed file formats. Filter plug-ins appear in the Photoshop's Filter menu, but may appear under different menus in different programs. They are used to modify all or a selected part of an image. Format, sometimes called File or Image Format, plug-ins provide support for reading and writing additional image formats than are not normally supported by the program and appear in the Format pop-up menu in the Open, Save As, and Save A Copy dialog boxes. Selection plug-ins appear under the Selection menu and are used to create shapes or paths—especially when used with text.

The "secret" plug-ins such as extension are not accessible by the average user and permit implementation of session-start and session-end features, such as when initializing devices connected to the computer. They are only called at program execution or quit time and have no user interface. Parser is another class whose interface isn't public and performs similarly to Import and Export plug-ins by providing support for manipulating data between bitmapped programs and other formats.

In addition to some of the other plug-ins that have been introduced in previous chapters, here's a look at several kinds of plug-ins that you will find will allow you to put together an indispensable toolkit.

iCorrect EditLab Pro will let you convert a batch of images from one file format to another and is Photoshop Action-enabled (we'll get to Actions in the next section) so each color correction can be recorded as an Action. © 2005 Joe Farace.

ENHANCING THAT IMAGE

After initially acquiring an image, I like to start by making it look as good as it possibly can. Plug-ins help me do that fast. Let me show you some of my favorites.

PhotoTune's (www.phototune.com) 20/20 Color MD works like an eye exam. During each step of the process, you're presented with two preview images and you just pick the rendition you like and 20/20 Color MD analyzes the feedback to determine what you want, and then shows you another pair. In about 15 seconds, the plug-in produces a corrected image you can fine-tune in 1% increments. If you spend 10 minutes fixing an image using Photoshop's Curves, Levels, Hue & Saturation, or Variations, it'll take you 16 hours to correct one hundred images. With 20/20 Color MD, you'll be done in less than an hour.

The step-by-step Color Wizard in 20/20 Color MD has nine steps and contains 6144 different solutions. Once the Color Wizard has finished, you've got access to several tools and sliders, so fine-tuning is quick and easy. © 2005 Joe Farace.

If there is anything that drives people crazy when working with fashion, portrait, or wedding images it's correcting skin tone. SkinTune is a Photoshop-compatible plug-in for Mac OS and Windows computers that was specifically designed for correcting skin color. PhotoTune compiled a series of skin tone libraries for different skin types, including African, Asian, European, Latin, and Middle Eastern. Each library contains approximately 45,000 different colors that encompass the entire flesh tone spectrum for that particular library. After opening an image in Photoshop, select SkinTune from the Filter menu and after two mouse clicks it will find the nearest acceptable skin color from the library and automatically correct your image.

After SkinTune does its magic, you can tweak the final image by using the built-in tools to adjust hue, brightness, and saturation, and (here's the kicker) all these adjustments stay *within* the boundaries of the library so you can't accidentally introduce stray colors. © 2005 Joe Farace.

MANIPULATING IMAGES

Silver Oxide (www.silveroxide.com) is well known for their black and white Photoshop-compatible plug-ins (see Chapter 10) and recently announced their first *color* product called Color Landscape. It builds on their monochrome Landscape filter and includes a BANG (Blue Algorithm Neutral Gray) setting. The BANG setting reacts to the blue content of each pixel and acts like a polarizer deepening the sky and water and gives greater depth to trees. If you need a less dramatic contrast, red and orange color filter settings are available. Silver Oxide's Bill Dusterwald told me that "You can get a similar effect by fooling around with curves, but this is faster, less intimidating." The Color Landscape plug-in includes a histogram function that lets you to see if you're clipping highlights and works with 8- and 16-bit images including 16-bit layers supported by Adobe Photoshop CS and CS2. I tested a Windows copy, but a Mac OS version will also be available by the time you read this.

There are lots of free plug-ins out there, but virtualPhotographer (http://www.optikvervelabs.com) is so good I would actually pay for it if they offered a Mac OS version. virtualPhotographer's structure should be familiar to traditional film photographers. It can simulate the film type as "Film" or "Slide," adjust grain effect to match film speed, and lets you apply digital filtration, as well as lots of cool darkroom effects and tints that can be applied via presets. The best way to use

The histogram in Silver Oxide's Color Landscape plug-in represents the entire image, regardless of the enlargement in the preview window. You can move the histogram display by Right-Clicking and dragging it wherever you want. © 2004 Joe Farace.

virtualPhotographer is apply some of the Presets to your image to see which ones look best. Then, fine-tune the other controls to get the exact results you want. To see the original image, click and hold the left mouse button on the image in the Preview Window.

virtualPhotographer is a double rarity in the world of Photoshop-compatible plug-ins: It is Windows-only and is free. © 2004 Joe Farace.

Alien Skin Software's (www.alienskin.com) Eye Candy 5: Impact contains 10 plug-in filters for Photoshop and compatible programs. This third update to Eye Candy 4000 features three new filters—Backlight, Brushed Metal, and Extrude—and seven updated oldies but goodies. Backlight projects light beams and spotlight effects behind any selection. Bevel carves and embosses, creating text with custom bevel shapes and textures. Brushed Metal simulates textured metal surfaces, and filter produces a reflective, embossed effect, simulating chrome, liquid metal, and other shiny surfaces. Extrude gives 2D objects a 3D look, adding thickness and perspective. Glass renders a colorful, gel layer over selections and Gradient Glow creates soft glows or hard outlines around any selection, including single colors or complex gradients. Motion Trail creates the illusion of rapid movement, even in a curved line. Perspective Shadow renders an array of drop, perspective and cast shadows. Super Star generates shapes, including stars, flowers, and gears.

Impact works with 16-bit and CMYK images making color transitions smoother, with less banding. Unlimited undo and redo make experimentation painless, while context-sensitive help answers your questions.

Alien Skin Software's Eye Candy 5: Nature is a set of Photoshop-compatible plug-ins that simulate natural phenomenon. Corona creates solar flares, gradient glows, and wispy auroras while drip melts images, melding colors, and rendering "oozing drops" from selections. Fire creates incendiary effects ranging from blue flames to rocket exhaust. Ripples produces refractive ripples around any shape, as well as reflective waves. Rust tarnishes and corrodes images and text with rust, moss, and mold. Smoke simulates anything from voluminous clouds of smoke to murky haze. Squint mimics poor or wet vision, defocuses images, and adds

highlights and halos. Water Drops splashes images with a variety of drops and spills. Nature works with 16-bit images; so transitions are smoother, with less banding, and photographs print with more accurate color. Its street price is $99 and a free demo can be downloaded from Alien Skin's website.

The icicles filter drips translucent icicles from any selection and works great with the Snow Drift filter that piles snow on text and lightly dusts images with snow or frost. © 2004 Joe Farace.

The number of plug-ins in your toolkit will vary based on the kind of image you create and how you output them. In addition to all of the above plug-ins, you'll find a few more with illustrations showing what their dialog looks like giving you an insight into how they work. Plug-ins are fun to use and also make your digital imaging easier.

WHERE THERE'S SMOKE THERE'S FIRE

Like a lot of kids, I loved fire trucks. As I got older, I began photographing them and still do to this day. While their size, color, and abundance of details make fire trucks wonderful subjects, sometime I feel, like Emeril, that a particular image needs to be "kicked up a notch."

When I received a copy of Alien Skin Software's Eye Candy 5, a new package of Photoshop-compatible plug-ins that lets you apply natural effects like ice, smoke, and fire to a digital image, I decide to apply some fire to a fire truck. Here's how I did it:

Step 1: I opened the file in Adobe Photoshop CS2 but *any* image enhancement program that supports layers and compatible plug-ins will work. Although

I used the Mac OS version of the products mentioned, they are also available for Microsoft Windows.

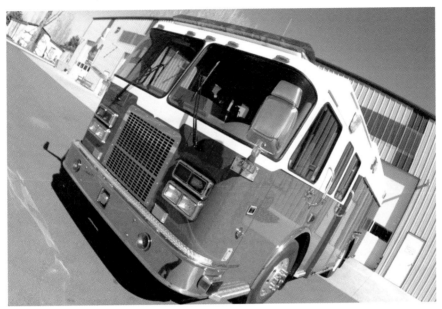

My original fire truck photograph was made on location at SVI Trucks in Loveland Colorado using a Canon EOS D60 with Ukrainian-made 16 mm Zenitar f2.8 lens. Image was made at f/11 at 1/250 second at ISO 400 and was captured as a JPEG file.

Step 2: My first step when working with any image file, even those that may look perfectly color balanced, is to run them though PhotoTune's (20/20 Color MD

The way that PhotoTune's 20/20 Color MD works is that you are presented with a series of pairs of images in a dialog box. You click the one that looks best as the process homes in on a desired result.

Photoshop-compatible plug-in). In PhotoTune, you are presented with a series of pairs of images in a dialog box. You click the one that looks best as the process homes in on a desired result. I'm often amazed how this simple plug-in can make minor changes in color and contrast that produce major improvements to a photograph. When the image's color is really bad, this indispensable plug-in really comes to the rescue.

Step 3: In my continuing effort to make any digital file look as good as it can before I lay on the effects, my next step is to use Pixel Genius' Sharpener Expert to sharpen the photograph. Unlike other one-size-fits-all software products, Capture Sharpener Expert lets you choose the type of sharpening that's applied from a menu of options based on the image's method of capture, including film or digital, and even the resolution of the original capture.

Step 4: Since my original background was pretty bland, I wanted to add separate effects to it later. To make the process simpler, I created a Duplicate Layer (Layer > Duplicate Layer) for effects that would be applied to the fire truck. Working on that duplicate Layer, I used the Extract tool (Filter > Extract) to separate the fire truck from its background so that the flames could be added to it.

Extract has a dialog box giving you all the tools you need to separate an object from its background, but here are a few tips that might make the process less stressful: Start by outlining the truck using the Highlighter tool; but unless you're good at freehand drawing I suggest clicking the Smart Highlighting check box to help guide the tool along areas of varying color or contrast. It's also a good idea to work with a small brush on enlarged sections of the image, using short easy strokes to trace the truck's outline. It's easier to undo mistakes this way.

When you're finished outlining, select the Paint Bucket tool and click the middle of the outlined subject filling it with color. When you click the Extract button, the truck will be removed from its background.

When you're finished outlining, select the Paint Bucket tool and click the middle of the outlined subject to fill it with color. After you click the Extract button, the truck will be removed from its background.

Step 5: Working on the extracted truck on the duplicate layer, I selected Filters > Alien Skin Eye Candy 5: Nature > Fire. The Nature package includes over 500 presets for frequently used effects so you can find the perfect effect quickly.

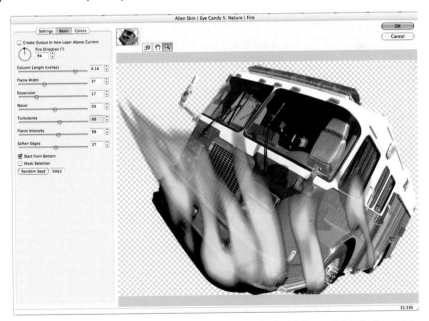

As with all special effects, it's a good idea to apply different presets to see what kind of effect you like best. Tire Fire was too black and sooty for me, but Large High temp was just right. To finish up, I used the plug-in's sliders to change the flame intensity, width, and waver. Here's your chance to play with fire and Dad won't paddle your bottom.

You can choose from big fires to small, smoky to blazing, and the plug-in offers sliders to let you tweak specific attributes of the flames (no matches required).

Step 6: My last step was changing the color of the background layer to give it a *warmer* look.

For this step I used nik Color Efex Pro's Burnt Sienna filter (Filter > nik Color Efex Pro 2.0: stylizing Filters > Burnt Sienna) to give the background an overall orange color to the photograph that looked better, to me anyway, than the cool, bland tones of the original file.

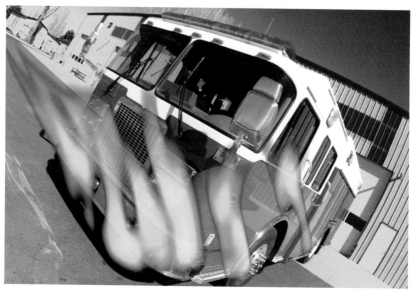

Here is the finished result.

FILM GRAIN VS. DIGITAL NOISE

All digital cameras add noise to images. Like film grain, it's worse at high ISOs and more noticeable in areas of uniform color, such as skies and shadows. Since noise can be objectionable, there are lots of digital noise reduction applications available to help you solve that problem. I've tested quite a few of them and here's a short list of some noise reduction products in my personal order of my preference. Keep in mind that your cameras and the kind of images *you* make may be different from mine, so download a demo version of each product and try it yourself.

For less than a hundred bucks, Noise Reduction Pro (www.imagingfactory.com) is the first tool I reach for to reduce high ISO noise, CCD color noise, JPEG artifacts, and color fringing. Unlike the less expensive non-Pro version, it features separate controls for luminance (brightness) and color noise. Noise Reduction Pro is not the strongest grain removal product available, but its application avoids the mushy look some noise reduction solutions produce. Which version of the product do you need? Download 30-day demo versions of both plug-ins and try each of them. © 2005 Joe Farace.

Grain Surgery (www.visinf.com) reduces digital noise *and* film grain, reduces JPEG compression artifacts, and will even remove halftone patterns from scans. The interface provides easy access to all settings, provides a wonderfully useful split-screen comparison window, and lets you save your settings and reload them later for similar image files. It even lets you *add* grain from built-in samples or your favorite grainy film, such as Ilford's Delta 3200. © 2005 Joe Farace.

Eastman Kodak's (www.asf.com) Austin Development Center offers a $99 Digital GEM Professional Plug-In that also supports 16-bit images produced by high end digital capture devices. The Clarity control in its dialog box lets you customize the effects by providing additional sharpening or softening to the overall image while a Radius slider controls the area of surrounding pixels that are affected by the sharpening/softening. A Noise Preview Screen shows the actual image noise/grain that's affected by your setting choices. © 2005 Joe Farace.

PictureCode's (www.picturecode.com) Noise Ninja is available either as a stand-alone application or a Photoshop-compatible plug-in, which is the way I like to use it. Noise Ninja uses a proprietary type of wavelet analysis that avoids introducing artifacts, such as ringing or blurring edges to the final image file. To refine its noise reduction capabilities, it also uses camera profiles that are offered *free* on its website. © 2005 Joe Farace.

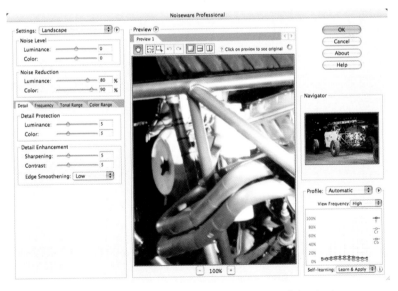

Noiseware (www.imagenomic.com) uses heuristic techniques to rescue noisy images by learning about your camera or image acquisition device as it works. It removes high and low ISO noise and film grain from scanned images, JPEG compression artifacts, and moiré patterns, and is available as a Photoshop-compatible plug-in or stand-alone application. Both versions' programming continuously perfects the processing every time you process an image; the more you use it, the better the results. © 2005 Joe Farace.

MOONSTRUCK

Landscape images are where you find them. I just happened to find this one around the corner from where I live and started photographing the farm—because someday it would be gone. That day is now. By the time you read this, a six-lane highway with a median strip will replace the two-lane country road the farm now faces. I've chosen this image to remember it as it was:

Step 1: The original image was captured on Kodak color negative film with a Canon EOS IX SLR and EF 22–55 mm zoom lens. The camera uses the near-obsolete Advanced Photo system film format, but any camera that still has media available for it and lets you make photographs is *not* obsolete. Film was processed and printed at a local camera store but while the overall color and density approximates the hot day when I made the photograph, it captures little of the mood.

Step one was scanning the image, which was accomplished using an Epson Perfection 4870 PHOTO flatbed scanner.

Step 2: I think it's a good idea to make an image look as good as possible before starting any manipulations and in this case with making sure the horizon line is *straight*.

Using Adobe Photoshop's Measure tool, I rotated the photograph to straighten the horizon. Next, I used the Crop tool to straighten any exposed (white) edges that were caused by the rotation.

Using Adobe Photoshop's Measure tool (it's in the Eye Dropper tool's fly-out menu; press and hold over the tool to bring up the fly-out) I drew a line across the horizon. Next, I rotated (Image > Rotate canvas > Arbitrary) the photograph and Photoshop automatically inserted the exact amount of rotation need to straighten the horizon in the Rotate Canvas dialog box. Then I used the Crop tool to remove any exposed edges cause by rotation.

An Adjustment Layer was used to punch up the contrast and make the landscape image appear less "flat".

Next, I applied an Adjustment Layer—Curves (Layer > Adjustment Layer > Curves) to punch up the contrast and make the landscape image appear less "flat."

Step 3: I'm a big fan of using graduated density filters, even colored ones, to improve the drama of landscape photographs. Although I didn't use one on the camera for this particular shot, I can digitally apply one later with a product like nik Color Efex Pro filters, which offers a choice of colors.

I selected the Graduated Coffee filter from (Filter > nik Color Efex Pro 2.0: Traditional Filters > Graduated Coffee). The plug-in's interface lets you make changes in the amount of filter density, color, transition, and even how it's is rotated—as if it were on the front of your lens. Play with the various sliders to produce an effect you like then click OK.

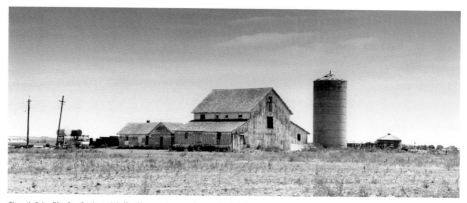

The nik Color Efex Pro Graduated Coffee filter produces an image that's different, and I hope, better than what was originally captured.

Step 4: But I don't want a mid-day look; I wanna night photograph! Part of nik's Color Efex Pro package is a family of Midnight filters that lets you add varying amounts of blur, contrast, brightness, and color to create pseudo moonlight.

I selected the Midnight filter from (Filter > nik Color Efex Pro 2.0: Stylizing Filters > Midnight) and experimented with different settings to give the landscape a "day for night" (*La Nuit Américaine*) look.

What's moonlight without a moon? I didn't have any sharp moon photos, so I borrowed a digital file from my friend and Pulitzer prize-winning photojournalist Barry Staver (www.barrystaver.com) who gave me permission to use it for this project.

You can shoot your own Moon shot by using the longest lens you have and photographing a full moon with your camera mounted on a tripod just as Barry did during a recent lunar eclipse.

Using Photoshop's Elliptical selection tool I selected the moon, copied it (Edit > Copy) to the Clipboard, then pasted it (Edit > Paste) into the *farm* file, thus adding the moon as a separate layer.

After you select "Show Bounding Box" in the Options bar, clicking the Move (Arrow) tool shows manipulation handles on the moon layer. To resize it and maintain proportion, hold the Shift Key and drag one of the layer's corners to get your size, then click on the moon and drag it where you want it.

Step 5: I wanted the final image to include water effects and selected Flaming Pear's (www. flamingpear.com) Flood plug-in to produce a lake effect. The interface has controls that let you change the kind of digital water and its reflection, but the most important tool is Horizon to sets the water's level. Try different levels to see what works best with your particular image.

In this case I brought the digital water up to the farm building to give it a "on the lake" look. Next, play with the sliders, and I encourage you to so do. Or do what I do: Click on Flood's Dice icon and be presented with random choices of all the variables. Keep clicking until you find something you like. Go ahead and do it; it's fun.

For the final image I used Photoshop's burn tool to darken the sky even more to give the image an overall early dark, moonrise look. Sure this isn't the way the farm actually looked, but it's the way I would prefer to remember it. It sure beats the heck out of a six-lane blacktop.

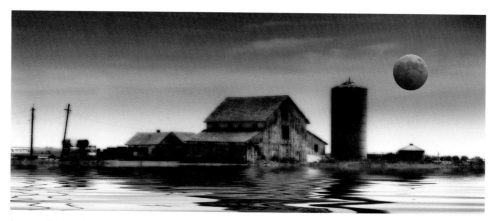

Just remember that when creating digital landscapes there are *no rules* except to have fun!

While I used Adobe Photoshop CS to create this digital landscape, any image enhancement program that supports layers and compatible plug-ins will work. I also used the Mac OS version of the products mentioned, but all of this software is available for Microsoft Windows too. In additional, trial versions of all the plug-ins are available for download, so give one or more of them a try for *your* next landscape photograph.

PHOTOSHOP ACTIONS

Do Actions speak louder than . . . software? Photoshop Actions are not applications or even plug-ins; they are simply a series of instructions that direct the host program to produce a desired effect. The Photoshop Actions palette lets you record a sequence of image-editing steps that can be applied to a selection in an image, another image file, or to a batch operation on hundreds of different image files.

Panos Efstathiadis' Film Machine Action set has the ability to combine *four* images in horizontal or vertical filmstrips. It contains three sets with 15 different Actions. Each one produces five different effects: The flat real version has the look of a real filmstrip including color and markings, a black flat version replicates the look of a black filmstrip frame, the 3D real version produces an eye-catching 3D filmstrip, the 3D black version produces a 3D filmstrip with a black frame. © 2005 Joe Farace.

MAC OS? WINDOWS? DOESN'T MATTER!

As I mentioned in another chapter, Actions are cross-platform and can be shared with others. If you create an Action on your Mac OS computer, anyone using the Windows version of Photoshop can load and apply your original Action to his or her images. In Mac OS or Windows form, Actions files use the .ATN extension. Let's get right to the Action(s).

The Actions Palette (Windows > Actions) is your key to creating and using Photoshop Actions. The palette has two modes: List View and Button. List mode lets you create and edit Actions starting with the New Action command that's accessed from the fly-out menu in the upper right-hand corner of the palette. Choosing "Button Mode" from the same menu activates playback or Button Mode.

Actions ⊙ Styles History Hist	
Image Size	F11
Vivid: Panos FX Mosaics	
Vivid–white gaps	
Soft	
Soft–white gaps	
Pastels	
Pastels–white gaps	
Sandstone texture	
Vitreaux	
Gems	
Cells	
Byzantine golden	
Synthesis customized	
Preset layout	
InfraRed Adjustments	
Movie Film	
Alternative look #1	
Alternative look #2	
Alternative look #3	
Alternative look #4	
Add Text	
ShadowSoft Grainy	
ShadowSoft	
ShadowSoft Grainy – B/W	
ShadowSoft – B/W	
ShadowSoft Grainy – Blue	
ShadowSoft – Blue	
ShadowSoft Grainy – Sepia	
ShadowSoft – Sepia	
ShadowSoft Grainy – Green	
ShadowSoft – Green	
Action Graphik® : 35 mm Fr...	
FILMSTRIPnoTEXT Convex	
FILMSTRIPTEXT Convex	
FILMSTRIPnoTEXT Concave	
FILMSTRIPTEXT Concave	
BRIGHTENTEXT	
SEPIANEGATIVE	
RESET SHEAR FILTER	
CORE ACTION	

Before you can record an Action, the palette must be in List View. To do that, access the Action menu and deselect Button Mode. To play an action, no matter where it came from, the Actions palette must be in Button Mode

To create a New Action, click the Record button from the fly-out menu. The circle icon at the bottom of the Actions palette will now turn red. At that point, work through a series of manipulations on an image or portion of an image. When you're finished, click the Stop button (the square icon) at the bottom of the palette. Afterwards, the order in which tasks are executed can be edited by dragging-and-dropping in any order you wish.

Although Actions apply creative effects, they are not filters, and don't have to be treated like plug-ins. Some pundits recommend you store Actions in a folder

or directory and load them as you need them. I don't think that's a good idea. One of the main attractions of Actions is that they're convenient.

Since the Actions palette is scrollable, you should keep all of your favorite actions stored there, ready for use. The trick is not to blindly accumulate Actions, but to explore and test to find ones that fit the way you work. If you uncover a marginal Action, you can store it in an "Inactive Actions" folder or dump it in the trashcan or recycling bin.

THIS IS A RECORDING

Pre-recorded Actions can be found on the Photoshop CD-ROM. Some of them include downsampling images to 72 dpi for use on the World Wide Web, saving

The Adobe Studio Exchange site has a section that lists all of the Actions that are available for download, along with a sample image showing what the effect looks like. To install pre-recorded Actions, use the Load Actions command in the fly-out menu.

GIF and JPEG files with optimal Web settings, and adding drop shadows to text. On versions released before the current Photo CS you could even find "secret" Actions on the CD-ROM stored in the "Goodies" folder or directory. The best source for pre-recorded Actions is the Adobe Studio Exchange (http://share. studio.adobe.com). Since most actions require less than 10K, you don't have to be worried about download time (or hard disk space).

COMMERCIAL AND FREEWARE ACTIONS

Panos Efstathiadis has created many impressive Actions, some of which can be found on Adobe Studio Exchange as well as his own website (www.panosfx. com). B&B Filmstrip is a set of Actions that frame your image as a strip of film. The author urges you to take a minute to play the Read Me action first to get some useful information. Then it's just a matter of clicking a few buttons to choose from the basic effect or a more sophisticated, text-decorated one including optional sepia and negative effects.

Craig Minielly's Actions (www.craigsactions.com) offer increased productivity and creativity in four separate Volumes, available at the click of a button. Production Essentials contains four sets of Actions providing control over image

While most Actions are just one-click process, the author urges you to take a minute to first play the Read Me Action for B&B Filmstrip to get some useful information. © 2004 Joe Farace.

PanosFX Mosaics is a set of Photoshop Actions that produces 11 mosaic effects. The first group contains Soft, Vivid, and Pastels. They differ in the color of the *tesseras* (tiles) they produce, which vary from neutral to colorful. Other Actions differ in the color of the gaps *between* the tesseras. The full set contains five another effects, including Sandstone Texture, Vitreaux, Gems, Cells, and Byzantine Golden.

This original photograph of Tia Stoneman was made with a Canon EOS 20D and an EF 28–135 mm IS zoom lens set at 63 mm. Exposure was 1/60 at f/4 and ISO 800, and the pop-up flash was fired for fill. Image was captured as a color JPEG file and converted to monochrome and digitally aged using Panos Efstathiadis' The Vintage Photo Photoshop Action set. © 2005 Joe Farace.

If you've ever wanted to see your photographs on a postage stamp, try the Stamp Action from Panos Efstathiadis, whose website features inexpensive commercial and free Actions including the wonderful Stamp. © 2005 Joe Farace.

This photograph of "your father's Oldsmobile" was made with a Canon EOS 20D with an 18–55 mm EF-S zoom lens attached. ISO was 200 and exposure was 1/320 second in Program mode with a *minus* one-third stop Exposure compensation. © 2005 Joe Farace.

sharpening, dust removal, advanced image retouching, facial feature enhancements, custom logo insertion, copyright and proof watermarking, and image effects such as cross-processing and monochrome. Creative Effects can add a softening effect to your images including grain enhancement. When running these Actions there are stops (with hints provided) allowing you to interact and customize the effect. The stops can be unchecked for continuous operation. CMYK Production and Ad Image Producers offers professional applications for CMYK Conversions for business card, brochure, or ad production, while StoryTellers1 contains 32 Actions with artistic effects such as infrared, soft pastels, and selective color.

After opening the image in Adobe Photoshop the ShadowSoft Grainy Sepia from Craig's Actions (Volume 2) was applied giving it a *film noir* look that matches the style of the car. This was accomplished with one button click and no pixels were harmed during the process. © 2005 Joe Farace.

The Norphos Blur Set by Norbert Esser can be downloaded for *free* from Adobe Studio Exchange (http://share.studio.adobe.com). He explains it this way: "This set of three different kinds of blurs will help you to have a photo look instead of the 'normal' CG blur look." The set contains three Photoshop Actions: Hamilton Blur is based on the dreamy photographic stylings of David Hamilton; Loop Blur is a mixture of "bloom" blurring techniques that can be applied ("looped") many times until you get the desired effect; and Overbloom is designed to mimic the kind of blur created by overexposure and overdevelopment of film images. Norbert tested the Action set on a German version of Photoshop CS but I found that it performed equally well on Photoshop CS2.

Brenda from North Platte, Nebraska is a beautiful and vivacious model that I photographed last Halloween in a most sincere pumpkin patch. The original image was captured with a Canon EOS 5D with an EF135 f/2.8 SF lens that was set for sharp focus. The soft focus effects were added with Norbert Esser's *free* Norphos Blur Action Set, specifically the Hamilton Blur Action. © 2005 Joe Farace.

The Monochrome Difference

Project Black Hole? Never heard of it.

One of the reasons purists often refer to black and white prints as "monochrome" is that it's a much more precise term that also covers prints made in sepia and other tones. One of the advantages of working with monochromatic digital photographs is that the original image can come from many sources. Some digital cameras even have black and white or sepia modes for capturing images, but more often than not they actually capture these monochrome images in RGB mode. That's right, it's a color file without any color!

There is much more to black and white photography than simply an absence of color. Maybe we wouldn't feel this way if the first photographs had been made in

This Nissan Skyline was photographed in color while I was hanging out the window of my car (somebody else was driving) shooting with a Canon EOS 1D Mark II and a 28–105-mm lens. Exposure was 1/25 second at f/7.1 in Program mode. Because the car was white, the colorful surrounding took the spotlight away from the car. Converting the color file into monochrome puts the focus back on the car. © 2004 Joe Farace.

full color, but that *didn't* happen, and like many photographers, I grew up admiring the works of W. Eugene Smith and other photojournalists who photographed people at work, play, or just being themselves. As a creative medium, traditionalists may call it "monochrome" and digital imagers may prefer "grayscale," but it's still black and white to me.

Black and white is a wonderful media for making portraits because the lack of color immediately simplifies the image, causing you to focus on the real subject of the photograph instead of their clothing or surroundings. Sometimes the nature of the portrait subject *demands* that the image be photographed in black and white. Arnold Newman's portrait of composer Igor Stravinsky could never have been made in color and have the same impact it has as a monochrome image.

One reason that many publications print photographs in black and white is purely economical. It costs them less to produce their publication in black and white than to use color. This is especially true for small runs of brochures or newsletters produced by companies and non-profit organizations. There are also the trendy aspects associated with creating images in black and white. MTV, motion pictures, and fashion magazines periodically "rediscover" black and white as a way to reproduce images that are different from what's currently being shown. Right now, many professional photographers are telling me that they're seeing a higher than normal demand for black and white portraits than previously was the case. Individual and family portrait purchases like these are driven by these same trends.

IN CAMERA

Many digital cameras have a black and white mode. Some, including those from Canon and Olympus, include the ability to add digital filters and toning modes along with their monochrome capabilities. Canon's newest digital SLRs include

The Canon EOS 1D Mark II N includes a set of "Picture Styles" including six presets that emulate different film characteristics including monochrome. © 2006 Joe Farace.

a set of "Picture Styles," including six presets that emulate different film characteristics (see "Picture Styles Extended"). Snapshot, for example, produces punchy, print-from-the-camera color; Portrait creates softer, more natural skin tones; and Landscape has vivid blues and greens along with increased sharpness. You can vary an image file's contrast, color saturation, color tone, sharpness, and craft up to three additional user-defined styles. Then there's Neutral, Faithful, and Monochrome. Monochrome can be further customized to emulate the color *filters* used with black and white films to darken skies for example; and you can add common tints like sepia and cyanotype.

Picture Styles Extended

Picture Style replaces internal image processing previously controlled by setting "Parameters" and is also supported by Canon's Digital Photo Professional software. The EOS 1D Mark II N, along with the EOS 5D and EOS 30D, have the ability to *add* Picture Styles and you can download new styles from Canon's website (www.canon.co.jp/Imaging/picturestyle). Right now, three styles are available. *Nostalgia* produces desaturated colors, except yellow, and works great for portraits and landscapes. *Clear* is the digital equivalent of a UV or Haze filter, and is perfect for shooting images with a telephoto lens against a hazy sky. *Twilight* punches up the purples in a sunset image and produces saturated colors.

The EOS 1D Mark II N also has the ability to add Picture Styles permitting even further in-camera creativity. Photo courtesy Canon USA.

BLACK AND WHITE WITH COLOR FILTERS

If you're new to the world of traditional filters for black and white photography, here's a quick primer: A yellow filter slightly darkens the sky, emphasizing clouds, and is primarily used for landscape photography; but when shooting in snow, it can produce brilliant, dynamic textures. An orange filter produces effects similar to the yellow filter, but skies are darker and clouds more defined. While useful for landscapes, it can also be used for higher contrast in architectural photography. An orange filter can be used in portraiture, especially under warm household light sources to produce smooth skin tones. The red filter produces dramatic landscapes. Skies turn almost black and contrast is maximized. In portraiture, freckles and blemishes can be eliminated with this filter. A green filter is useful for landscape photography as it lightens vegetation but doesn't darken the sky as much as the red filter. Skin tones may also be more pleasing, but freckles and blemishes are more apparent.

This color portrait of aspiring model Emily Blakely was made as a reference to show the effect of using digital filters in camera for direct monochrome capture with the EOS 1D Mark II N. For this shot, the camera was set in "Faithful" Picture Style. The lens used for this entire series of photographs was Canon's EF 135 mm f/2.8. Exposure was 1/100 second at f/6.3 in Shutter Priority mode at ISO 400. © 2005 Joe Farace.

If you select "Monochrome" from the EOS 1D Mark II N's Picture Styles menu, this is the result you achieve, but what happens when you add a digital filter? © 2005 Joe Farace.

The Green filter is usually my favorite filter for portraits because of the pleasing things it does for skin tones, but also maximizes Emily's freckles, which is not a bad thing. There is no one-size-fits all approach to what filter works best. The text provides some guidelines, but experiment with the kind of pictures that you make to get the optimum results. © 2005 Joe Farace.

Emily's freckles are minimized with the Red filter but it washes out her red lipstick. If you like this look, but want to punch up lip color in black and white with this filter, *blue* lipstick is the way to go. © 2005 Joe Farace.

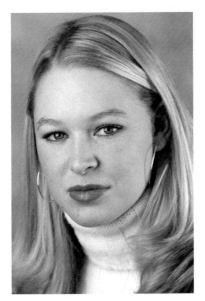

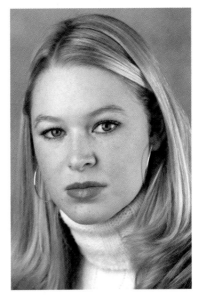

My first filter choice is Yellow, probably because that's a general-purpose filter for outdoor photography, but it works well for this portrait of Emily because he's a blond and makes her a little "blonder." © 2005 Joe Farace.

The Orange filter produces a softer look and smooth skin tones in portraiture, when photographed under warm household light sources. © 2005 Joe Farace.

While you could always use *real* color filters on your camera to achieve the same effects as cameras such as the EOS 1D Mark II N produce internally there are advantages to using digital filters: While most SLR's in-camera metering systems automatically take "filter factors" (See "Filter Factor") into consideration, you still have to look through and compose through a colored filter whose factor might range from three to five. Depending on how dark the filter is, it may not be that easy to see through. In addition, Canon's digital solution is an easier one to live with because the exposure for no filter is *identical* to one with the dark red filter.

Filter Factors

In the world of traditional photography, the light loss that caused by a filter's absorption and color density is expressed as a *filter factor*. A 2X factor means the exposure has to be increased by one stop, 3X means one and one-half stops, etc. When using several filters at once, filter factors, aren't added together but instead are *multiplied*, reducing depth of field or slowing shutter speeds.

IN-CAMERA COLOR EFFECTS

Monochrome images can be fun, but sometimes you might want to add some color—just not too much! That's when Canon's Mark II N's (and other similar camera's) digital toning modes come in handy. The camera lets you apply one of four different digital toning effects including Sepia, Blue, Purple, Green, and None. Digital filters and toning can even be applied together and since you get to see

I photographed my 1953 Packard Clipper club sedan at the Adams County Historical Society's outdoor museum using Canon's EOS 1D Mark II N and a 70–300-mm IS zoom lens at 300 mm. Exposure was 1/400 second at f/10 at ISO 200. © 2005 Joe Farace.

the results right away, you can decide if you like the effect and want to make any changes. There is no one-size-fits all approach to what toning effect works best. It depends on the subject itself, the original colors in the image (if you want to provide hints), and the mood you're trying to achieve. When's the last time you heard

In Monochrome mode the image looks like it could have been a newspaper advertisement in the 1950s. © 2005 Joe Farace.

The Sepia toned example, like the use of digital color filters, does not change the exposure of the image and produces a wonderfully nostalgic effect. This exposure is identical to that of the fill color image and is, after all, still an RGB file. © 2005 Joe Farace.

the words "mood" and "digital" in the same sentence? But that's what the combination of monochrome filter and toning capabilities is all about. Not every photograph should be in color: sometimes a black and white or toned monochrome image tells a better story.

Depending on the subject matter, the Blue toning effect would apply a wonderful cyanotype look to an old or pseudo old portrait. © 2005 Joe Farace.

The biggest surprise I had was when looking at the Purple toned image; it was my favorite one in the series. The Purple tone produces a POP (Printing Out Paper) "proof" look of the 1940s that I found enjoyable to look at. © 2005 Joe Farace.

The Green tone effect may not be the best choice for this particular image but might be wonderful for some landscape photographs. As in any creative pursuit, make some tests, try different filters and toning combinations, and have some fun. © 2005 Joe Farace.

I CAN DO THAT IN PHOTOSHOP!

You can always make these kinds of adjustments *after the fact* using Adobe Photoshop or your favorite digital imaging software, but I'd like to give you a few reasons why an in-camera approach may be better:

- *Aesthetics:* Shooting directly in black and white impacts how you *see* while making the images and having the instant feedback made possible with digital cameras helps focus your vision. Sometimes too much color confuses the viewer—even you—and takes the focus away from the real subject of the photograph.
- *Workflow:* There are many ways to use post-production software and Photoshop-compatible plug-ins to produce great-looking black and white images from color files, but not right now! If you want to make prints on-site using PictBridge-based printers or drop your memory cars off at your local digital minilab, capturing the file in black and white saves time.
- *Quality:* The quality of Canon's black and white conversion exceeds that of what's built into Photoshop CS2, including using the Channel Mixer function. A Mark II N's monochrome image looks like "real" black and white even though the file itself remains in RGB.

OK, I know what you're thinking . . . what if you change your mind and wished you made that image in color? Some cameras, like the Mark II N, offers simultaneous

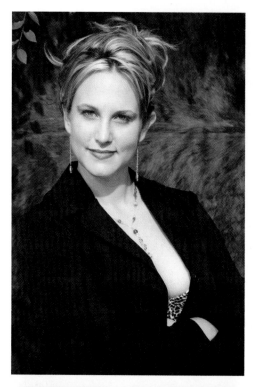

This RAW file of model Brenda was captured with a EOS 1D Mark II N with an EF 28–135-mm IS zoom lens at 135 mm. Exposure was 1/200 second at f/5.6 and ISO 200. © 2005 Joe Farace.

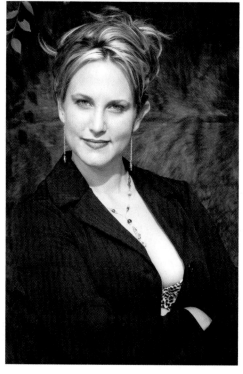

This monochrome JPEG portrait of Brenda was made *at the same time* as a color RAW file. Exposure was identical. The only thing that was different is that the Picture style was set at Monochrome and the Sepia option was used. Oh yeah, the EOS 1D Mark II N lets you capture toned photographs too. © 2005 Joe Farace.

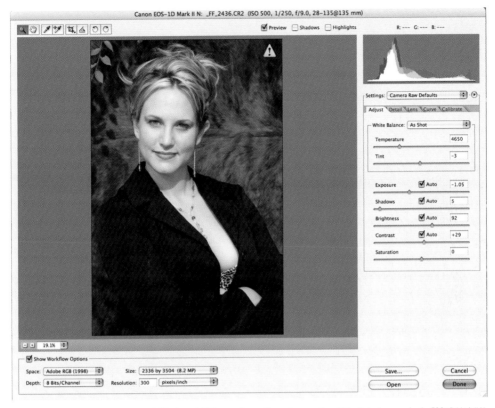

Canon EOS-1D Mark II N: _FF_2436.CR2 (ISO 500, 1/250, f/9.0, 28–135@135 mm)

One of my favorite techniques is capturing RAW color and JPEG monochrome files at the same time. Using its back-up mode, the EOS 1D Mark II N lets you simultaneously capture the different file types on different memory cards. © 2005 Joe Farace.

color/monochrome capture, although it is sometimes disguised as RAW + JPEG (Joint Photographic Experts Group) capture. The Mark II has separate slots for CompactFlash and SD memory cards. The N model adds a unique twist by being able to capture a RAW image onto one memory card and JPEGs on the other. That means you can capture *color* RAW files on the CompactFlash card, while recording JPEG files in *monochrome* at the same time on the SD/MMC card!

Other digital SLRs that offer simultaneous RAW + JPEG capture allow two files to be captured onto the *same* card. Whatever monochrome/filter setting you have will be applied to the JPEG file but the RAW remains unprocessed and in glorious color.

THE DIGITAL DIFFERENCE

If your camera doesn't have a monochrome mode you have no choice but to convert that image into black and white after the fact. Here are some entry-level methods to turn that living color image into something a little more dramatic.

This image was captured as a color file using a Samsung GX-1S and 12–24-mm Pentax lens. Exposure was 1/180 second at f/11 in Program mode at ISO 200. The built-in flash was used to fill in shadows at the bottom (of what is left of a) Datsun 2000 roadster. © 2006 Joe Farace.

When you select Image > Mode > Grayscale in Adobe Photoshop CS2, a small dialog box appears asking if it's OK to discard the color information. Since you should be working with a *copy* of the file and the original is safely ensconced on a CD/DVD tucked away somewhere safe, it's OK to click OK and remove the color, but that's all you will do.

One of the simplest ways to create a black and white image from an all-color file is to use the Monochrome command found in many image-editing programs, usually under the Mode menu. (In Adobe Photoshop CS2 it can be found under Image > Mode > Grayscale.)

The resulting monochrome file will usually be flat looking and lacking the contrast of the original image file, so the simplest way to correct this is to use the Brightness/Contrast control to kick up the contrast a bit. The number shown is what I actually applied to the finished image but there are no magic numbers here. Gradually move the slider (increasing the contrast) and observe the effect before clicking OK.

The finished image was made with only two image tweaks: the first to remove all color and the second to increase contrast slightly. It may be all you need to do but if you want to try something else, keep reading.

CHANNEL MIXER

Adobe Photoshop CS2's Channel Mixer command produces grayscale images by letting you choose the percentage of contribution from each color channel. The Channel Mixer modifies a targeted output color channel, in this case grayscale, using a mix of the existing image's color channels. When using the Channel Mixer, you add or subtracting data from a source channel to the output channel (Grayscale, when the Grayscale box is checked). It has more steps than the two in the previous example, but takes place in only one dialog box and gives you greater control. With practice you can whip through it.

Step 1: The original image was captured in color mode using a Pentax*ist DL camera and 10–17-mm Pentax fish-eye zoom lens. Exposure was 1/6 second at f/2.8 at ISO 400. The image was opened in Adobe Photoshop CS2. © 2006 Joe Farace.

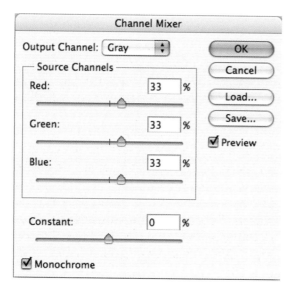

Step 2: The next step is opening the Channel Mixer dialog box (Image > Adjustments > Channel Mixer). Be sure to check the Monochrome option to set Gray as the output channel. This creates a color image that contains *only* gray values. Move the sliders to control the amount of detail and contrast in the image you plan to convert to grayscale, but first view how changes in each source channel affects the final monochrome image which is "live" as you work on it. *Tip:* When adjusting the percentages of the source channels, you often get the best results when the combined values of the source channels add up to 100%. If you go over 100%, you'll overexpose an image and if you go under 100%, you will underexpose an image.

Step 3: Applying the Channel Mixer command is all most photographers may need to convert image files to monochrome, but if you want MORE POWER, it's time to reach for a few *power tools*. © 2006 Joe Farace All Rights Reserved.

MONOCHROME POWER TOOLS

After RAW conversion, the next hottest bit of digital alchemy is black and white conversion of color images. Everybody has his or her favorite method, but Black & White Studio (www.powerretouche.com) may be the best ever monochrome conversion Photoshop-compatible plug-in. You can use the light sensitivity of films (Kodak Tri-X, T-MAX) to make the conversion or create your own sensitivity curves and save them for later use. Black & White Studio's color filters are arranged on two "pages" for Windows and *three* in the Mac OS version.

The Black Definition plug-in makes a wonderful complement to Black & White Studio and lets you adjust black as if it were a color channel. Before you finish, use Power Retouche's Toned Photos plug-in to add Sepia, Van Dyck, Kallitype, Silver Gelatin, Palladium, Platinum, Cyanotype, Light Cyanotype, or Silver toning using built-in presets or create your own. All three plug-ins work with 8-, 16-, 48-, and 64-bit RGB, Grayscale, Duotone, or cyan, magenta, yellow, and black (CMYK) image files. Power Retouche offers a suite of 20 Mac OS and Windows power tools for $175. *Ala Carte*, Black & White Studio sells for $75. Black Definition costs $32, and Toned Photos is $54.

Black & White Studio is a Photoshop-compatible plug-in that features four groups of controls including Filters, Film, Print (multigrade, exposure, contrast), and Zones, but instead of *those* zones you get three selectable and adjustable zones.

Power Retouche's Black Definition Photoshop-compatible plug-in makes wonderful complement to its Black & White Studio and lets you adjust black as if it were a color channel in color, black and white, or even digital infrared images as demonstrated here. © 2005 Joe Farace.

The Toned Photos plug-in can add Sepia, Van Dyck, Kallitype, Silver Gelatin, Palladium, Platinum, Cyanotype, Light Cyanotype, or Silver toning with the built-in presets, or create your own. All Power Retouche's plug-ins work with 8,- 16,- 48,- and 64-bit RGB, Grayscale, Duotone, or CMYK image files. © 2005 Joe Farace. All Rights Reserved.

This image of an Austin delivery van was originally captured as a color file with a Canon EOS 20D and EF 10—22 mm-EF-S lens at 13 mm. Exposure at ISO 800 was 1/500 second at f/16. Image was converted into monochrome using Power Retouche's Black & White Studio, then tinted in Toned Photos using the Van Dyck preset. © 2005 Joe Farace All Rights Reserved.

Convert to BW Pro 3.0 automatically compensates exposure for prefiltering and color responses. For the Contrast tab, Ilford provided their original curves data allowing the Multigrade slider to set contrast that matches their traditional darkroom papers.

Two different "Sepia" types are available: Tone is a graded transition that leaves whites pure, whereas Tint adds an overall color tint.

The Imaging Factory's (www.theimagingfactory.com) Convert to BW Pro 3.0 has more user control than before and the ability to save favorite settings for later use. The floating control palette contains four tabs for adjusting all relevant parameters needed for conversion. The Prefilter tab lets you filter the original image to enhance or dampen certain color areas. The Color Response tab is like using different Black & White film types when shooting a film camera and acts as a color equalizer.

Bill Dusterwald is the genius who created Silver Oxide (www.silveroxide.com), a family of Photoshop-compatible plug-ins allowing digital images to emulate the tonalities of "real" analog film, such as the Kodak's classic Tri-X, or my favorite Panatomic X. Now's he's begun a series of new monochrome filters designed to optimize based on subject matter. The first is the Landscape filter and addition to the typical filter options Silver Oxide offers in the dialog box, such as red, orange, and the ubiquitous none, he's added a new purely digital filter called BANG (Blue Algorithm Neutral Gray) that acts like a polarizer filter.

Alien Skin Software's Exposure (www.alienskin.com) brings the look and feel of film to digital photography. Exposure is *two* plug-ins: Black and White Film emulates a dozen different film stocks and Color Film not only recreate a film's

Usually Silver Oxide filters are modeled on the existing analog world, but creator Bill Dusterwald says that the BANG filter is "pure digital whiz bang." All I can add is that it sure is.

distinctive look as a more-or-less one-click operation, but manages saturation, color temperature, dynamic range, softness, sharpness, and grain at same time. These presets are just the starting point and can be tweaked to suit a particular photograph or applied to a batch using Photoshop Actions. Exposure can add grain to an image's shadows, midtones, or highlights, and models the size, shape, and color of real-world grain. The plug-in presets include high-level contrast and highlight and shadow controls that can be applied with just a click. Additional features reproduce studio and darkroom effects such as cross-processing, split-toning, push processing, and glamour portrait softening. Exposure even includes presets for cross-processed Lomo-style image shots with your choice of four different manufacturer's film! In addition to a before/after button, the preview window includes an optional, split-preview, and combines unlimited undo/redo pan and zoom using Photoshop-style keyboard shortcuts.

Alien Skin Software's Exposure is really *two* plug-ins: Black and White Film emulates a dozen different film stocks and Color Film recreate a film's distinctive managing saturation, color temperature, dynamic range, softness, sharpness, and drain at same time. Here the Black and White module was used to recreate the look of Agfa's Delta 3200 film.

IT WAS A DARK AND STORMY NIGHT . . .

Just because it's a bright and sunny day doesn't mean you want that same mood for the photographs you're making. That's the kind of thoughts that were running through what's left of my mind when I was looking at this photograph of Mary and I standing in front of the *Psycho* movie house that was shot during a private tour of Universal Studio's backlot. (Pssssst, that's "Mother" staring at us out the window in the second floor window.) I decided to change the cheerful mood by using Adobe Photoshop CS2 (www.adobe.com) along with some powerful digital power tools to create a spookier image.

The original photograph of Mary and me was made by Ralph Nelson, a noted movie set photographer who's also a heckuva nice guy. Be sure to visit Ralph's website (www.ralphnelson.com) to view some astonishing work by this talented photographer. For the photograph, he borrowed my Pentax Optio S digital point-and-shoot camera. According to the exchangeable image file (EXIF) data, exposure was 1/800 second at f/4.3 in automatic mode.

Step 1: The first thing I do with any digital photograph is to tweak its color, density, and contrast. There are lots of ways to accomplish this, but I still usually start with PhotoTune's 20/20 Color MD plug-in.

As before, 20/20 Color MD gives me a pair of images and I click the one I like. It doesn't have to be the "perfect" one, just the best one of that pair. The plug-in uses all of your choices to come up with something much better and you can even do manual tweaks at the end of the process.

Step 2: When Hitchcock made *Psycho* it was a low budget effort that was shot in black and white using the same film crew he worked with on his television show,

My tool of choice for monochrome conversion is The Imaging Factory's Convert to B/W Pro Photoshop-compatible plug-in. The plug-in interface provides several options including emulating the tonality of "real" film, so I picked Kodak Tri-X as an obvious choice. Convert to B/W Pro also lets you apply color filters, add toning, and tweak contrast and brightness based on digital versions of traditional darkroom paper grades.

"Alfred Hitchcock Presents." So, my next step was to convert the color image file into a monochrome photo.

Step 3: To add a nighttime mood to the photograph, I reached for the Midnight filter that's part of nik Color Efex 2.0.

TIP

Don't be timid when using a plug-in's slider controls. Push them to the extremes and explore the possibilities rather than just inching them up until you see something you like. Maybe what fits the image best is an extreme or mild application of an effect, but you'll never know until you try.

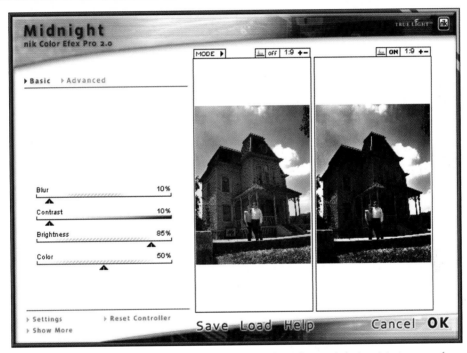

nik Color Efex 2.0 includes a set of Traditional and Stylizing filters, and the Midnight set offers several color tint variations you can use from depending on your image. For "Joe & Mary go Psycho" I used the standard Midnight filter, but manipulated all of its sliders to get the effect I wanted.

Step 4: To give the photograph a little "bam!" seasoning *ala* Emeril, I decided a lightning strike would be a nice touch. That's when I selected the Xenofex package of Photoshop-compatible plug-ins from Alien Skin Software.

TIP

Although the photograph is in black and white it's still an RGB file. (Convert to B/W Pro doesn't change the image file's Mode to Grayscale.) So I decided to give the lighting a green exterior glow in homage to "The X Files."

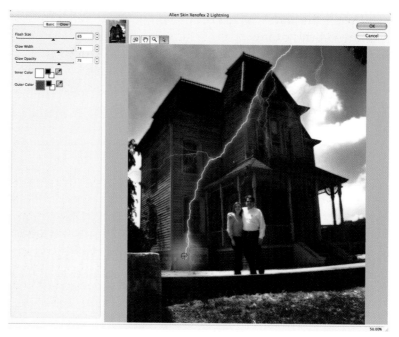

Xenofex can do more than add Thor's lighting bolt to your digital images; the package also includes Burnt Edges, Puffy Clouds, Cracks, and lots of other fun effects. Lightning has a large resizable preview screen and gives you controls for the shape and style of the lighting bolt as well as its inner and outer color.

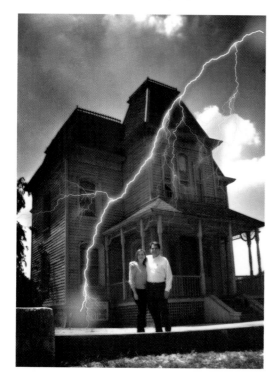

I did a little digital burning and dodging along with cropping to produce the final photograph that I call "Joe & Mary go Psycho." I normally don't like to crop my own photographs let alone another photographer's, but cropping some of the grass in the foreground and that tree branch coming "out of nowhere" in the upper right-hand corner tightened up the image by removing extraneous visual data that doesn't add to the overall impact.

Although I used the Mac OS version of Adobe Photoshop CS2 and all of the plug-ins shown in this example, all of this software is also available for Microsoft Windows. In addition, you can download demo versions of many of the products shown here, and I urge you to give them a try to create your own digital weather effects. Sometimes, it's OK to fool Mother Nature, especially when using digital power tools such as the ones shown here.

THE DUOTONE COMMAND

When black and white photographs are printed on a press, they are sometimes produced using more than one color ink in order to add depth. When two colors of inks are used it's called *duotone*, when three inks are used it's a *tritone*, and when four are used it is a *quadtone*. As with all photographic techniques—including digital imaging—there is more than one way to accomplish working with monochromatic images. Located inconspicuously in Photoshop's Image menu is the Duotone command, which can open many creative doors for the pixographer who is interested in printing monochrome images.

One gateway to adding Duotones, Tritones, or Quadtones to a grayscale photograph is the Duotone Options dialog box that appears after selection Mode/Duotone from Photoshop's Image menu.

- *Duotones*: In order to apply the Duotone command, the image must first be in Grayscale mode. When starting with a color image, be sure to convert it first. When you select Image > Duotone, you'll see a dialog box showing the two colors that are used. To use sets of color that are guaranteed to work together, click the dialog's Load button to get

to Adobe's Duotone Presets folder. In Adobe Photoshop 5.5, a Duotone Presets folder, containing all kinds of color combinations, is found inside the Goodies folder, inside the Adobe Photoshop Only folder. In version 6.0, look in the Presets folder inside the Photoshop folder. This is true for both Macintosh and Windows versions of the program. In the latest version, there are three choices: Gray Black Duotones, Pantone Duotones, and Process Duotones. Open any folder and click on one of the choices. If you don't like any of the results that you get, keep trying until you find one that you like. Using the Duotones command creates a file that has layers. This means you can save the finished file in Photoshop's native format (.PSD) or use the Flatten Image command in the Layers menu to save it in other formats such as tagged image file format (TIFF).

This photograph of a restored 1920s Conoco station was made on Kodak Tech Pan film and digitized on Photo CD. Since Grayscale Photo CD files are in RGB format, the image was converted to Grayscale format using Photoshop's built-in conversion before applying the Duotones command and using one of the presets from the Gray/Black duotones folder. © 2001 Joe Farace.

- *Tritones*: Making a tritone image is identical to making a duotone; the only difference is that now you have a three-color palette of colors to work with. For an image of a model dressed as *Little Red Riding Hood*, a red-based set of presets was loaded from the Process Tritones folder to compliment the image. If I wanted to show a snowy landscape, I might have selected a blue-oriented combination. While looking at the finished, printed image, you should notice it has more depth than a duotone.

The original portrait of Kim as Little Red Riding Hood was made on Kodak Ektapress Plus color negative film, but was converted into grayscale using nik Color Efex Pro's B/W Conversion plug-in. It was converted into a Tritone using the Duotone command selecting the BMY red 1 (black–magenta–yellow) preset from the Process Tritones folder. © 2001 Joe Farace.

- *Quadtones*: If you've been following along, you should know how to make a quadtone image: You start by applying the Duotone command that converts your grayscale file into a duotone, then load in a collection of *four* complimentary colors to add depth and color to a monochrome image.

This photograph of a building in downtown Denver was originally made on Kodak 100VS slide film before being digitized and converted to grayscale with Silver Oxide's Ilford Pan F filter. It was converted into a Quadtone using a preset that used black plus four shades of gray providing a "split-fountain" effect in which a cooler gray is used at the top of the building for the sky, while warmer tones are used on the street level. © 2001 Joe Farace.

Making Photo Quality Ink-Jet Prints

You guys are the Lone Gunmen, aren't you? You guys are my heroes. I mean look at the crap you print.

Printing using digital technology is simply the latest link in a chain that started when Louis Jacques Mandé Daguerre placed a silver-covered copper plate in iodine vapors and watched an image appear. Printing photographic images in a desktop darkroom means no more working in the dark, fingers soaking in smelly chemicals, while waiting for results to appear on dripping wet paper. This is not to demean traditional darkroom methods; there is nothing more luminescent than a platinum contact print made from a properly exposed large format negative, but the ink-jet print is clearly this millennium's medium.

Some purists may scoff at digital printing, claiming that the images created using computer technology aren't permanent, but the truth is that while traditional photographic prints may be processed to assure permanence, others, through either choice of materials or the processes used, may not be. In much the same way, some digital prints may be produced using inks and papers that *will* create an archival print, while others may not. The image maker's choices made through experience or inexperience will determine the final result.

The Zuiko Digital ED 7–14 mm f/4.0 was used to photographing the rare McLaren M6GT in the Mathews Collection (www.mathewscollection. com) set at 7 mm. It was also shot wide open at f/4.0 yet look at the depth of field! Yes I used a tripod. ©2005 Joe Farace.

INK AND PAPER COMPATIBILITY

We all know how well ink-jet printers and papers work together? All you have to do is to stick some papers in the printer, tell your software that you want to produce photo quality output, and the results are perfect. Right? If that's hasn't been your personal experience, you should read what follows.

All ink-jet printers spray ink through nozzles—or *jets*—onto paper and the technology used falls into two categories:

Micro Piezo: Much like a tiny *Super Soaker,* the micro piezo print head used in Epson printers, squirts ink through nozzles using mechanical pressure. Depending on the amount of current applied, the print head changes shape to regulate the amount of ink released.

Thermal: In the system used by Canon, Hewlett-Packard, Lexmark and other manufacturers, ink in the print head is heated and expands to where it's forced though the nozzles and onto the paper. There are variations with how each company's printers accomplishes this task, but you get the idea.

Some printers have nozzles built into the print head, while others place them in the ink cartridges, but I've never seen much visible difference in the output because of this difference in design.

How much ink exits the print head is measured by its *droplet* size. In general, the smaller the size, the better the image quality. Ink droplets are measured in *picoliters*, which is one million *millionth* of a liter! Printer resolution is rated in dots per inch or dpi. A 720 dpi device prints 518,400 dots of ink in one square inch; the greater the number of dots, the higher the resolution.

PRINTING IN THE REAL WORLD

One of the first things digital imagers are in a hurry to do after capturing an image is to print it. Here in the digital darkroom where technical advances have freed us from most of the restrictions of the traditional darkroom, for most photographers ink-jet printer use breaks down along the classic line of the three "P's"—proofs, prints, and portfolios.

Proofing: Most digital color printers started life as proofing devices for making a quick approval print for a client before producing separations, and many photographers still use their desktop printers for proofing. A proof printed on inexpensive but high-quality media provides insurance that the final image will look the same way it looks on your monitor. Making a paper proof is also a good idea when sending a digital file to a client or service bureau so the recipient knows what the finished image will look like. I made proof sheets of all of the images in this book to give the designer an idea of how the images should appear.

Printing: The papers and inks that can be used by the latest ink-jet printers produce prints that have a life as long as a lab-made print. Information on archival stability of inks and papers can be found at Wilhelm Research's website (www.wilhelm-research.com). For most applications, people receiving the prints I send don't even ask if they're "digital" because they look just like "real" photographs.

Portfolios: For professional and aspiring professional photographers, one of the advantages of producing photo quality output in-house is the ability to update and customize a portfolio. Having an ink-jet printer, such as the Epson Stylus Photo R1800, lets photographers print high-quality portfolio images up to 13 × 19 inches.

The revolution in color ink-jet printing technology forever changed the deskscape. For less than $100, inexpensive printers from companies such as Canon, Epson, HP, and Lexmark let you produce photographic quality output, but there is a price to be paid for this capability. As color printers became better and better (and cheaper too), computer users began to demand more from them; not just higher resolution but better, more accurate color. This quest engendered an endless cycle of continued printer improvements to find color nirvana: WYSIWYG color.

Before starting on the path to accurate color there are many roadblocks that must be overcome, including price. Somewhere along the way, you are going to have to stop and ask yourself this question: "How much am I willing to pay for accurate color?" Your answer determines which of the several available software

and hardware solutions are appropriate for your situation. That's why one of my goals in this chapter is to point you toward inexpensive solutions to the color management dilemma.

PRACTICAL COLOR

There are few obstacles standing in the way of obtaining an exact color match between what you see on the monitor and what your printer will deliver. The most fundamental difference is that when looking at a monitor you are viewing an image by *transmitted* light. Much as when viewing a slide on a light box, light is coming from behind that image. When looking at output, you are seeing the print by *reflected* light. Right away there is a difference, but these differences can be exacerbated by environmental factors, including monitor glare and ambient light color. While light may appear white to our eyes, it actually comes in many hues.

Depending on chemical composition (more on ink idiosynchracies later), the output of printers using pigmented inks exhibit a characteristic called *metamerism*. If you look up "metamerism" in the American Heritage Dictionary of the English Language, Fourth Edition 2000, it is defined as "The condition of having the body divided into metameres, exhibited in most animals only in the early embryonic stages of development." Aren't you glad you know that? As the coachman said to Dorothy when taking her to see the Wiz, "that's a horse of a different color." Metamerism refers to situations where output from a color printer looks fine under one set of viewing conditions but not under another.

Since metamerism can never be completely eliminated with output from some desktop printers, you should make sure it's originally viewed under consistent

Ott-Lite's VisionSaver Plus table lamp can be used parallel to the desktop, straight up to illuminate larger areas, or can be attached to a wall. It features a 13-W VisionSaver Plus tube that lasts up to 10,000 hours. Photo courtesy of Ott-Lite Technology.

lighting. If you go into any professional photographic lab or a commercial printer, you'll find a special area set aside for viewing output. This area will have test prints posted and will have lighting fully corrected for daylight. If it looks good there, as the song goes, it'll look good anywhere. Most computer users can't afford the kind of viewing boxes professional labs have, but Ott-Lite (www.ott-lite.com) sells affordable accessory lamps that can bring color-correct viewing to your desktop printer. They offer a family of modestly priced VisonSaver lights that you can place near your printer to help you see color properly. Ott-Lite's 13-W Portable lamp, for example, should fit into anybody's workspace.

MONITOR CALIBRATION

Once you're aware of the environmental effect on output, you need to take steps to bring your computer system into color harmony. There are a few ways to minimize problems, but the key is knowing what the color of your image is to begin with. Running Adobe's Gamma software (www.adobe.com), automatically installed with recent versions of Photoshop as well as the inexpensive Photoshop Elements, is the first step. The Gamma Control Panel lets you calibrate your monitor's contrast and brightness, gamma (midtones), color balance, and white point. There are two ways to work with Gamma and both are easy, including a step-by-step wizard approach. More detailed information of setting Gamma can be found in Adobe's on-line Technical guides (www.adobe.com/support).

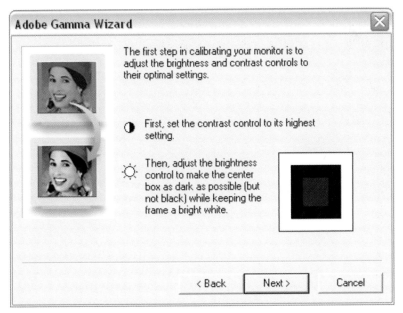

Adobe Gamma can calibrate and characterize your monitor: *Calibrating* your monitor brings it into compliance with a standard. *Characterizing* your monitor simply creates a profile that describes how the monitor is currently reproducing color. It also helps you set optimum brightness and contrast range.

The settings you obtain by working with the Gamma control panel are used to create a *profile* for your monitor that is used by color management systems such as ColorSync for the Mac OS and Microsoft's ICM for Windows.

While Gamma isn't perfect, it will get you into the ballpark. Once again the better the color match, the pickier you may become. The secret in pursuing the quest is *not* to hunt until the color dragon is slain but until you are satisfied, considering how much it has cost so far, with the match between monitor and print. One of the least expensive ways to calibrate your monitor is by using ColorVision's Monitor Spyder (www.colorcal.com). This combination of hardware and software can calibrate any cathode ray tube (CRT) monitor and will produce International Color Consortium (ICC; www.color.org) profiles for Mac OS and Windows color management systems.

This Spyder is a Plexiglas and metal device that attaches to your liquid crystal display (LCD) or CRT monitor, the way you may already have stuck a stuffed Garfield there. When used with ColorVision's software, such as PhotoCal or OptiCal, it's relatively simple to calibrate your monitor.

Monaco Systems (www.monacosys.com) offers a color management package that includes MonacoPROOF software and X-Rite's Digital Swatchbook spectrophotometer. Digital Swatchbook works with Macintosh or Windows computers using measured spectrophotometer readings for color-managing desktop

computers. MonacoPROOF builds custom ICC profiles to let you obtain accurate color from scanners, digital cameras, monitors, printers, and even color copiers. The software has a wizard-like interface that guides users through the profiling process and displays on-screen images accurately to produce "soft" proofs. Some ink-jet printers bundle a copy of Monaco EZcolor Lite that lets you create a single monitor profile for your system.

OUTPUT SOLUTIONS

You may find after you've tried one of these monitor calibration methods, that while your on-screen image and output are a much closer match, they are not quite the same. (Don't forget differences in reflective and transmitted light and the possibility of metamerism.) In my own case after happily using Adobe Gamma for many years I started using ColorVision's Monitor Spyder and PhotoCal software. The result was that output from my printers looked *better* than it did on screen. If you're still not happy with your prints, it's time to look at output profiling.

There are two kinds of people in this desktop darkroom world; those who need output profiles and those who don't. When using ink-jet or even laser output as a proofing media, prepress users know output profiling is critical. Photographers using ink-jet output as the *final* product have different needs from prepress users. All these people need is for the prints to match their monitor or their original vision of how the image should appear—what Ansel Adams called *previsualization*.

A great companion to ColorVision's Spyder Monitor is their Profiler software, which is one of the neatest ways I've found for color managing a desktop printer. ColorVision provides target files that you output on your printer. After you digitize that output with your scanner, Profiler RGB compares your image with the original file and creates a unique profile for a specific paper/ink/printer combination. If you're serious about color management, you might want to check out two other ColorVision products. Doctor Pro software lets you edit RGB and CMYK printer files and uses Photoshop's capabilities to create adjustment scripts for editing output profiles, including color cast removal, opening shadows, correcting color mismatches, as well as adjusting brightness, saturation, and contrast.

OnOne Software's Intellihance Pro offers many image enhancement capabilities and functions the same way a traditional darkroom worker might produce a test strip. Printing a digital test proof shows what the image looks like with user-specified increments of additional cyan, yellow, and magenta, or red, blue, and green, so you can see how much of what color to add in the printer driver to get output matching your previsualization. The plug-in is available in Mac OS or Windows versions, and you can download trial versions from the onOne website (www.ononesoftware.com).

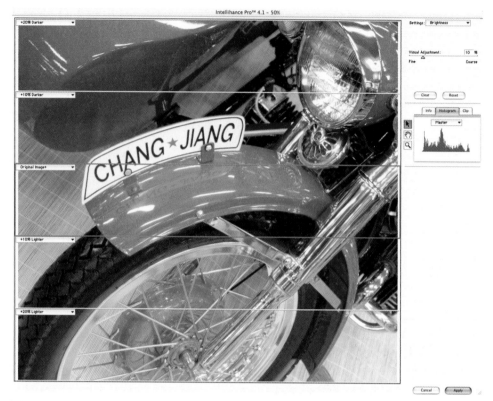

OnOne Software's Intellihance Pro has a feature that functions much like a traditional wet darkroom test strip. © 2006.

INK AND PAPER

Four-color ink-jet printers have the same Cyan, Yellow, Magenta, and Black color combination used by commercial printing presses. To reproduce delicate textures such as skin tones and metallic surfaces, six color printers add Light Cyan and Light Magenta. Some Epson (www.epson.com) printers, such as the Stylus Photo 2200, uses *seven* colors, adding a light black for more depth and better mono-chrome reproduction. There is a trend to keep adding more colors. Most desk-top ink-jet printers use one or two ink cartridges, but professional ink-jet printers typically have a separate cartridge *for each color*, something Canon (www.canon.com) originally popularized for desktop photo printers.

Ink-jet printers do *not* have the same ink formulations. Some companies use pigmented-based inks for their black ink cartridge and dye-based inks in their CMY or CMYcm color cartridges, while yet others use all dye-based inks or all pigmented inks. Why do you care? Pigmented inks last longer but are not as vibrant; dye-based inks are colorful but have less longevity. On plain paper, dye

and pigmented inks mix easily because of this media's high ink absorption rate, but when printing on coated stock, such as photo papers, printers with different types of inks turn *off* the black ink. (Black in the output then becomes a composite of the CMY inks.) Pigmented black ink is slightly better than dye-based ink for printing sharp, dense, black text on plain papers and some manufacturers prioritize black text over photo quality. Epson's UltraChrome inks, found in the Stylus Photo 2200 as well as their large format printers, is water-resistant and provides bright colors that are similar to dye-based inks, but retains pigmented ink's lightfastness.

Because of these differences, selecting the paper type in the printer driver is a critical step in achieving the best possible output. Each type of paper shown in the printer software driver uses a different look-up table and assigns different ink saturation. *Any* ink-jet printer can print black and color inks on plain paper at the same time, but if you select the wrong media—either by accident or on purpose—you'll get poor results. So waddaya do to get the best results?

- Read the paper's instruction sheets to see which driver settings are compatible with the paper and what settings should produce the best results.
- Not every paper and ink combination works together perfectly. Before making a big investment in papers, purchase a sampler pack or small quantity of a paper and make prints with your *own* test files. (More on how to do this later.) Write notes about the settings and papers on the back of the prints and put them away in a file for future reference.

Adorama's ProJet Photo Gloss papers are a premium, high-resolution *microporous* resin-coated photographic quality paper. It was designed for the highest-quality color images and features an excellent tonal range, bright whites, and "bleed control" to prevent banding. ProJet Photo Gloss is water-resistant and is compatible with all desktop printers. Photo courtesy of Adorama.

ALTERNATIVE INKS

There are all kinds of generic inks out there that are theoretically designed to replicate OEM inks, and if you don't mind getting messy, you can refill those puppies yourself. Using non-OEM inks will void your printer warranty, but I know many people using replacement inksets, especially continuous flow systems from Media Street (www.mediastreet.com) that have been happy with the results. A user of Media Street's Niagara II system told me, "I am not only saving a tremendous amount of money . . . but I also get the advantage of using specialty ink which allows me to print long-lasting photos right from my inkjet . . . and I will never run out of ink again in the middle of a print."

It's not a sin to use third-party inks, and my own experience, and that of others have shown that Media Street inks in continuous flow or cartridges that are compatible with Epson and other ink-jet printers are really *compatible* with them. Photo courtesy of Media Street.

While your printer is still coved by a warranty, your best bet for achieving the goal of quality output is with OEM inks. Thrifty shoppers tell me Costco has low prices on ink and media. On line, websites such as InkjetArt.com have some of the best prices available anywhere on OEM ink and paper. I advise digital imagers who want to work with archival and gray inksets to do it with *another* printer not the bread-and-butter model used for everyday work. Go to eBay or look for deals at the sales shelves of computer superstores to find discontinued models

and experiment to your heart's content with cheap, recycled, or whatever home brew ink you want. The real question to ask yourself is: Do I really care what the output looks like?

BLACK AND WHITE IN COLOR

One of the biggest challenges in managing color output is printing black and white or monochromatic images—including IR image files. This is especially a problem with ink-jet printers because the best you can accomplish by using colored inks is cool or warm toned output, which when used with printers using pigmented inks, finds metamerism rearing its colorful head. You can always print using black ink only, and I have successfully produced output this way especially using 2800 dpi printers, but the results are heavily dependent on the original image. To get truly continuous tone black and white output, you need a grayscale inkset. These replacement inksets and complimentary software are available from companies such as Media Street and Lyson (www.Lyson.com.) These companies offer archival quality inks that when used with acid-free paper produce museum quality giclée images (pronounced zhee-CLAY) that can be sold in art galleries anywhere in the world.

I think "Captain Hook" looks more dramatic in monochrome than color because it removes the distraction of color from his handsome face. He was captured directly in black and white using the Canon EOS-1D Mark II N's Monochrome mode. Exposure was 1/160 second at f/5.0 at ISO 320. He was digitally toned using Pixel Genius' PhotoKit Photoshop-compatible plug-in. © 2005 Joe Farace.

Printer manufacturers including Epson and HP have started offering printers that will print IR monochrome images by using *additional* black ink cartridges. Epson's R2400 has a maximum output size of 13 × 19, and uses the printer's *eight* UltraChrome K3 pigment inks to produce archival color and black and white photographs. Yup, that's the same inkset Epson offers in their professional wide format printers, but are available here at a more or less desktop price. The printer is delivered with *nine* inks including user-interchangeable Photo and Matte Black cartridges. With its expanded inkset, including Black, Light Black, and Light–Light Black inks, Epson's Stylus Photo R2400 produces beautiful black and white prints that should last up to 200 years, and color prints that are fade-resistant for up to 108 years.

On the Epson 2400, monochrome IR image files are printed deliciously warm on Epson media, which I liked. If you go into the Advanced section of the printer's driver and select "Black and White printing" only the three black inks are used and the images produced are falling down beautiful and as neutral as Switzerland.

THE PRINT BUTTON

Sometimes it seems that different people can get different results from the same photographic file printed working with the same kind of ink-jet printer while using the same kind of paper. How is this possible? The biggest difference is that one of these pixographers is getting the most out of his printer's driver, while the

other is just clicking the "Print" button. I get this question all the time from people who ask why the prints made on my printer look different from those that they're making with the same brand and model of ink-jet printer.

There are a few steps you should take before even starting to work with your printer's software:

Before you make your first print, do something that some male readers may find difficult: Read the instruction manual. If you do, you'll discover that there are usually several utilities that will help your printer produce the best possible results. With new Epson ink-jet printers, it's always a good idea to run both the Head Alignment and Nozzle Check utilities before putting in any "good" paper and making a print. Some new printers run two head alignment tests, one for black ink, the other for color. When you run these tests, it's a good idea to evaluate the output using a high-quality magnifying loupe so that the feedback you provide the utility is as accurate as possible.

Download the latest printer driver. Don't assume that just because you unpacked a brand new printer you'll have the latest driver. It may be that

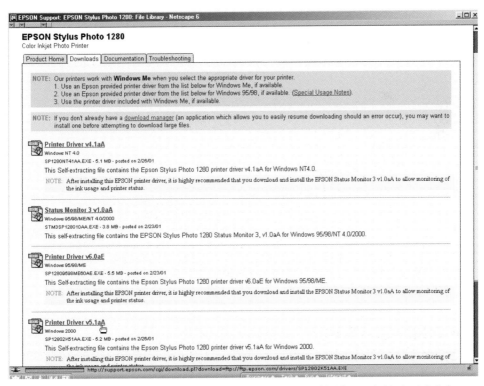

Don't assume that just because you unpacked a brand new printer you'll have the latest driver and don't forget to check back periodically for updates.

support has been added for new, different kinds of papers or it could be that software bugs have been fixed, but take the time to go to your printer manufacturer's website, download the most current driver, then install it.

Clean the printer heads! If you don't like the results coming off your ink-jet printer, clean the print heads! They get *clogged* and your printer's manual contains information on how to use software to clean clogged heads. If you are having a problem and don't like the output from your ink-jet printer this will fix it—most times anyway. Many photographers show me ink-jet prints and ask what's wrong with them when the answer is simply that the heads are clogged. How do heads get dirty? If the printer is left on and not used regularly, air gets into the heads and dries the ink, which clogs the ink ports. Print heads get dirty or clogged from not being used, so try to use them every day.

TIP

If you don't use your printer daily, at least turn it on once a day. Most printers include a startup routine that cleans the heads. By simply running this every day you can prevent clogged heads. Yes, this uses ink, but far, far less than running repeated head cleanings to clear clogged heads.

Until somebody invents a self-cleaning head for ink-jet printers (why just have it for ovens?), we'll have to clean them periodically, wasting precious Dom Perignon-priced ink in the process. Hey, you used to have to scrub your ovens by hand too; now self-cleaning ovens make that chore a cinch. So maybe somebody will figure out something similar for ink-jet printers—or maybe not.

GET TO KNOW YOUR PRINTER DRIVER

Some printers have built-in calibration routines that set up the device after you've made your initial connections. With most computer systems, this will most likely happen when the printer driver is installed, but you may also need to recalibrate it from time to time.

Experimenting with different kinds of papers with interesting textures and ink absorption characteristics can be fun, but judging from the questions I get during workshops, this is often when fun goes *out* of the process. The stock answer is that you should create a custom profile that is hardware, ink, and paper specific. Many new digital imagers don't want the hassle involved, but some forward-thinking paper companies are taking steps to put that creativity back into printing and have created generic profiles for each of their papers and different kinds of ink-jet printers. I used to go to the art supply store to find papers with interesting textures, but now papermakers such as Hahnemühle (www.hahnemuhle.com) and Adorama are offering interesting surfaces.

While the *safest* way to get the best possible results is to use the inks and papers produced by the printer manufacturer, it isn't always the best way. If you are still not satisfied with the results—but before you go running of to try other inks and papers—make sure that the printer itself is capable of providing the best possible results. It may not be. If your friends and colleagues are getting better results than you, the first place to look for improvements is the printer driver. Only after you've first optimized the printer to produce the best possible results you should start looking for ways to improve your printer output.

PRINT LONGEVITY

One of the best things to ensure a print's longevity is to take a few simple steps:

- Allow prints to dry for 24 hours before framing them. Avoid framing when humidity is high because condensation can form behind the glass. Don't hang prints in direct sunlight or display prints outdoors.
- When storing prints in a stack, allow them to dry for at least 15 minutes, and then place a sheet of plain paper (I use copier paper) between the individual prints. Allow a full day for prints to dry before removing the separator sheets. And don't force-dry prints with a hair dryer.
- Keep prints away from sources of ozone, such as computer monitors, televisions, air cleaners, or high-voltage electricity. Don't store prints where they are exposed to chemicals, such as in a traditional darkroom.
- When storing prints in photo albums, use acid-free, archival sleeves.
- Finally, visit Wilhelm Research's website, which is regularly updated with information on the stability and longevity of new inks and papers.

test prints seen in computer and electronics stores where you press a button and output rolls off of the printer. While these files are usually optimized to make the printer look good, the output can be compromised if the paper used is either the best or cheapest available. In this kind of setting, there are too many variables present to use these test prints for comparing one printer to another. The key to comparing results from different printers or papers is to create a standardized test file and use *it* to compare results.

Your personal test file should reflect your typical image, such as an IR landscape photograph. Use your favorite image-editing program to save a photograph in a high-resolution format such as TIFF (tagged image file format). Instead of making the image 8 × 10 or full letter size, keep it around 5 × 7. This will make the file size smaller and take less time to print. The file should then be saved on some kind of removable media, such as recordable CD/DVD so it can be used later when testing new printers, inks, or papers.

Start by printing the testing image on your own printer, but also ask friends if you can output it on *their* printer, so both of you will be able to make a valid comparison. Use the test print with the printer driver's Advanced settings and experiment with the slider settings for brightness or contrast. Then take a look at color bias. Monochrome prints will clearly show any kind of color shifts for the papers, inks, or printers because color shifts will be more apparent with no color in the image. Working with your customized test file will let you know what driver settings will produce results you like and can also be a big help when evaluating different kinds of paper brands. After a little testing, you'll find the best paper and settings that will produce the optimum quality output from your printer.

INK-JET PAPER CHOICES

The ink-jet paper you use can have a dramatic effect on the quality of your output. Printer manufacturers may insist that the best output will *only* be produced when using their papers, and I won't argue that some of them are spectacular, but we wouldn't be photographers if we weren't looking for something different. When working in a traditional wet darkroom, I used Agfa, Ilford, and Kodak papers, and would try to match the paper used to the image. Now I keep papers from Epson, Media Street, Moab Paper (www.moabpaper.com), and others on hand and use the same concept of matching paper to the image's mood.

I like glossy papers such as Epson Premium Glossy Photo Paper and Konica's (www.konicaminolta.com) Professional Glossy QP for photographs of automobiles and other shiny machines. Portraits look fabulous on Moab's Kayenta matte paper but don't be bound by anybody's dictums. Adorama (www.adorama.com) offers a true heavyweight paper (80 lb, 12 mil) that's double-sided matte and perfect for use in presentations or portfolios. Complementing their Double-Sided Matte is a Double-Sided Matte Gloss and a Royal Satin, which has a fine "pearl" surface.

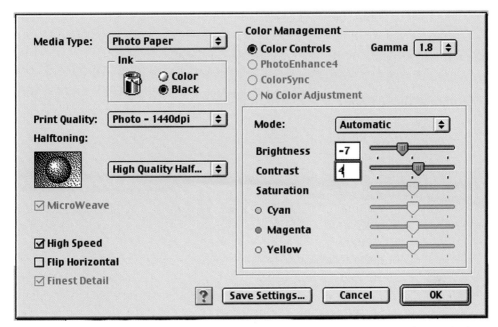

Many ink-jet printer's drivers include full manual control over the output's brightness, contrast, saturation, and color; but before you work with these controls, it's a good idea to create a personal test print file.

Printer Drivers

After connecting your printer to a computer, you need to install software that lets the two devices communicate. This is called "driver" software because it *drives* the printer and makes it work. With Mac OS computers, I prefer to insert the driver software CD-ROM, and then double-click the icon to make it work. With Microsoft Windows computers I've found the most prudent way to install printer drivers is by connecting the printer and restarting the computer. This will cause Windows' Plug-and-Play feature to recognize that a new device is connected and will guide you through the process of installing the driver. While more experienced computer users may feel they can just install the hardware, then install the software, I've often found that when working with some printers, *not* using Windows plug-and-play installation features can create problems with partially installed software. This is more trouble to fix that simply letting Windows guide you through the installation in the first place.

A PERSONAL TEST PRINT

Some ink-jet printers automatically output a test page shortly after you connect it to the computer and install the driver, and while these pages may tell you that the printer is actually working, you may want more information than that. One of the best ways to discover your printer's capabilities is to create and print a "personal" test print.

Comparing test prints is one of the best ways to evaluate different kinds of printers as well as different brands of papers. I'm not talking about the kind of

HP's PhotoSmart Toolbox software that's bundled with their printers, such as the PhotoSmart P1100, let you perform an automatic series of diagnostics and corrections, and when completed it outputs a test page.

No matter what brand of printer you use, its driver software has many controls that allow you to print on different kinds of papers, which are usually those offered by the printer manufacturer. While you can use software, such as ColorVision's Profiler RGB to precisely calibrate a specific kind of paper for your printer, the driver itself provides enough controls that let you fine tune the color, density, and contrast of your output. I liken these controls to manually tweaking a color enlarger in a traditional wet darkroom.

Printer drivers do more than just direct your computer to send data to the printer. In most cases, the drivers let you specify information about the kind of paper you're using and how you want the finished print to appear. You can simply pick the kind of paper you're using, click the "Automatic" button, set the slider to "Quality" and you'll usually get a pretty good output, but maybe not the best possible print. Just as you sometimes need to take your camera off its automatic mode, and apply all of your experience and take manual control over a special photographic situation, there are times you need to do the same thing printing digital images.

With most drivers, you can tweak output by slightly increasing or decreasing brightness or contrast settings as well as the color balance to get the best results. Before making a print, take a look at any Advanced settings that are available in the driver.

Preparing Images for the Web

This is like some kinda prehistoric Internet.

There are two really important aspects to consider when producing graphics for the World Wide Web: technical and esthetics. Given the vagaries of connections, servers, and the short attention spans of most Web surfers, you've gotta be

Krystene was photographed with a Canon EOS 10D and 28–105 mm zoom lens. Exposure was 1/200 second at f/5.6 at ISO 200. Fill was provided by the camera's pop-up flash. The photograph was captured as a JPEG file but it might be too big to e-mail, so it needs to be converted to a smaller file, yet maintain the original image quality. © 2003 Joe Farace.

concerned not only with getting their attention, but the technical aspects of saving files in compressed formats that load as fast as possible. To accomplish both of these objectives, you not only need talent; you must have the proper tools. Since most of us are stuck with the talent that came at birth, it helps to have the right software to create Web graphics that attract attention and display quickly.

THE PIXEL PARADE

Producing images for the World Wide Web introduces variables into the design process that doesn't affect other media. One of the most dramatic differences is that you no longer have control over the how a viewer sees your artwork. Some things that affect preparing image files for the Web are the viewer's display system and speed of their Internet connection. Since you have no control over *these* variables, all you can do is take a few steps to prepare your image for the Web that will minimize download time and display well on most systems.

Among Web designers there is occasional controversy over which image file type is best: JPEG or GIF. As in everything else in digital imaging there are tradeoffs over which file format works best. A GIF file work bests when there are a few colors in the image. If your image contains less that 64 colors, a GIF will be smaller than a JPEG file. Because JPEG is a "lossy" compression method, text can become

VSO Software's Image Resizer (www.vso-software.fr) is a handy Windows-based freeware tool that resizes and converts images between different formats. It is aimed at people who store their digital pictures on their computer and want to quickly create e-mail friendly versions of their images, load them fast, move them easily from folder to folder, change format, and edit large numbers of images to save hard drive space.

blurry when combined with an image. That's why GIF is the best choice if your graphic contains text or sharp edges.

In general, use JPEG when saving photographic files. JPEG allows the use of more colors, but depending of the viewer's graphics can be wasted on the viewer and can take longer to display because the files tend to be larger than GIF. On the other hand, GIFs have less on-screen quality but often display faster. JPEGs make good backgrounds. Because of the low contrast and similarity of colors required for a good background, the larger number of possible colors available with the JPEG format makes it a good bet.

Unlike other compression systems, GIF was designed specifically for on-line viewing. If your image was stored in non-interlaced form, when half of the image download time was complete, you would see 50% of the image. At the same time in the download of an interlaced GIF, the entire contents of the image would be visible—even though only one-half of the image data would be displayed.

You don't need an expensive image-editing program to create files for e-mailing or Web use. Apple's iPhoto, which is free with all new Mac OS computers, includes the ability to simply convert and resize and image into a JPEG or PNG file. © 2003 Joe Farace.

An alternative to using interlaced GIF is progressive JPEG. This file format rearranges stored data into a series of scans of increasing quality. When a progressive JPEG file is transmitted across a slow communications link, a decoder generates a low-quality image very quickly from the first scan, then gradually improves the displayed quality as more scans are received. After all scans are complete, the final image is identical to that of a conventional JPEG file of the same quality setting. Progressive JPEG files are often slightly smaller than equivalent sequential JPEG files, but the ability to produce incremental display is the main reason for using progressive JPEG.

THE MACHINE THAT GOES PING

Portable Network Graphics or PNG (pronounced "ping") is the successor to the GIF format widely used on the Internet. In response to the announcement from CompuServe and UNISYS that royalties would be required on the formerly freely used GIF file format, a coalition of independent graphics developers from the Internet and CompuServe formed a working group to design a new format that was called PNG. PNG's compression method has been researched and judged free from any patent problems. PNG allows support for true color and alpha channel storage and its structure leaves room for future developments. PNG's feature set allows conversion of GIF files, and PNG files are typically smaller than GIF files. PNG also offers a more visually appealing method for progressive on-line display than the scan line interlacing used by GIF. PNG is designed to support full file integrity checking as well as simple, quick detection of common transmission errors. All implementations of PNG are royalty free, but that doesn't seem to have helped it achieve greater popularity.

SAVE FOR WEB

One of the simplest ways to prepare an image for the Web is Adobe Photoshop's Save for Web command (File > Save For Web.) It also lets you preview an image's *gamma* at different values. A monitor's gamma affects how light or dark an image looks in a Web browser. Because Windows systems use a gamma of 2.2, images look darker on Windows than on Mac OS systems, which are normally set to a gamma of 1.8. Save for Web lets you preview how your images will look on systems with different gamma values and you can even make adjustments to the image to compensate. Save for Web also lets you save the files as a JPEG, GIF, PNG, or BMP file.

To save a file to e-mail: Open the image in Photoshop, and choose File > Save For Web. Next, click the Optimize tab at the top of the Web dialog box. Pick your preferred file type (most always JPEG). For e-mail choose "JPEG Low" from the Preset menu. Click the Image Size tab but make sure "Constrain Proportions" is selected and enter an image width. For most e-mail systems and to avoid the file being bounced by your own ISP, 400 pixels is a good place to start. Click Save and

Photoshop's Save for Web dialog box lets you view the image with the current optimization settings applied. You can see 2-Up to view two versions of the image side by side, or 4-Up to view four versions of the image side by side. If you work in 2-Up or 4-Up view, you must select a version before you apply optimization settings. © 2003 Joe Farace.

enter a file name and location in which to save the file. You are now you are ready to e-mail the file. In some e-mail programs, you can drag the file into the body of the message. In others, you should use the Attach or Insert command.

WEB TIPS

Number 1: Because Web surfers have the attention span of a Honduran Water Moth, if something doesn't display FAST, you have lost them. Make sure it loads fast.

Number 2: Choose the appropriate graphics file format. To make sure a site loads fast, avoid large, complex graphics, and follow the previous suggestions about choosing the right kind of image file format. There is some controversy over which graphic file type—JPEG or GIF—is best.

Number 3: Consider interlaced files. If your image was stored in non-interlaced form, when half of the image download time is complete, you would only see 50% of the image. At the same time in the download of an interlaced GIF, the entire contents of the image would be visible—even though only one-half of the

image data would be displayed. An alternative to using interlaced GIF is progressive JPEG.

Number 4: Use an appropriate color palette. The color scheme of a website is key to its overall design and attractiveness. For most sites, avoid dark colors like black and maroon, and harsh colors light bright red. Instead, use soft grays, pastels, and even light textures to make it easy on the viewer's eyes. One common design flaw is a lack of uniformity of color within a site and far too many sites alternate between vivid and subdued color schemes, resulting in an unbalanced appearance that lacks a visual signature.

JPEG 2000

With the introduction of 4 GB CompactFlash cards (even if they aren't cheap) and Adobe's' awesome Camera RAW plug-in, it might seem that serious photographers will only shoot RAW files. So why should we even care about JPEG 2000? It's like this, Bunky, out here in the real world sometimes size *does* matter. Files have to be distributed, e-mailed, and archived, and even with Terrabyte-sized drives for desktop computers around the corner, some kind of compression strategy is gonna be required. And everyone would prefer that approach to be lossless.

Welcome, my friends to JPEG 2000, the latest incarnation of the ubiquitous image file format and compression method known as JPEG. Like the existing format, this new one is sponsored by the Joint Photographic Experts Group of the International Standards Organization, but provides an integrated system for coding digital images, instead of just a method for compressing still images. Classic JPEG uses DCT (discrete cosine transform) functions to compress an image, while JPEG 2000 uses *wavelets* that decompose the image signal into different little *waves*, that when summed up become as equal to the original as possible. The new format uses two different kinds of wavelets: family 5×3 (reversible) and 9×7 (irreversible). When compressing an image with 9×7 you lose some image quality, but produce really itty-bitty files; or you can choose to preserve *all* the quality and still save lots of space.

According to Andrea de Polo, head of the New Technologies Office at Fratelli Alinari, which owns the oldest photographic archive in the world, "JPEG 2000 might soon replace all previous file formats used up to now." Why is that? Simple, because de Polo claims that "JPEG 2000 is faster, better, and provides error resilience, file history, metadata (for Electronic Copyright Management Systems), color correction, and files can be saved as *lossy* or *lossless*." Other critical features for professional photographers consist of Intellectual Property Rights (IPR) protection in the form of labeling and watermarking, including a unique identifier that can be delivered and managed by Trusted Third Parties. There is also built-in access control for confidentiality and pay-per-view systems, so JPEG 2000 is more than just another compression system.

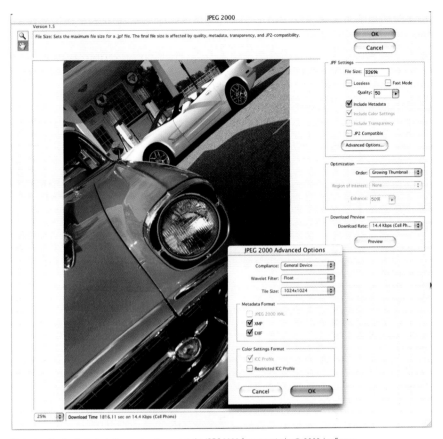

Photoshop Creative Suite, including version 2, supports the JPEG 2000 format natively. © 2003 Joe Farace.

How can you use it? Adobe Systems provides support for JPEG 2000 with its original introduction of the Camera RAW plug-in for Photoshop 7.01, and Photoshop Creative Suite further supports JPEG 2000 by having the capabilities built-in. SouthDowns' Perl software for creating JPEG 2000 files can be downloaded at http://public.migrator2000.org/downloads.xalter. Algo Vision LuraTech, Inc. has been working with the format longer than anybody, it seems, and you can download their Photoshop-compatible plug-in at luratech.com/products/lurawave_jp2/photoshop/index.jsp?OnlineShopId=498221062010392790.

As the dust settles around JPEG 2000, you may see several different acronyms, but don't be confused; simply check to see if your favorite imaging application reads and writes the format. One version, JJ2000, was developed by EPFL (L'Ecole Polytechnique FÈdÈrale de Lausanne), Ericsson, and Canon Research Center France (CRF,) as a Java implementation. In case you're not familiar with Java (*not* an acronym, by the way), it makes the format both platform-independent and portable. A Java implementation makes it easy for JPEG 2000 integration in browsers and other Internet applications, which accelerates its adoption as a still

image compression standard. http: Read more about it JPEG 2000 at: http://jj2000.epfl.ch/jj_whitepaper/index.html and, www.jpeg.org, and www.migrator.org.

TOOLS OF THE TRADE

Trevoli's (www.trevoli.com) Photo Finale automatically transfer photos from digital cameras, memory cards, photo CDs, and scanners, and helps you organize photos into categories and folders. You can search and find photos by up to 10 different ways including name, date, rating, category, and caption. A calendar view lets you view all photos, or drag and drop photos directly to a date. You can access 100 printable templates to create announcements, greeting cards, magazine covers, and certificates, or print one or multiple images on a single page using templates from wallet size to 13 × 19 inches. You can e-mail directly from Photo Finale with automatic photo conversion and no additional software required. Photo Finale offers a free version of the program, that you can upgrade to the Premium version for $40.

You can e-mail directly from Photo Finale with automatic photo conversion and no additional software required.

PHOTO-SHARING WEBSITES

Don and Chris MacAskill started SmugMug; it's a photo-sharing website that doesn't quite fit any conventional category. SmugMug.com features an interesting blend of tools and a design that will appeal to photographers and surfers alike. The site is scalable, allowing users to add new albums, and upload hundreds of images

in a single click. Amazingly, the site is free of advertising and pop-ups. Its kinda like a personal home page and sharing website that lets you tweak its appearance and functionality to work the way *you* want. You can control almost all layout aspects and esthetics of your SmugMug page, including comments, personal URLs, and custom subcategories. If you have even modest HTML skills (I don't) you can replace the Smugmug logo and navigation with your own identity, customize the colors and backgrounds, write scripts, and use style sheets. SmugMug has a lot going for it, including the ability for visitors to add comments to your images (or not) or order prints (or not) or download photographs—you guessed it—or not. It's totally customizable. SmugMug offers three levels of membership: Standard, Power, and Professional. The annual cost is $29.95, $49.95, and $99.95, respectively, and all provide 8 MB of storage for what SmugMug calls an "unlimited" number of images. The two more expensive memberships allow for unlimited customization, while the higher priced options permit traffic up to 120,000 views per month.

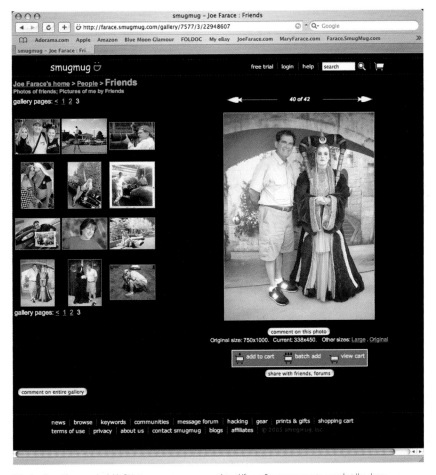

What's a SmugMug page look like? Visit my power user page at http://farace.Smugmug.com to see what I've done.

Ranked by Nielsen/NetRatings as the #1 photo site, Webshots (www.webshots.com) defies easy description; it's much more than just a photo-sharing site. Sure, Webshots offers a number of ways for friends and family to share imagery with one another, such as Photo Messages, online photo albums, and custom prints and gifts, but there's more; like their own software. Called Webshots Desktop, made for both Mac OS and Windows, the software is a surprisingly robust (yet free) photo management application that combines the ability to make wallpaper and screensavers with tools for managing and sharing photos. The application lets you produce on-screen slideshows, gives you one-click uploads of photos from digital cameras to online albums, along with a feature that lets you track and view the photo albums of friends and family. Free (there's that word again) membership allows members to download any of their Gallery images to their computer and upload and share their own photographs. Once your own image files are uploaded, you can send Photo Messages or invitations to view entire albums, and can choose to list albums publicly in the Webshots Community and Photo Search directories.

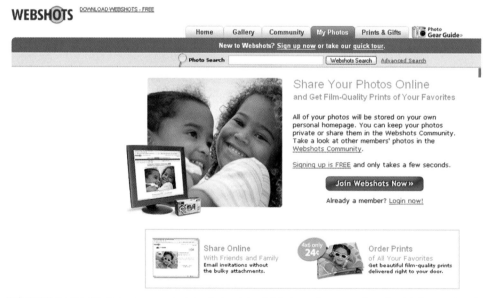

Within WebShots personal My Photos area, you can track downloads and view statistics for your images, as well as order prints, frames, and a variety of customized gifts, such as t-shirts, mugs, and mouse pads. Premium features (that means you gotta pay), such as high-resolution downloads, additional image storage, and ad-free browsing, are available with Webshots' Unlimited service.

For cell phone slinging digital photographers, Webshots' My Photos Viewer mobile service lets members use their wireless phone or handheld device to remotely browse their own and favorite members' albums. My Photos Viewer is

carrier-independent, operates on WAP 2.0-enabled, color screen phones and wireless handheld devices with graphic Internet browsers. (Wireless Application Protocol is an open international standard for Internet access using cell phones.)

OTHER WEBSITES

Flickr (www.flickr.com) is part of the Yahoo! Empire and provides a way to store, sort, search, and share your photos online and provides a way to organize yours, and for you and your friends and family to tell your stories about them. Flickr allows photo submitters to categorize their images by use of keyword "tags" that allow searchers to easily find images concerning a certain topic such as place name or subject matter. Flickr also allows users to categorize their photos into "sets," or groups of photos that fall under the same heading. However, sets are more flexible than the traditional folder-based method of organizing files, as one photo can belong to many sets, or one set, or none at all.

In March 2005, Yahoo! Inc. acquired Ludicorp and Flickr. During the week of June 28 all content was migrated from servers in Canada to servers in the US.

Snapfish (www.snapfish.com) is an online photo service with more than 24 million members and one billion unique photos stored online. It enables members to share, print, and store their most important photo memories at low prices; Snapfish offers professionally developed digital camera prints as low as 10¢, film developing for just $2.99 per roll, free online photo sharing, unlimited online photo storage, free editing tools and software, wireless imaging services, and more than 80 personalized photo products, ranging from calendars, mugs, and mouse pads, to boxer shorts, dog leashes, and teddy bears.

Based in San Francisco, Snapfish is a division of Hewlett-Packard. Snapfish also provides infrastructure services to leading retailers, Internet service providers and wireless carriers, allowing them to offer these same products and services to their own consumers.

Photobucket (www.photobucket.com) is a simple, fast, and reliable service that enables efficient sharing and publishing of visual digital content online. Images and videos can be directly linked from Photobucket to any site, including popular sites like MySpace, eBay, LiveJournal, Xanga, Friendster, and Neopets. Photobucket was named the fastest growing site of 2005 according to Nielsen/Netratings and now ranks as a Top 100 site by traffic. As of March 2006, Photobucket had over 15 million users growing by over 65,000 users per day and, like McDonald's,

serves over 50 billion images per month. Founded in 2003, Photobucket is based in downtown Palo Alto with technology operations and development based in Denver, Colorado.

Photobucket essentially serves as a central "hub" for storing, sharing, and publishing visual digital media. In just the last 12 months, Photobucket has welcomed more than 10 million unique visitors per month, driven purely by word of mouth.

CYBERTHEFT

The Internet represents the greatest marketing and sales opportunity for photographers—greater than any previous technological breakthrough—but it's not without a few problems. First and foremost in many photographers' minds is the possibility of digital theft of copywritten images.

What sends shivers down many photographers' spines is the ease in which Internet images can be illegally obtained. Most browsers allow you to click on any object—like any one of your best selling photographs—and print it, save it as a file, or copy it to the Clipboard. Once on the Clipboard, your image can be pasted into a blank document in any kind of image-editing program. Because of the ease in which this copying is done, some photographers feel they will have no real control over their copywritten images one they are posted on the Internet. To many,

it is worse than the adverse affects that the color copier or digital copy stations brought to their business; some see it as the color copier from hell. Before you run screaming to your lawyer, lets back up a bit.

All of the hysteria surrounding Internet copyright issue is based on the naive assumption that stealing images isn't already going on in the non-digital arena. We all know that this is not true. Even ignoring the impact of the color copier and digital copy stations, people have been stealing our images for years. Does this true story sound familiar?

A client called me to talk about a concern that he had with the quality of some prints that I had delivered to her. It seemed that the prints of a portrait I made of the company's CEO were not acceptable and a publication they sent it to told them it was not of "reproduction quality." This sounded hard to believe so I made an appointment to meet with the client to look at the "problem" prints. Before I went, I pulled the client's file along with a file print of the same image that she had questioned. When I went to her office, I asked to see the bad print and she showed me the poorest quality copy print I'd ever seen. It was flat, unspotted, and covered with scratches. At that point, I handed her the file print and said this was the quality of the prints that I had delivered and without naming names suggested that someone in her organization had made illegal copies of my original prints. I left with a big print order and a client better educated in what copyright means on a practical level.

BASIC PROTECTION

One of the most obvious ways to protect the rights of your digital images is with a visible copyright symbol. Sometimes called a "watermark" this is a secondary image that is overlaid on the primary image, and provides a means of protecting the image. One of the easiest ways is to use your image-editing programs and simply add a text layer with a copyright statement. If you have a lot of them to watermark, multiple image files use a power tool such as ReaWatermark (www.reasoft.com/products/reawatermark.) This Windows-based software simplifies the process of creating and applying watermarks to multiple files in multiple folders. It supports a mixture of text, copyright symbols, graphics, and drawing watermarks of any complexity. A multi-level transparency setting allows you to choose and preview how your watermark image or text will affect the protected image.

One of the most powerful protection tools you have at your disposal is the ability to create small, low-resolution images that look good on screen but aren't worth stealing for use in print or as a print. Just as you can post "No Trespassing" signs on your property to keep interlopers out. The first thing you need to do when setting up a website is to post a notice saying "No Stealing Allowed." Rohn Engh (www.photosource.com) suggested posting a legal notice on your website

ReaWatermark, the watermark software helps you apply transparent logo on images. It takes just one step to process large number of photos of variable size and orientation in multiple folders. Photo courtesy of ReaSoftware.

relating to the photographs that appear there. Here is his suggested warning label that appeared in my book, *"The Photographer's Internet Handbook"*:

"Image Restrictions: Each image on this website is legally protected by US and International Copyright Laws and may NOT be copied and used for reproduction in ANY way unless arranged for in writing. All pictures on this website are Copyrighted © YOUR NAME and are for Web browser viewing only. Usage of any image (including comp usage) must be negotiated. No Image on this website may be used for any purpose without express written consent of the Copyright holder [YOUR NAME]. Unauthorized duplication of these images is prohibited by US and International Copyright Law. In the event of an infringement, the infringer will be charged triple the industry-standard fee for usage, and/or prosecuted for Copyright Infringement in US Federal Court, where they will be subject to a fine of $100,000 statutory damages as well as court costs and attorney's fees."

Quoted by permission from PhotoSource International, producers of the stock photographer's directory, "The PhotoSourceBook."

EMBED PROTECTION WITHIN THE FILE

There are lots of ways to protect digital images from theft, but I prefer to use a method that makes that copyright notice a part of the image file. Adobe's Extensible Metadata Platform (XMP) is a labeling technology that provides a

method for capturing, sharing, and most important to us as photographers, implementing rights management. Built into both Photoshop CS and CS2 is a way to embed metadata containing copyright information into the image file. Instead of digitally stamping a big copyright notice across the image, you can use the following steps to make your copyright notice an integral part of a digital file itself:

Step 1: Open a blank document in Adobe Photoshop CS2 (File > New). Click OK. (Don't worry about any of the settings that appear in this dialog box.)

Step 2: Choose File Info from the File menu (File > File Info). Select "Description" in the menu on the left-hand side. Next chose "Copyrighted" from the Copyright Status pop-up menu. In the Copyright Notice section that appears just below this menu, you should enter all of the information that you want to appear as part of this image file.

Untitled–1

Description	Description
Description	
Camera Data 1	Document Title:
Camera Data 2	Author:
Categories	
History	Author Title:
IPTC Contact	Description:
IPTC Content	
IPTC Image	
IPTC Status	
iView MediaPro	Description Writer:
Adobe Stock Photos	Keywords:
Origin	
Advanced	

⚠ Commas can be used to separate keywords

Copyright Status: Unknown

Copyright Notice:

Copyright Info URL:

Go To URL...

Created: 5/5/06 11:50:32 AM
Modified: 5/5/06 11:50:32 AM
Application: Adobe Photoshop CS2 Macintosh
Format: application/vnd.adobe.photoshop

Powered By
xmp

Cancel OK

You can include a phone number, © symbol, year created, "All Rights Reserved," or whatever you think is appropriate. If you have a website, enter its URL (uniform resource locator) in the Copyright info URL space. If you don't already have a website, maybe it's time you did.

Step 3: Next, choose "Advanced" from the menu on the left-hand side of the File Info dialog box. Next, click the Save button to save all of the data you have entered as an .xmp file containing your copyright notice.

Choose whatever file name you like (but make it easy to remember) and decide where on your hard drive you want to store it, but make sure it's an easy place to remember. Then click OK.

Step 4: To assign all of this copyright information to an image, open File Info (File > File Info) for that specific file, and then click the Append button.

TAKE ACTION

Having to go through this process for each and every image file you create is tedious, so the next phase will be to create a Photoshop Action (see Chapter 9 for more details on Actions) that will automate the entire process:

Step 1A: Make sure you have gone through the above process at least once and have saved an XMP file with the appropriate copyright data. You can have more than one file for different purposes or even different websites. Then, start with a blank document (File > New).

Step 2A: In the dialog box that opens, assign a function key so that the next time you want to associate a file with your copyright notice, it's simply a button click.

Go to the Actions palette making sure you are not in Button Mode. (If so, go to the Actions fly-out menu and select Button Mode.) Then choose New Action.

You can choose to group the Action with some of Photoshop's sets of Actions that you've already installed. Then click Record.

Step 3A: Chose File Info (File > File Info), select Advanced, click Append, navigate to the place on your hard drive where you stored the related .xmp file and click Load. Then click OK to close the File Info box.

After appending, click the Stop Recording button at the bottom of the Actions palette, and you're done!

You only have to go through this latter process once. The next time you want to embed copyright information into any image file, just click the function key you've chosen or on the newly created button (when back in Button mode) in the Actions Palette and you're finished! You can even do an entire folder of image files at once using Photoshop batch processing features (File > Automate > Batch) and assign your Action to the batch.

Glossary

Heeeeerrrrre's Johnny!

Experienced photographers may be familiar with traditional film-based terms and acronyms, many of which have their origins in the disciplines of optics, chemistry, and physics. The language of digital imaging has *its* roots in the fields of computing and commercial printing and has shown itself remarkably inventive in creating new buzzwords at the drop of a microchip. Here's a brief introduction to some of them that digital photographer might find useful.

AF. Autofocus, automatic motorized focusing.

AI FOCUS AF. In cameras such as Canon's EOS 1D and D60, this is an autofocus mode that automatically switches from One-Shot autofocus to AI-Servo autofocus when a subject moves.

AI SERVO AF. Autofocus mode for moving subjects with focus tracking and shutter priority.

ALIASING. Sometimes when a graphic is displayed on a monitor, you will see jagged edges around some objects. These extra pixels surrounding hard edges—especially diagonal lines—are caused by an effect called aliasing. Techniques that smooth out these "jaggies" are called anti-aliasing.

ANALOG. Information presented in continuous form, corresponding to a representation of the "real world." A traditional photographic print is an analog form, but when this same image is scanned and converted into digital form, it is made up of bits.

AVERAGE METERING. Through-the-lens (TTL) metering that takes into considera-tion the illumination over the entire image.

BIT. Binary digit. Computers represent *all* data—including photographs—using numbers or *digits* that are measured in bits.

BITMAP. A bitmap is a collection of tiny individual dots or *pixels*—one for every point or dot on a computer screen.

BMP. Often pronounced, "bump," it's the file name extension for a Windows-based bit-mapped file format.

BYTE. Each electronic signal is 1 bit, but to represent more complex numbers or images, computers combine these signals into larger 9-bit groups called bytes.

CCD. A Charged Coupled Device. This is the kind of light-gathering device used in scanners, digital cameras, and camcorders to convert the light passing through a lens into the electronic equivalent of your original image.

CD-R. Compact Disc Recordable. With these discs, you can write image file data only once, and read it many times.

CD-ROM. Compact Disc Read-Only Memory. A disc that resembles a music compact disk but can hold all kinds of digital information including photographs.

CD-RW. Compact Disk Recordable Writ-able. You can write and read these discs many time but the disks themselves cost more than CD-R's.

CIELAB. This color system created by the Committee Internationale d'Eclairage to produce a color space consisting of all visible colors. The CIELAB system, sometimes shortened to just LAB, forms the basis for most contemporary color matching systems and lets you convert, for example, RGB images to LAB to CMYK to produce accurate color matching.

CMOS. Complimentary Metal Oxide Semiconductor. An alternative to the CCD (Charged Coupled Device) imaging chips used by some digital cameras. The CMOS chip is simpler to manufacture so costs less. It also uses less power than CCD chips, so it doesn't drain batteries as fast. The downside is that the chip does not perform as well as CCD imagers under low-light conditions, but recent digital SLR models are said to have improved performance under less than ideal lighting conditions.

CMS. Color Management Systems software helps produce an accurate reproduction of your original color photograph. A good CMS includes calibration and characterization aspects and is (mostly) software based. CMS is used to match the color that you see on your monitor to the color from any output device, such as a printer, so that what you see on the screen is what you get as *output*. You might think of this as the last step in the WYSIWYG (What You See Is What You Get) process.

CMYK. Cyan, Magenta, Yellow, and Black. For magazine reproduction an image is separated into varying percentages of CMYK, which is why CMYK film output is called *separations*. Ink-jet printers also use CMYK pigments and dyes to produce photographic quality prints.

COLORSYNC. Apple Computer's Color-Sync is a Color Management System (CMS) that uses a reference color space based on the way humans see colors. The heart of the system is a set of device profiles that describe what color in that reference space corresponds to the RGB or CMYK values sent to an output device. ColorSync can predict the color you'll see when you send a set of RGB values to a monitor or CMYK values to a printer and will automatically adjust those values so you'll see the same color on both devices—or as close as possible within the limits of the devices.

COLOR DEPTH. Sometimes called "bit depth." Color depth measures the number of bits of information that a pixel can store and ultimately determines how many colors can be displayed at one time on your monitor. Color depth is also used to describe the specifications of devices such as scanners and digital cameras as well as a characteristic of an image file.

COMPRESSION. A method of removing unneeded data to make a file smaller without losing any critical data, or in the case of a photographic file, image quality.

CPU. Central Processing Unit. The CPU powers your computer, although many cameras and lenses too have built-in CPU chips. Digital imagers need to have enough computing power to handle the kind, and especially size, of image they working on. Shooting wildlife or sports photography is possible with a 50-mm lens, but the photographic experience will be much better—and less frustrating—when armed with a 400 or 800-mm lens. Similarly, choosing the right computer is first a matter of finding one with enough power to process digital images fast enough to minimize frustration, and expedite creativity by processing that data as quickly as possible.

CPXe. Common Picture Exchange Envi-ronment. A new standard for distributing photos over the Internet for photofinishing that was created by a consortium of companies including Eastman Kodak, Fujifilm, Hewlett-Packard, and others.

DEVICE RESOLUTION. This refers to the number of dots per inch (see *dpi*) that a computer device, such as a monitor or printer, can produce.

DVD. Digital Video Disc. Unlike the 600 + MB capacity of CD-ROM discs, a DVD can store 4.7GB or more on a single disc that is the same physical size. While competing formats exists for writable DVDs, this has not stooped a number of companies form installing writable DVD drives in computers or offering them as external peripherals. It is just a matter of time, before the DVD format replaces *all* disc-based data media, including CD-ROM and music CDs too.

DYNAMIC RANGE. Dynamic range can be interpreted as the range of f/stops that can be captured from a print or slide and is rated on a scale from 0 to 4, where 0 is a clean white and 4 is total black. Photographers may recognize these are the zones Ansel Adams called Zones IX and 0 in his Zone System. The maximum and minimum density values of capable of being captured by a specific scanner are sometimes called dMax and dMin. If a scanner's dMin were 0.3 and its dMax were 3.5, its dynamic range would be 3.2.

EI. Exposure Index is the rating at which a photographer actually exposes a specific kind of film, therefore deliberately underexposing or overexposing it. This is accomplished by changing the camera or hand-held meter's ISO film speed to reflect a number different than recommended by the manufacturer.

E-TTL. Evaluative Through-the-Lens flash exposure metering used by Canon EOS film and digital cameras.

EV. Exposure Value; numeric value to describe the exposure where a variety of shutter speed/aperture combinations produces the same exposure with a constant film speed; for example $1/250s + f/2 = 1/125s + f/2.8 = 1/60s + f/4 = 1/30s + f/5.6 = 1/15 + f/8$, etc. (This is different from Exposure Index.)

FAQ. Frequently Asked Questions. A term found on Internet home pages, that lead you to an area containing answers to the most FAQ visitors to the website might have.

FRACTAL. A graphics term originally defined by mathematician Benoit Mandel-brot to describe a category of geometric shapes characterized by an irregularity in shape and design and used by computer software, such as Lizard Tech's (www.lizardtech.com) Genuine Fractals, as a mathematical model for resizing and enlarging image files.

GAMMA. A measurement of the contrast that affects midtones in an image. One of the differences between Mac OS and Microsoft Windows operating systems is that they have different basic Gamma settings. For a Windows computer it's 2.2, while Gamma is 1.8 on a Mac OS computer, which is why images that look fine on a Mac appear darker on a Windows computer.

GAMUT. A range of colors that a printer, monitor, or other computer peripheral can accurately reproduce. Every device from every manufacturer has a unique gamut. If you find that the output of your color printer doesn't match what you see on screen, you are beginning to understand the need for *color management*. The image may be "in gamut" for the monitor, but not the printer.

GAUSSIAN BLUR. Adobe Photoshop's filter gets its name from the fact that this filter maps pixel color values according to a Gaussian curve. A Gaussian curve is typically used to represent a normal or statistically probable outcome for a random distribution of events and is often shown as a bell-shaped curve.

GIF. (Pronounced like the peanut butter.) Graphics Interchange Format. A compressed image file format that was originally developed by the CompuServe Information Systems (www.cis.com) and is platform independent. The same bitmapped file created on a Macintosh is readable by a Windows graphics program.

GIGABYTE. A billion bytes or (more correctly) 1024 megabytes.

GRAYSCALE. Refers to a series of gray tones ranging from white to pure black. The more shades or levels of gray, the more accurately an image will look like a full-toned black and white photograph. Most scanners will scan from 16 to 256 gray tones. A grayscale image file is typically one-third the size of a color one.

GUI. Graphic User Interface.

ICC. The International Color Consortium is a group of eight large manufacturers in the computer and digital imaging industries. The consortium works to advance cross-platform color communications, and has established base-level standards and protocols in the form of ICC Profile Format specifications, to build a common foundation for communication of color information.

ICON. Those little "pictures" that represent files and programs that are used by graphical user interfaces (GUI) for operating systems such as the Mac OS or Microsoft Windows.

IDE. Integrated Drive Electronics. Com-puters accepts several kinds of circuit boards to control hard disks, the most common standard was originally called IDE, but the more commonly used current term is ATA (Advanced Technology Attachment).

IEEE. The Institute of Electrical and Elec-tronics Engineers is an organization that's involved in setting standards for computers and data communications, such as the popular IEEE 1394 *aka* FireWire *aka* iLink.

IMAGE EDITING PROGRAM. The broad term for software that allows digital photographs to be manipulated and enhanced to improve and change images much as you would produce similar effects in a traditional darkroom and then some.

IMAGEBASE. Visual database programs that keep track of digital photographs, video clips, graphic files, and even sounds.

INDEXED COLOR. To keep GIF files sizes small, the format's designers limited the number of colors to 256 and created a palette of those colors that each image using the format draws from. There are two kinds of indexed color images. Those that have a limited number of colors and pseudocolor images. Pseudocolor images are really grayscale images that display variations in gray levels in *colors* rather than shades of gray, and are typically used for scientific and technical work.

INITIALIZE. The process of setting all values on a hard disk, removable media, or floppy disk to *zero*; in other words, erasing all of the data that's currently stored.

INKJET. This kind of printer works by spraying tiny streams of quick-drying ink onto paper to produces high-quality output. Circuits controlled by electrical impulse or heat determine exactly how much ink—and what color—to spray creates a series of dots or lines that form a printed photograph.

INPUT. (verb) (noun) Information entered via keyboard or other peripheral device is called input. Data entered into a computer is said to have been *input*. A photograph scanned into an image-enhancement program is *input* into it.

INPUT DEVICE. Any computer peripheral such as a keyboard, memory card reader, or scanner that converts analog data into digital information that can in turn be handled by your computer.

INTEGRATED CIRCUIT. A self-contained electronic device contained in a single semi-conductor computer chip.

INTERFACE. The "real world" connection between hardware, software, and users. This is the operating system's method for directly communicating with you. It's also any mechanical or electrical link connecting two or more pieces of computer hardware.

INTERLACED. Broadcast television uses an interlaced signal, and the NTSC (National Television Standards Committee) standard is 525 scanning lines, which means the signal refreshes the screen every *second* line 60 times a second, and then goes back to the top of the screen and refreshes the other set of lines, again at 60 times a second. The average non-interlaced computer monitor refreshes its *entire* screen at 60–72 times a second, but better ones refresh the screen at higher rates. Anything over 70Hz is considered flicker-free.

INTERNET ADDRESS. The format for addressing a message to any Internet user is recipient@location.domain. The recipient is the person's name or "handle," the location is the place where the recipient can be found, and the suffix tells the kind of organization

the address belongs to. Locations outside the United States have an additional extension identifying their country.

INTERPOLATED RESOLUTION. Scanners are measured by their *optical* as well their *interpolated* resolution. Optical resolution refers to the raw resolution that's inherently produced by the hardware, while interpolated resolution is software that adds pixels to simulate higher resolution.

IS. Image Stabilization on Canon EOS lenses, called VR (vibration reduction) on Nikon lenses. Konica Minolta, on the other hand, builds its Anti-Shake technology into the camera's body.

ISO. (1) International Standards Organi-zation. Founded in 1946 with headquarters in Geneva, Switzerland, the ISO sets international standards for many fields. (2) Film speed and equivalents (in digital cameras) are usually referred to by their ISO speed rating that measures light sensitivity. The higher the ISO number, the greater the light sensitivity.

ISP. Internet Service Provide.

JPEG. Joint Photographic Experts Group. JPEG was designed to discard information the eye cannot normally see and uses compression technology that breaks an image into discrete blocks of pixels, which are then divided in half until a compression ratio of from 10:1 to 100:1 is achieved. The greater the compress ratio that's produced, the greater loss of image quality and sharpness you can expect. Unlike other compression schemes, JPEG is a "lossy" method. By comparison, Lempel-Ziv-Welch (LZW) compression used in file formats such as GIF is lossless—meaning no data is discarded during compression.

K. In the computer world, K stands for two to the 10th power, or 1024. A kilobyte (or KB) is, therefore, not 1000 bytes but is 1024 bytes.

KEYWORD. Words that identify certain characteristics of a photograph for later searching with a photo-organizing, or imagebase program. A good imagebase program should be able to add "keywords" to your photographs, and then be able search for the images that have those words associated with them.

LANDSCAPE (MODE). An image orientation that places a photograph across the wider (horizontal) side of the monitor or printer.

LAYER. In image-enhancement programs, like Adobe Photoshop, layers are any one of several on-screen independent levels for creating separate—but cumulative—effects for an individual photograph. Layers can be manipulated independently and the sum of all the individual effects on each layer make up what you see as the final image.

LZW. Lempel-Ziv-Welch. A compression algorithm used by Adobe Photoshop to perform lossless compression on TIFF files.

MAGNETO-OPTICAL. This class of removable drives uses the ability of lasers to heat material and thus change reflectivity to produce media that can be erased and reused. One of the negatives of optical drives is that writing data to optical media requires three spins. The first erases existing data, the second writes new data, and the third verifies the data is there. When compared to magnetic drives, all this spinning tends to reduce performance. Typical performance specifications for magneto-optical drives are seek times of

30 ms, access time of 40 ms, and average write transfer rate of 0.44/s. The drives are more expensive than magnetic drives—although the media is less so, and like their magnetic competitors, manufacturers have yet to standardize on a single magneto-optical format.

MASK. Many image-enhancement programs have the ability to create masks—or stencils—that are placed over the original image to protect parts of it and allow other sections to be edited or enhanced. Cutouts or openings in the mask make the unmasked portions of the image accessible for manipulation while the mask protects the rest.

MEGABYTE. When you combine 1024 kilobytes, you have a megabyte (MB) or "meg."

METAFILE. This graphic file type that accommodates both vector and bitmapped data. While more popular in the Windows environment, Apple's PICT format is a metafile.

MOIRE. (Pronounced "mwah-RAY.") Moiré patterns are an optical illusion caused by a conflict with the way the dots in an image are scanned and then printed. A single pass scanner is all most people require for scanning an original photograph, but when scanning printed material, a three-pass scan (one each for red, green, and blue) will almost always remove the inevitable moiré or dot pattern.

MTF. Modular Transfer Function curves show how much contrast is retained by a lens in a given image point, for example 0.9 means 90% of the original scene's contrast was retained.

MULTI-ZONE METERING. Through-the-lens metering where the exposure is measured by several metering cells depending on the subject distance.

NANO. A prefix that means one-billionth.

ND FILTER. Neutral Density filters are rated by how many f-stops they decrease your lens aperture setting. A ND filter let you control an image when the stated combination of film speed, lens aperture, and shutter speeds won't let you produce the effect you're attempting to produce.

NTSC. National Television Standards Committee. NTSC sets the standards that apply to television and video playback on resolution, speed, and color. All television sets in the United States (and Japan too) follow the NTSC standard, and videotape and other forms of video display (such as games) meets NTSC standards.

PCX. This is not an acronym and is a bitmapped file format originally developed for the Windows program PC Paintbrush. Most Windows graphics programs read and write PCX files.

PDF. Portable Document Format. A standard file format invented by Adobe Systems that allows people to send graphics files that include text and graphics and can be read exactly as created by the recipient using the free Adobe Acrobat Reader software. You can download-free Mac OS, Windows, and UNIX versions of Acrobat Reader from www.adobe.com.

PHOTO CD. Kodak's proprietary digitizing process stores photographs onto a CD-ROM disc. The Photo CD process can digitize images from color slides and black and white or

color negatives and a Master Disc can store up to 100 high-resolution images from 35-mm film. Images are stored in five different file sizes and five different resolutions.

PICT. Another acronym without a strict definition, this time for a metafile file format for the Mac OS. As a metafile, PICT files contain both bitmapped and vector information.

PICTURE CD. A Kodak process that converts film-based images into digital files, using the JPEG format, and places them photos on a CD-ROM. This service can be ordered when you have your film processed by camera stores and other retail outlets. Their images are returned to consumers as traditional prints and on a Picture CD as digital files that can be viewed, enhanced, printed, or e-mailed.

PIEZOELECTRIC. The property of some crystals that oscillate when subjected to electrical voltage. A form of print head design that is used by Epson in their Stylus Color family of ink-jet printers. On the other hand, *piezo-electric* (with a hyphen) technology generates electricity when applying mechanical stress.

PIXEL. An acronym for *picture element*. A computer's screen is made up of thousands of these colored dots of light that, when combined, produce a photographic image. A digital photograph's resolution, or visual quality, is measured by the width and height of the image measured in pixels.

PMT. Photomultiplier Tubes are a type of sensing technology used in drum scanners.

PNG. (Pronounced "ping.") Portable Net-work Graphics. This successor to the GIF format created by a coalition of independent graphics developers to design a new royalty-free graphics file format. Not many people use it, though.

POSTSCRIPT. A programming language created by Adobe Systems that defines all of the shapes in a file as outlines and interprets these outlines by mathematical formulae called Bezier curves. Any PostScript-compatible output device uses those definitions to reproduce the image on your computer screen.

PPI. Pixels per inch.

PROFILE. A small file that tell your monitor (or any other device) that associates each number with a measured color based on specifications created by the International Color Consortium (www.icc.org.) When you computer communicates color information it not only transmits numerical data, but also specifies how those numbers should appear. Color-managed software (the next step) can then take this profile into consideration and adjust the device accordingly.

RAM. Random Access Memory. RAM is that part of your computer that temporarily stores all data while you are working on an image or a letter to Granny. Unlike data stored on a hard drive this data is *volatile*. If you lose power or turn off your computer, the information disappears. Most computer motherboards feature several raised metal and plastic slots that hold RAM chip in the form of DIMMs (Double Inline Memory Modules.) The more RAM you have the better it is for digital imaging work, there are economic considerations too. As I write this RAM, is inexpensive, but prices can be volatile.

RESOLUTION. A digital photograph's resolution, or image quality, is measured by an image's width and height as measured in pixels. When a slide or negative is converted

from silver grain into pixels the resulting digital image can be made at different resolutions. The higher the resolution of an image—the more pixels it has—the better the visual quality. An image with a resolution of 2048 × 3072 pixels has better resolution and more photographic quality than the same image digitized at 128 × 192 pixels.

RGB. Red, Green, and Blue. Color monitors use red, blue, and green signals to produce all of the colors that you see on the screen. The concept is built around how these three colors of light blend together to produce all visible colors.

RIP. Raster Image Processor. RIP is a process that prepares image data for the screen or printer.

ROM. Read-Only Memory is that memory in your computer that you can only *read* data from. It's a one-way street.

SATURATION. Saturation, often referred to as *Chroma*, is a measurement of the amount of gray present in a color.

SEARCH ENGINE. Since the actual number of websites on the World Wide Web is big and getting bigger everyday, finding the Exacta Collectors home page (www.ihagee.org) might be impossible without a way to search for the word "Exacta." That's the function of search engines: you type in a word or words and a list of websites whose descriptions contain those keywords appear.

SELECTION TOOL. One of the most important tools found in an image-enhancement program are selection tools. These allow you to highlight or select portions of an image that will have an effect applied to them.

SERIAL PORT. An outlet on the back of a computer used to connect peripheral devices such as modems and printers. The serial port sends and receives data one bit at a time.

SHAREWARE. Shareware is a creative way of distributing software that lets you try a program for up to 30 days before you're expected to pay for it.

SLR. Single Lens Reflex. In an SLR camera, the image created by the lens is transmitted to the viewfinder via a mirror and the viewfinder image corresponds to the actual image area.

THUMBNAIL. This is an old design industry term for "small sketch." In the world of digital photography, thumbnails are small, low-resolution versions of your original image.

TIFF. Tagged Image File Format is a bitmapped file format that can be any resolution and includes black and white or color images. TIFFs are supposed to be platform-independent files so files created on your Macintosh can (almost) always be read by any Windows graphics program.

TRANSFER RATE. A measurement of the average number of bytes per unit of time passing between disk storage and processor storage.

TTL. Through-the-Lens. In this system, the camera measures the actual light entering the lens.

TWAIN. Not an acronym, although some pundits insist it stands for "Technology Without An Interesting Name." A hardware/software standard that allows users to access scanners

and other hardware peripherals from inside Windows applications, although the TWAIN standard can be found on Mac OS computers too.

UNDO. One of the most useful tools, commands and/or features an image-enhancement program can have; it lets you go back to the way the image was *before* you made the last change.

UNIX. A multi-user, multi-tasking (doing more than one thing at the same time), multi-platform operating system originally developed by Bell Labs for mainframe and mini-computers back in the bad old days of computing.

UNSHARP MASK. In Adobe Photoshop, and other image-editing programs, this is a digital implementation of a traditional darkroom technique where a blurred film negative is combined with the original to highlight the photograph's edges. In digital form, it's a controllable method for sharpening an image.

URL. Uniform Resource Locator. That's how you find a website (www.joefaraceshootscars.com, e.g.) when using an Internet browser software.

VARIATIONS. A command found in Adobe Photoshop that gives you control over the hue and color intensity of an image.

VECTOR. Images saved in this format are stored as points, lines, and mathe-matical formulae that describe the shapes making up that image. When vector files are viewed on your computer screen or printed, the formulae are converted into a dot or pixel pattern. Since these pixels are not part of the file itself, the image can be resized without losing any quality.

VIRTUAL MEMORY. Sometimes called (by Adobe in Photoshop) a "scratch disk." When not enough "real" memory is available, this process borrows a chunk of your hard disk to store data and perform imaging calculations.

VRAM. Video Random Access Memory.

WMF. Windows Metafile Format. A vector graphics format designed to be portable from one PC-based program to another.

WORM. (1) Write Once Read Many times and (2) a form of computer virus that continually duplicates itself on your hard disk, gradually using all of your computer's resources before ultimately shutting it down.

WYSIWYG. (Pronounced "wissy-wig.") What You See Is What You Get. This term refers to the ability to view text and graphics on screen in the same way, as they will appear when printed.

XAOS TOOLS. (Pronounced "chaos.") A software company that offers several packages of Adobe Photoshop-compatible plug-ins that can produce artistic-looking images.

YCC. The color model used by Kodak in its Photo CD process. This involves the translation of data that was originally in RGB form into one part of what scientists call "luminance" but the rest of us call brightness—this is the Y component. The format includes two parts—the CC—of chrominance or color and hue.

ZFP. Zero Foot Print.

ZIP. Iomega's Zip removable media drive that has a cartridge that looks like a fat floppy disk and uses a combination of conventional hard disk read/write heads with flexible disks. Zip disks are available in two capacities: 100 and 250 MB.

ZOOM. A tool found in most image-enhancement program that lets you zoom into any photograph by clicking your mouse button. The Zoom is tool depicted by a magnifying glass icon so often that it's often just called "magnifying glass."

Index